DEDICATED TO THE MEMORY OF LARRY BARTLETT

Larry Bartlett's
Black & White
PHOTOGRAPHIC PRINTING WORKSHOP

TEXT
Jon Tarrant

DESIGN
Grant Bradford

FOUNTAIN PRESS

Published by
FOUNTAIN PRESS LIMITED
Fountain House
2 Gladstone Road
Kingston-upon-Thames
Surrey KT1 3HD
England

Photographic Printing
Larry Bartlett

Text
Jon Tarrant

Design
Grant Bradford

Illustrations
Kuo Kang Chen

Origination
Regent Publishing Services
Hong Kong

Printing & Binding
Die Keure n.v.
Belgium

ISBN 0 86343 366 9

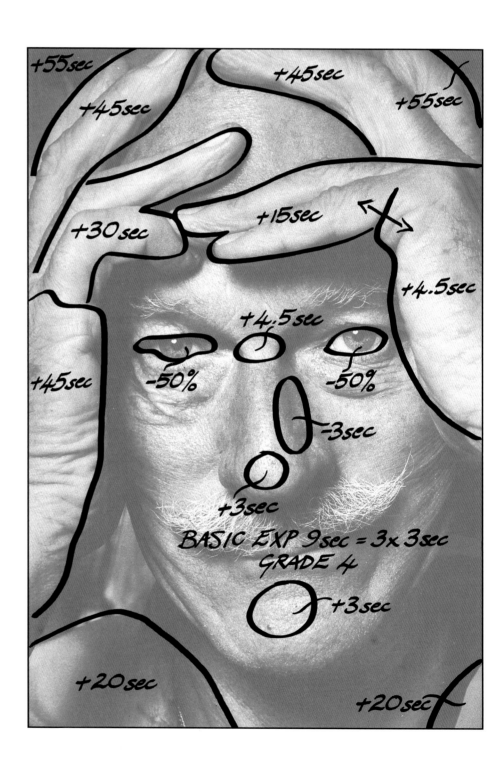

FOREWORD

Photographic printing, like landscape painting, is not an absolute art. Both are matters of interpretation, the first of a negative and the second of an original scene. In each case, it is not enough just to reproduce the starting material exactly. Rather, it is the element of individual style that makes the results what they are.

Unfortunately, photography has had a hard time trying to convince the world that it is an artistic medium. Far too much emphasis has been placed on objective technicalities, with correspondingly little given to subjective interpretations. This book attempts to correct this imbalance by combining both aspects. The first section is given over to equipment, materials and basic principles; the second to the ways in which specific techniques have been used to obtain the very best finished prints from a variety of different negatives.

It is not our intention to present either a wide-ranging or an unbiased approach to b&w printing. Indeed, although there are two authors, this book is very much Larry Bartlett's approach. For this reason, and also the growing dominance of such materials, a heavy emphasis is placed on the usefulness of variable contrast papers in general, and Ilford's resin-coated Multigrade papers in particular. Similarly, although colour enlargers are commonly recommended for printing onto b&w variable contrast papers, first-hand experience has proved that this method of working is unlikely to produce the very best results. Where given, specific comments and recommendations such as these are made in the best faith, and are not done simply for the sake of being controversial. It is our firm belief that some authors have skirted around these issues in the past, having preferred to give pros and cons for all the various options, rather than stating their own preferences. In Larry Bartlett's case, his unrivalled success in having printed winning images for every major UK press photography competition proves that the equipment and methods he uses are the ones that work. This book therefore concentrates on these aspects.

Stylistic considerations are harder to explain than are the technical aspects of printing. Most difficult of all is the fundamental approach that printers have to negatives. Were the same negative to be given to a number of different printers, as many different results would be obtained. In all cases, the available techniques were the same, yet the ways in which they were used were different. By mastering a number of simple techniques, a whole host of options become possible. Choosing which to use is a matter of intention and experience. Two things are therefore required if great prints are to be produced; a clear vision of what is wanted and the means of achieving that end. We hope that this book teaches both.

During the final stages of producing this book, Larry Bartlett died. It was always his intention, and remained that of his wife, Pat, that the book should be a lasting testament to his skills and methods. Now, more than ever, that desire has lasting poignancy. This book is therefore dedicated to the memory of Larry Bartlett - without doubt, the most successful black and white printer the UK has ever known, and a man whom I am very proud to have been able to call friend.

Jon Tarrant

CONTENTS

PHOTOGRAPHIC PRINTING WORKSHOP

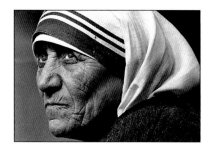

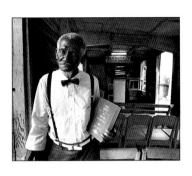

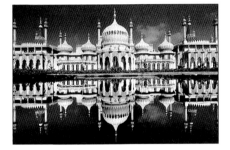

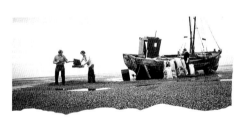

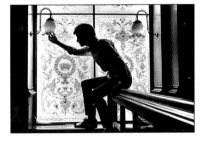

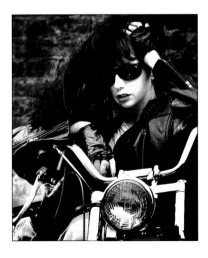

CHAPTER ONE

Equipment

Buying photographic equipment is like walking across a mine-field of poor advice and vested interests. In view of this, two simple criteria have been used here when discussing and recommending particular items. The first is that the equipment must be genuinely useful and worthy of its price. The second is the makes and models mentioned must be rugged and durable. Both these factors can be linked in a single observation: if a piece of equipment is good enough for professional printers then it is good enough for everyone. Amateurs are too often tempted by appearances without sufficient regard to functionality. Professionals use what they do because it works, and works well. All who aspire to the results produced by professional printers should bear this simple fact in mind.

ENLARGERS

An enlarger, and the lenses to fit it, will be your most important darkroom purchase and should be regarded as being at least equal to the camera and lenses that you use to expose your negatives. Enlargers come in several different designs and types, as well as different formats. The choice can seem confusing, but a few basic considerations make matters much clearer.

The first is the "hardness" of the light. The various types of light sources, going from the hardest to the softest, are point-source, condenser, diffuser (or mixer-box) and cold-cathode. Their different optical qualities produce finished prints with differing degrees of grain sharpness. The smaller the light source used in the enlarger, the more sharply defined is the image grain. Point source enlargers give the sharpest grain, whereas cold-cathode enlargers give the softest. Grain sharpness is not necessarily a good thing: firstly because it is not the same thing as image sharpness, and secondly because scratches, flecks of dust and imperfections in the negative all become more obvious as the grain becomes sharper. Using a softer light makes negative defects less obvious without softening the image itself. Unfortunately, cold-cathode light sources have another problem in that the colour of their light differs from that given out by the incandescent bulbs for which slot-in variable contrast filters are designed. Cold-cathode enlargers should therefore not be chosen if you are likely ever to want to use variable contrast papers. Overall, the best type of enlarger is a diffuser, with condensers coming a close second.

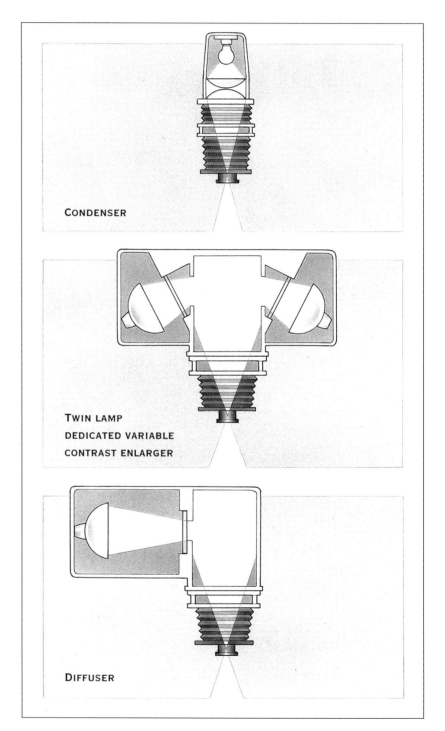

CONDENSER

TWIN LAMP
DEDICATED VARIABLE
CONTRAST ENLARGER

DIFFUSER

Assuming that you will want to print onto variable contrast paper, either exclusively or in addition to fixed grade papers, your enlarger needs to be fitted with a system for changing the colour of its light, for this is the means by which different contrast grades are obtained. There are three basic ways of doing this. The first is to use a special variable contrast light source that has a dial marked directly in b&w grades. The second is to use slot-in filters mounted either above the negative or below the enlarger lens. The third is to use a colour enlarger that has dial-in head calibrated for colour work. Of these options, the last is the least satisfactory – despite being the most commonly recommended!

There are two types of dedicated variable contrast enlarger light sources; one uses a single lamp and a colour wheel that dials-in different filtrations, while the other uses two different colour lamps that are adjusted in brightness relative to each other. The former type is the less expensive and is essentially just a very convenient way of providing slot-in filters at the turn of a dial. If your enlarger cannot be fitted with such a head, or if you can't afford this expense, slot-in filters should be used. In theory, you might get better image quality using filters that fit into the enlarger above the negative carrier, but not all enlargers have provision for this. Not only that, but the filters are more difficult to remove and insert from this position than they are when placed under the enlarger lens. The latter is therefore the better type of filter to use.

As has already been mentioned, enlargers intended for colour printing are not ideally suited to b&w variable contrast papers. This is because there is no direct read-out of the grades and the brightness of the illumination varies with changing filtration. Although it is possible to balance the brightness across the range of grades with such heads, this can only be done by adding third-colour filtration in varying amounts, which decreases the brightness and so increases exposure times for the common middle grades. Even once this has been done, there is a further problem in that some colour enlargers lack sufficient range to provide the highest contrast grade on variable contrast papers. In short, while colour heads are cheap and commonly available, they are also a definite compromise when it comes to b&w work. Fortunately, there is a very simple solution. Just set the enlarger to white light, ignore the dial-in filtrations, and use a below-the-lens filter set instead.

The third enlarger consideration to be taken into account is the type of negative carrier(s) offered. Glass carriers, which sandwich the negative between two plates of anti-Newton (anti-interference) glass, ensure that the film is kept completely flat. Unfortunately they also mean four extra surfaces to keep free from dust. Glassless carriers, on the other hand, are less efficient in preventing the negative from buckling as it becomes heated by the

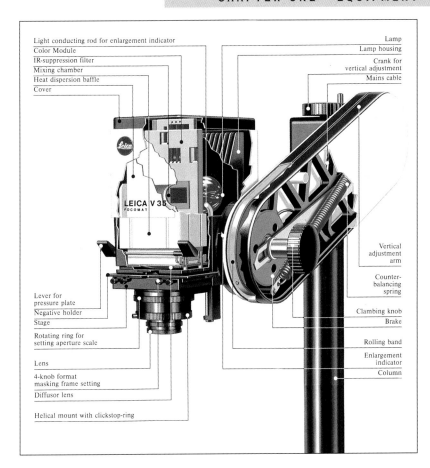

LEICA V35 ENLARGER.

light. Such buckling causes the negative to "pop" and makes the image to go out of focus, either all over or in areas. There is, however, a very simple way of avoiding this problem – which is to tape the negative onto the carrier, pulling it taught when doing so. This is particularly effective with roll film negatives. Suitable tapes include low-tack masking tape and film splicing tape. For 35mm negatives there is a mid-point between glass and glassless carriers, which is a system that has a single glass sheet that lies on top of the negative. This works well because 35mm negatives tend only to bow upwards and not droop downwards, but works less well with roll films where this is not the case.

Finally, there are a number of practical points that should be kept in mind when choosing an enlarger. Some models offer auto-focus operation, where the negative to lens distance is automatically varied by a gear coupled to the baseboard-to-lens movement. This is handy, but should never be an excuse not to check the focus for each and every print. Some enlargers have baseboard mounted controls for altering position and focus. This can be very convenient when making large prints on a big baseboard as it can be difficult to reach the enlarger head at such times. Remote setting of contrast grades, using a pad located beside the

baseboard (as is provided on dedicated variable contrast enlargers), is a similarly useful feature in such situations. Drop-down baseboards, where the lens to baseboard distance is increased by lowering the baseboard instead of, or as well as, raising the enlarger head, also make life easier when doing larger prints.

At the bottom of the list of priorities when choosing an enlarger comes thoughts about covering negative formats other than that for which the enlarger is needed right now. If you are working only in 35mm, the Leitz Focomat V35 is simply the best. It is unbeatable, but with a price to match. For greater versatility, covering formats from 35mm to 5x4" and with options to fit a range of light sources including dedicated variable contrast heads, there is the DeVere 504. These two models are recommended from first-hand experience; no doubt there are other enlargers that are capable of producing similar quality results. As a general guide, you get what you pay for, so always buy the best you can afford. If budgets are tight, a rugged secondhand enlarger will probably give better results and longer service than a flimsier new model. Within reason, for the same money, a less sophisticated enlarger will probably be of better build quality than one that is more feature packed.

LENSES AND ACCESSORIES

Like cameras, the performance of an enlarger is limited by the quality of lens fitted. Although there are some very good value cheaper lenses, the best are almost without exception the more highly priced designs from the major manufacturers. Top names here are Leitzar (Focotar), Schneider, Rodenstock and EL-Nikkor. Unless you are very lucky, a good enlarging lens will cost about as much as a similar focal length lens for an SLR camera. It might be tempting to try and cut costs by buying a cheaper lens, but remember that every print you make will be exposed through this optic, so don't compromise on quality in this case.

Strangely, one area where people sometimes spend more money than necessary is on an enlarger timer. Partly this is because modern timers can be seductively sophisticated and partly it is because some books suggest that particular timers are all that is needed to make you into a better printer. The fact is that you will probably become a better printer quicker by buying a cheap timer and spending more on paper to practice with than by committing all your funds to an elaborate piece of electronics.

Although it might seem possible to time exposures simply by watching the second-hand of a wall-mounted clock, this method is not accurate enough for top quality printing. It is far better to have a timer that connects directly to the enlarger's light source. A digital timer with an illuminated countdown display is best. The range of times offered should go from one second to about

five minutes, with an accuracy down to tenths of seconds at the shorter end. Actual exposures used will depend on the type of light source: hard light sources are generally brighter, making shorter timed intervals more important here, whereas longer maximum times are more likely to be used with softer lights. The option to connect a foot switch to the timer can be useful but is by no means essential. What is essential, however, is a "focus" setting that switches the lamp on indefinitely for adjusting framing and focusing. It is also very useful to have a red filter positioned below the lens, arranged so that it can be swung into the light path to allow the image to be viewed without affecting any paper that might be on the baseboard. This is especially important when making double exposure prints.

Although the image has so far been said to be seen on the baseboard, in fact it is more usually seen on an easel. The primary purpose of the easel is to hold the paper securely in the desired position, with a secondary purpose being to provide borders around the image. It is not essential to have an easel at all, though without one a method needs to be devised for making sure the paper is flat and correctly positioned before printing. Easels do, however, make life a lot easier. In accordance with this, there is a lot to be said for having both a small easel and a larger one, each best suited to particular range of print sizes: trying to make small prints using a large easel can be very awkward.

There are a number of different easels available and it is mostly a matter of choosing one that has a solid feel. Some modern types are rather insubstantial, making secondhand purchases worth considering. Versions are available with either two or four moving blades. The latter allow greater versatility in framing the image on the paper, but the former are much simpler both to set-up and to use. With a little ingenuity, almost everything that can be done with a four-blade easel can also be done with a two-blade. The very best easels are made by RR Beard (often known as RRB, or just Beard), with their older two-blade models being generally better than the four-blade types.

CONTACT PRINTING FRAME

Although commercial contact printing frames available off-the-shelf, it is quite simple to make your own if you prefer (see diagram). A major advantage of doing this is that it enables you to fix the size of the frame to suit the way you work. In particular, some commercial frames require you to slot your negatives into channels, which involves considerable handling of the film. If your negatives are stored in see-through pages, from within which they can be contact printed without being removed, it is clearly very useful to have a frame that will accept such pages. Similarly, there is a difference between contacting 35mm films, shot as thirty-five exposures and cut into seven strips of five frames for printing onto

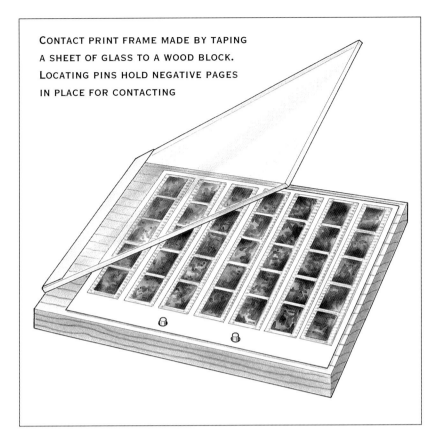

CONTACT PRINT FRAME MADE BY TAPING A SHEET OF GLASS TO A WOOD BLOCK. LOCATING PINS HOLD NEGATIVE PAGES IN PLACE FOR CONTACTING

A HOME-MADE CONTACT PRINTING FRAME.

A4 paper, compared to contacting 6x7cm negatives, which need a 9x12" sheet. In each case, a dedicated contact frame can be made to give the best results with the minimum of fuss.

PROCESSING EQUIPMENT

Print processing can be done either by machine or in trays. Although machines offer greater throughput and ease of working, such benefits come at a high price and can only really be justified by commercial printers. For those who print on a smaller scale, tray processing is recommended.

At least four trays are needed for each print size. The sizes of trays chosen should be one size bigger than the paper being processed. This means using 10x12" trays for A4 paper (which is a more sensible choice than 8x10", as will be explained later), and 16x20" trays for 12x16" paper. To ensure ultimate cleanliness, separate trays should be bought, and labelled, for each chemistry – including each type of toner used – and a separate tray reserved for clean wash water.

Open trays lose heat quite quickly, so it is important to provide a means of controlling temperatures if consistent printing results are to be obtained. The cheapest way to do this is using a water

bath. If you have both 10x12" and 16x20" trays, the latter can be used to make a bath for the former. To hold the water bath at the correct temperature, a small submersible fish tank heater can be placed in the outer tray. When using still larger trays, this method of heating becomes impractical in terms of the amount of darkroom space required. An alternative is to use tray warmers. As well as using 12x16" warmers for the individual trays of that size, it is possible to push two 12x16" warmers together to make a 12x32" platform that will take three 10x12" trays.

In addition to the trays themselves, you will need a number of measuring jugs, a thermometer and a timer. Glass measuring jugs are better than plastic ones by virtue of their greater resistance to surface contamination and their greater transparency, which makes it is easier to see the liquid levels within. The required accuracy of the markings depends on the way in which the cylinders are to be used. A good guide is that general purpose jugs are best regarded as being accurate only to one-tenth of their maximum capacity. This means that a one litre jug shouldn't be used for measuring volumes that have to be determined to less than 100ml. It happens that general purpose jugs are rarely marked more accurately than this anyway, though the existence of finer markings is not always a guarantee of greater accuracy. Measuring jugs used for cooking, available from major hardware stores, are accurate enough for most photographic purposes and are often much cheaper than the specialist alternatives.

In view of the extra care needed when handling glass containers, some printers prefer to use plastic measuring jugs, especially when working with larger volumes of liquids. If you do opt for plastic, remember that the material retains chemicals on its surface even after washing, so – just as with plastic processing trays – be sure to have separate jugs for each type of solution. Glass doesn't suffer from this problem.

The inertness of glass is one reason why it is used for making thermometers. Inside the glass envelope is a column of either spirit or mercury. From a practical point of view, the difference between the two types is the temperature ranges that they cover. Spirit types usually have a maximum temperature of no more than 40°C, while mercury thermometers go to over 100°C. For b&w work, the former is sufficient. Given that mercury is highly toxic and poses both environmental and health problems if the thermometer gets broken, spirit thermometers are to be regarded as the more sensible choice.

An alternative to traditional analogue thermometers is provided by the digital read-out type. Such instruments are fine when they work, but can suddenly throw wild readings when they go wrong. This is similar to the traditional problem of broken glass thermometers, which was always guarded against by having a

stand-by thermometer on hand. The same precaution should therefore be used with electronic thermometers. The stand-by and main thermometers should be checked periodically against each other to confirm that they give the same readings.

Timers used for print processing need not be expensive or elaborate affairs, though it is important that they are easy to read under darkroom conditions. A large clock that is fitted with a sweep hand can be sufficient, though a proper timer is better because it can be started and stopped as required. But avoid timers without a countdown display, for if they stop working it can be very difficult to realise that this has happened. With digital timers, the most common reason for failure is water seeping in through gaps around the push-buttons. To help protect against this, cover such timers in transparent plastic food-wrapping film. The timer buttons can still be pressed, but the thin plastic film will provide an effective barrier against water.

EQUIPMENT FOR WASHING AND DRYING PRINTS

When it comes to washing and drying prints, the equipment required depends on the type of paper used; resin-coated or fibre-base. Resin-coated papers wash and dry quickly and easily: fibre-base papers less so.

A standard print processing tray, through which there is a steady flow of clean water, is sufficient for washing RC prints. To ensure even washing of a number of prints, the sheets should be turned and cycled from the bottom of the stack to the top as often as possible. This technique is not advised for FB papers because of their lower rigidity and hence greater vulnerability to damage during handling. Also, the extended washing times needed for FB prints would make this a very laborious procedure. For these reasons, and to provide a controlled flow of water, a custom-made print washer is used. In the best types, such as those made by Nova Darkroom Equipment, each print is contained in its own slot so that wash water from one doesn't contaminate another, so keeping washing times to a minimum. Print washers normally stand upright to reduce the space they occupy, and have to be used in a sink or other splash tray to collect the water that overflows from them. When working with FB papers, print washers are virtually essential. With RC papers, they are often an unnecessary additional expense.

As with washing, drying RC prints is very easy. They can be air dried, heat dried using a hair drier, heat dried in a dedicated hot air drier, or infra-red dried for a high gloss finish. In all cases, the cheaper the drying system, the slower it works. At the extremes, air drying takes hours, while infra-red drying takes seconds. As well as speed considerations, it also happens that the slower methods tend to give slightly less brilliant surface finishes, though

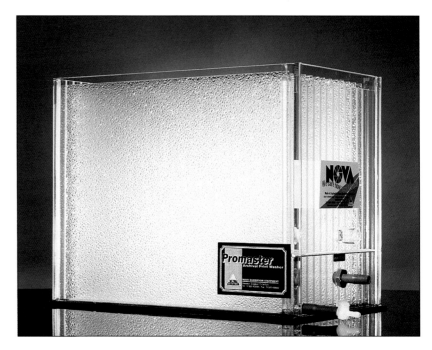

NOVA'S ARCHIVAL PRINT WASHER.

this is a very minor effect with RC papers. As a good all-round choice, a dedicated hot air drier is recommended for RC prints.

FB prints cannot be dried using hot air as this causes them to curl. For rapid drying, a hot drum or curved metal platen is used, against which the print is held in place by a canvas blanket. If the image faces the metal, a high-gloss glazed surface will result; if it faces the blanket, the print will have a dull gloss finish. Heated driers take about ten minutes or so to dry FB prints. When time is less pressing, FB prints can be dried between thick sheets of paper. All that is needed is a stack of photographic grade blotters, a rigid board that covers the full area of the blotters, and a weight to apply slight pressure. This is by far the easiest way to dry FB prints, and has the additional advantage of avoiding image colour changes that sometimes result from heated drying.

NEGATIVE HANDLING EQUIPMENT

The two areas that give most problems when handling negatives are inspecting the image and cleaning the film. Although it is possible to examine the images simply by holding them up to an overhead light, it is more comfortable and safer to lay them down on a lightbox. The lightbox should be at least twice the size of the negative page so that an entire film can be inspected, alongside its contact sheet, at a single glance. As well as allowing inspection of the images, a lightbox can be used to back-illuminate negatives for copying. If this is to be done, it is sensible to keep a protective sheet of glass over the lightbox's frosted perspex top. The glass can be removed when the lightbox is to be used for copying and ensures that the perspex surface underneath is kept unmarked.

Even if you only print in b&w, it is better to get a lightbox with colour corrected tubes as this can also be used as a light source when copying colour transparencies – should the need ever arise.

Negatives can be cleaned in one of three ways. The simplest method is to blow dust off using compressed air. On a small scale, this is most usually in the form of canned air, which must be non-staining, CFC-free and non-flammable. As an added precaution against staining, always hold the can completely upright and do a test squirt to check that no liquid is expelled. Better still, there are pump-up systems that are the ultimate in environment friendliness, albeit requiring rather more effort and giving rather less "puff" than pre-pressurised cans.

The second method is to use an anti-static system that takes away the dust by removing the means by which it is held onto the negative – static electricity. Hand held anti-static brushes get mixed reports from different users, but they are at least cheap enough to try out and abandon if they prove useless in your own case. Anti-static guns, as used on vinyl records, are generally less effective because they lack any physical contact so don't actually disturb the dust once the static electricity has been neutralised. Mains powered anti-static systems are the most effective type, but are also the most expensive.

The last option is to wipe the negative using a suitable cloth or clean chamois leather. If a cloth is used, care must be taken to ensure that it doesn't cause static to build up when the negative is rubbed. Chamois leather poses no such problems, and provides a very cheap alternative to specialist wipes. Commercial leather needs to be washed in frequent changes of water and detergent to remove all the oils, after which a small piece of the leather should be dried and carried around in your pocket, in a plastic bag, to soften it before use.

Chamois leather has an advantage over both the other systems in that it can remove both dust and surface stains. It does, however, have an important disadvantage: if the cloth is in any way dirty, grit on its surface can scratch the negative causing possibly irreparable damage. Not only that, but wiping too vigorously actually increases the static charge on the film, so making the dust problem even worse. This method must therefore be used only with extreme caution. In all cases it is worth remembering that dust marks can always be retouched out on the print, so it is better never do anything that might jeopardise the original negative.

Films should always be stored in see-through pages that allow easy inspection and also make it possible to do contact prints without removing the film strips from their protective sleeves.

AN A3 LIGHTBOX IS BEST FOR VIEWING NEGATIVES AND CONTACTS ALONGSIDE EACH OTHER. IN THIS CASE, IT IS A HANCOCKS PORTABLE LIGHTBOX THAT CAN ALSO EASILY DOUBLE FOR DARKROOM/STUDIO USE.

SAFETY EQUIPMENT

There are a number of other items of equipment that should be purchased, all of which relate to safety. Gloves and safety-glasses should be worn whenever handling photographic chemicals of any sort, and a dust mask should also be used when the chemicals are in powder form. It is important to have an eye-wash bottle on hand in case of chemical splashes. Either tongs or gloves should be used for handling prints in trays, rubber-tipped steel tongs being more durable and less likely to scratch than the hard plastic types.

Safety, from the point of not accidentally fogging light-sensitive paper, is provided by working from a paper safe. This is a device which dispenses single sheets of paper on demand, whilst keeping the remainder in a light tight container. The alternative tactic, that of working from the box in which the paper was supplied, is fine until you accidentally switch on the white light without remembering to replace the box lid. Paper safes typically cost about the same as a 100-sheet box of paper of that size and are very much easier to work from, not least because they can often be used stacked on top of one another – which is not true of the original paper boxes. Amongst the best paper safes are the range of Tomkins' Boxes, made in the UK by Garth Tomkins.

CHAPTER TWO

Darkroom Layout & Design

If ever there was a subject about which it could truthfully be said that size was unimportant, then darkroom design is it. Of course, there must be sufficient space in which to work, but this is a relatively modest requirement. Although expansion can make life more comfortable, or may be needed later to accommodate newly acquired equipment, the best size for a darkroom remains the minimum acceptable, rather than the maximum available. The exact design and layout of individual darkrooms depends on the size and shape of the room used and the size and types of prints made, but there are a number of general guidelines that commonly apply. In particular, you should pay close attention to considerations relating to health and safety in the darkroom.

DARKNESS AND LIGHT

Most darkrooms aren't purpose-built affairs, but rather are modified from rooms intended for other uses. As such, the first problem that needs to be addressed is one of light-proofing. Even if there are no windows, as might be the case when adapting a cellar, light will probably still get in around the edges of the door. Sticking heavy duty draught excluder onto the door frame can reduce light seepage around the edges, as can a "sausage dog" draught excluder for the bottom edge of the door. If light still gets in, special light-proof material, or a heavy curtain, can be hung across the door, overlapping at the top and sides and having a tail that comes out onto the floor, to finish the job. As a point of safety, darkroom doors should always open outwards, should never be locked from the inside and must not be obstructed but the light-proofing used. Windows can either be boarded up (if the room is to be used only as a darkroom) or fitted with blinds or removable black-out panels.

Darkrooms don't have to be totally light-tight, which is just as well since few actually are. But what they do have to be is sufficiently light-tight to allow photo-sensitive materials to be handled safely. The degree of darkness required, when all the lights have been turned off, varies with the materials that are to be used in the darkroom. Old fashioned fixed grade b&w printing papers are less sensitive to light than are more modern variable contrast types, and both are very much less sensitive than are common b&w

camera films. The same trend applies in respect to spectral responses: fixed grade papers are sensitive only to blue light, variable-contrast papers are sensitive to both blue and green light, and modern camera films are sensitive to all colours.

As a rough guide, if, with the darkroom lights turned off and your eyes given about ten minutes to adjust to the dark, you can see colours or clear outlines of the equipment, then there is too much light to handle any photo-sensitive materials safely. If you can't distinguish colours at all, but can still see just dim outlines of equipment, then film will probably be fogged but paper will probably be safe. If the room is so dark that you can't see anything – not even a hand in front of your face faintly silhouetted against blackout curtains – then it should be safe to handle all normal photosensitive materials. Bear in mind though, that these are just rough guides: for a more thorough check, the safelight testing procedure explained later in this chapter should be followed.

Opinions differ about the best colour to paint darkroom walls. One theory is that they should be black, to absorb scattered light and so reduce both direct reflections and general fogging. Another is that they should be orange, to absorb all blue and green light but reflect other (safelight) colours. And yet another is they should be white. This last theory assumes that there is only safelight illumination and has the advantage of making the room much less claustrophobic than it would be with darker walls.

Most professional printers opt to have their darkrooms painted white, though it is quite common to have a black wall immediately behind the enlarger to help reduce scattering of stray light from this the most likely problem area. On the other hand, it isn't a good idea to set up black boards to each side of the enlarger since they can create new surfaces from which light is reflected – even if only slightly from matt black panels – and, more importantly, block arm movements when dodging and burning-in a print.

WHEN DESIGNING A PERMANENT DARKROOM, THE ONLY MAJOR LIMITATIONS ARE THOSE IMPOSED BY THE LOCATION OF EXTERIOR WALLS AND INTERIOR DOORS.

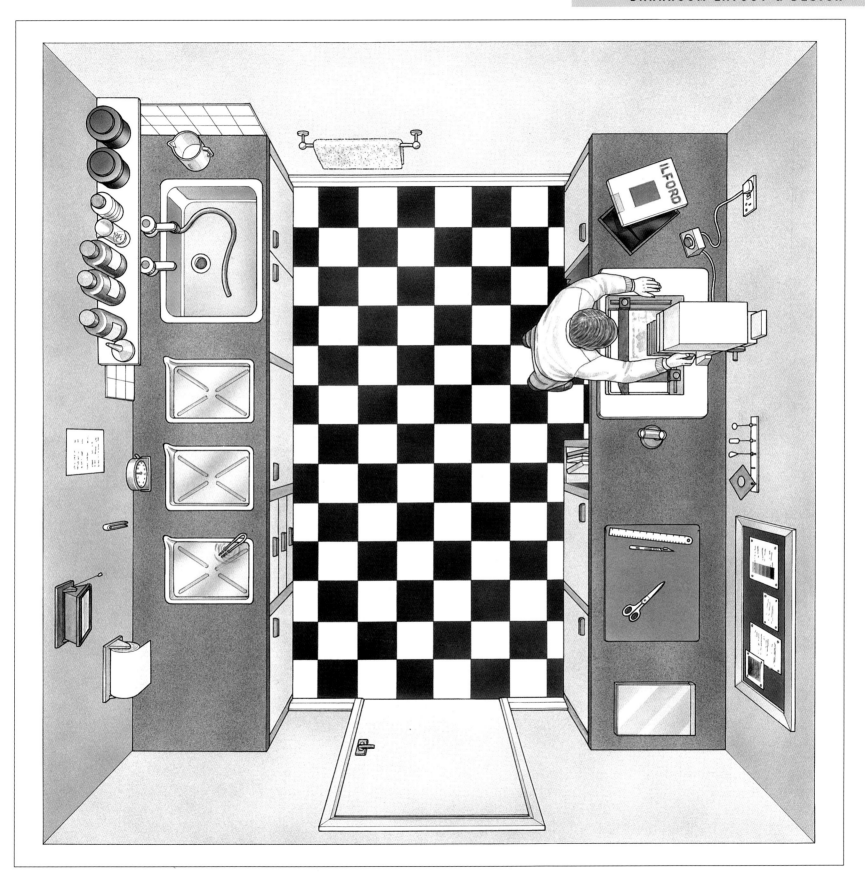

VENTILATION

A room that has been modified for darkroom use can become air-tight as well as light-tight. This is clearly a very serious potential problem and can be a good reason for not sealing the darkroom too well against the light. Poor ventilation causes not just a drop in air quality but also a rapid rise in room temperature, which makes working conditions much less comfortable and so reduces the chances of producing top quality prints. In short, bad ventilation tends to go hand-in-hand with bad printing.

There are two solutions to the ventilation issue: either keep your time in the darkroom sufficiently short to avoid air/temperature problems, or install an air-flow system. In general, high ceiling darkrooms are less prone to air/temperature problems. Low ceiling darkrooms, which include cellars and under-stairs cupboards, are most in need of additional ventilation. An air-flow system doesn't have to be expensive (though some are) and ought be regarded as a sensible, if not always absolutely essential, investment. There are, however, times when good ventilation is especially important. These include when using hot chemicals, which fume more profusely, and when using toners, the fumes from which can be especially troublesome. Toner fumes don't just pose health problems, they can also degrade unused photographic materials too. That said, since toning can usually be done under normal room lighting it can be much simpler to do this work with the black-out systems removed and the windows opened, or even outside the darkroom completely.

If you do decide to invest in an airflow system, there are a couple of details you should consider before making your final choice. Firstly, extractor fans are useless unless provision is also made to let air into the darkroom. The positions of the air inlet and extractor will determine the direction of airflow, which should always move fumes away from, not towards, your face.

When working at trays, it is best to have the inlet high up behind you and the extractor on the wall beyond the trays. It is also important that the flow of air is sufficient to keep up with consumption, otherwise the darkroom will become increasingly stale – albeit at a slower rate than it would without any additional ventilation. The best systems use heat extracted from outgoing air to condition incoming air and can control both air quality and temperature. All darkroom ventilation systems must, of course, be totally light-proof.

ELECTRICITY AND WATER

Darkrooms are home to a potentially lethal combination of water and live electricity. While electricity is essential to the running of a darkroom, it must be provided safely. The minimum safety precaution should be to fit an Earth Leakage Circuit Breaker (ELCB) or Residual Current Detector (RCD). These devices cut the power supply the moment that a current flows to earth – which is a far safer system than waiting for a fuse to blow. They can be installed either at the main fuse box or at each plug socket. The plug types are quite reasonably priced and require no special installation. The fuse box types have the advantage of protecting the entire building, rather than just one plug socket, but do require fitting by a qualified electrician. If in doubt, always consult a qualified electrician.

Running water isn't essential in a darkroom, though it definitely does make life a lot easier. In the absence of running water, prints need to be taken elsewhere for washing. They can be transported in processing trays, but only after all the excess water has been poured out to reduce weight and avoid slopping. For the same reasons, water and processing solutions are best not moved in open trays. Several rigid buckets, one reserved for incoming fresh water and others for used chemistries, provide a far safer means of transportation.

WORK SURFACES AND FLOORS

In an ideal world, work surfaces should be set at a height that suits the user and the method of working. If you intend to print sitting down, then the work surfaces should be lower down than they would be for use standing up. A distinction also needs to be made between work surfaces that will be kept dry and those that will support open trays and may therefore get splashed with chemicals or water.

Enlargers can be supported on a Black & Decker Workmate, or other sturdy, variable height, work-bench. The ability to lower the working height can be particularly useful when making large scale enlargements, as can the option to raise the level when making small prints. The normal enlarger level should be one which suits your most commonly printed paper sizes, and this should also be the height selected if a fixed-level work surface is used. To determine this height, work back from the enlarger head, putting the lens roughly at eye level and adjusting the baseboard position to give the right degree of enlargement. Something just below waist height is a good starting point.

Although many enlargers are supplied on a column that is fixed to a baseboard, it can be more useful to separate these two parts. The enlarger can be fixed to the wall (which should be a brick supporting wall, not just a stud partition), with the bottom of its column supported on a very rigid shelf if necessary, and the baseboard fixed to a separate platform. This allows both the baseboard and the enlarger heights to be varied, so giving a greater range of possible enlargement sizes and also increasing working comfort by keeping the enlarger head within easy reach.

Work surfaces should have coverings and fittings that reflect the uses to which they are put. Wet-benches should have waterproof,

THE CORRECT HEIGHT FOR AN ENLARGER IS WITH THE NEGATIVE CARRIER AT ABOUT EYE LEVEL.

chemical resistant tops, and are best fitted with a lip that prevents splashed solutions from dripping onto the floor. It is also wise not to store anything that might be damaged by liquid leakages underneath the wet bench. This is especially true of boxes of printing paper. Dry benches are much better suited to doubling as storage cupboards and can be fitted with drawers or shelves to this end.

Like wet-benches, darkroom floors should be waterproof and chemical resistant. Carpets, even the water repellent types, are best avoided. Vinyl flooring is a good choice and can be made even better by turning the edges up against coving, placed against the skirting-board, to make a giant dish-like surface that will contain any spillages that do occur. Absorbent paper, supplied from a wall-mounted dispenser, provides a convenient means of mopping up small spillages before they are forgotten. Unattended spillages can both pose a safety hazard by making the floor slippery and damage floor-level fittings.

SAFELIGHTS

Having gone to great lengths to exclude external light from the darkroom, it is now time to add carefully chosen interior lighting to create a comfortable and safe working environment. As has already been mentioned, different materials have different spectral sensitivities; fixed grade papers are sensitive only to blue light, variable contrast papers to both blue and green light and films to all colours. It therefore follows that fixed grade papers can be handled safely under yellow-filtered lighting since yellow filters look yellow because they absorb blue light, and that variable contrast papers can be handled safely under amber-filtered lighting (from which all the blue and green components have been removed). Film, of course, must be handled in total darkness.

Different makes of papers can have slightly different spectral sensitivities, so manufacturers sometimes supply safelight filters that are precisely matched to the colour responses of their own materials. Kodak specifies its OC "light amber" filter for both fixed grade Elite FB and variable contrast Polymax RC, Ilford specifies its 902 "light brown" for all b&w printing papers, and Agfa specifies both the aforementioned filters for its Multicontrast Premium RC, also advising that both Y71 "yellow" and G7 "yellow-green" filters can be used for its fixed grade papers (Brovira, Portriga and Record Rapid). Paper manufacturers that don't offer safelight filters of their own generally give less specific safelight recommendations. Kentmere, Oriental and Sterling fixed grade papers are all said to require unspecified "yellow-green" safelights. In the absence of any other advice, Ilford's 902 safelight should be suitable in all cases.

Safelights come in several different housings. The most useful one is mounted onto, or suspended from, a wall or ceiling and provides good overall illumination. Depending on the position of the safelight, it is sometimes useful to fit a flag (piece of card) that blocks its light from falling directly onto the enlarger baseboard. This ensures maximum visual contrast of the projected negative image and is especially beneficial when printing hard grades using variable contrast papers that require heavy magenta filtrations. Having flagged the main safelight from the baseboard, it can be useful to have a second, smaller safelight next to the enlarger. It may be possible to wire this light into the enlarger timer so that it is switched-off automatically when the enlarger light comes on. If not, a manual switch should be fitted. Finally, desktop safelights can be scattered around at various points wherever extra light is required. In professional darkrooms, there is usually a safelight over the developing tray to ease inspection of the image. The exact position of this light is often on the opposite side of the room to the enlarger, so that the printer's body automatically blocks it from the baseboard when exposing prints.

Be sure always adhere to paper manufacturers' safelighting guidelines. If you don't, your print quality will almost certainly suffer. Most printing problems, especially those involving veiled highlights or an inability to obtain hard grades on variable contrast paper, can be traced to incorrect safelighting.

SAFELIGHT TESTING

The whole "safelight" concept is something of a contradiction in terms. Whilst photo-sensitive materials can indeed be handled under appropriate lighting, there is still a limit to the time that can elapse before fogging starts to occur. Eventually, even if the paper is handled strictly in accordance with the manufacturer's guidelines, it will show a fog. Unfortunately, it is not usual for manufacturers' data sheets contain information about the safe handling times, though Agfa does provide this in its Multicontrast Classic instruction sheet. There is also a very thorough Kodak booklet devoted to this subject (Kodak publication K-4: "How Safe Is Your Safelight?").

A simple and extremely effective safelight test can be performed as follows.

❶ Set up your enlarger as you would for making your usual, or most common, size of print. Leave the negative carrier empty.

❷ Using test strips, determine the exposure necessary to give a print that is very light grey when processed.

❸ Take a fresh piece of printing paper and expose it for the pre-determined time. Don't process this print.

❹ Rest a board over the developer tray (which is a place that should be lit by safelighting) and lay the exposed print, emulsion side upwards, on this surface. Put a steel rule or other obstacle down the length of the paper to provide a reference area.

❺ Cover-up the paper one part at a time, using progressive exposures of 1,2,4,8,16 and 32 minutes. This will give test strips exposed for 1,2,4,8,16,32 and 64 minutes.

❻ Turn off all the safelights and process the test strip for the usual time. Only once the print has been put into the fixer solution can the safelights be switched back on.

❼ Wash and dry as usual, then examine the print under normal room lighting to find the first strip that is darker than the central band (which was covered by the steel rule throughout the safelight test). The total safelight exposure given to the strip before the first one visible is the maximum safe handling time.

This test should be repeated with each type of paper that you use, and both during the day and at night (to check whether any of the fogging is due to external light seeping into the darkroom). It should also be repeated every year or so to guard against safelight filter fading. Depending on your working methods, a minimum working time of four to eight minutes is required in order to expose and process prints safely. If the time drops below this, steps must be taken to trace the cause of the problem before any further printing is attempted.

SAFELIGHT TESTING DONE WITH AND WITHOUT LIGHT GREY CONDITIONING EXPOSURE. CLEARLY PRE-EXPOSED PAPER (RIGHT) IS MORE SENSITIVE TO SAFELIGHT FOGGING.

It is possible to distinguish between safelight fogging and background light fogging by repeating the safelight test with all the lights switched off. Under this condition, any fogging seen is due to light leaking into the darkroom and you should therefore check that all black-out systems are working efficiently. If the problem does lie in the safelights, further tests can be done with just one light switched on each time. Having found the problem light, ensure that it is the correct type for the paper being used and that it isn't leaking any unfiltered light. Failing these checks, if the light is quite old, it may have faded and be in need of a new filter. Whatever the reason for the problem, don't just ignore it and hope that it will go away!

TEMPORARY BATHROOM DARKROOM

Bathrooms make good temporary darkrooms because they have a ready supply of running water and are usually built with relatively small windows that are easy to black-out using a simple blind. For better light-proofing, an opaque panel can be velcro-fixed to the window frame. The door can be made light-tight with draught excluders and a curtain, as explained previously. Electricity can be brought in using an extension lead, which MUST be fitted with a suitable circuit breaker. The enlarger should be stood on a Black & Decker Workmate or similar type of collapsible work-bench. Trays can be lined up on a board rested over the bath. By part-filling the bath with water and leaving a gap at one end of the board, it is possible to make a convenient print collection/washing area. Ideally, the board should have lips to prevent splashed solutions dripping onto the floor, which should be covered with a tough polythene sheet just in case any chemicals do get spilt.

Safelighting can sometimes be provided by using the existing lighting fittings and simply changing the bathroom lights for photographic safelights. If this is not practical, safelights can be plugged into the extension lead. Remember to watch out for trailing wires while working. Do not store photographic paper in the bathroom as the humid environment will quickly ruin it. Photographic chemicals also need careful storing, especially if they might be found by young children. Under no circumstances should either fresh or exhausted solutions be stored in drinks bottles or other containers that could be mistaken for those containing consumable liquids.

PERMANENT DEDICATED DARKROOM

A good size for a one-person darkroom, fitted with one or two enlargers, is about eight to ten feet square. Proper ventilation should be installed, preferably using a heat exchanger system that regulates temperature as well as air quality. Water supplies should be filtered and fitted with thermostatically controlled valves on the hot pipe. Space should be allocated for storing both fresh chemistry and collected waste. All electricity outlets, whether plug sockets or hard-wired machinery, should be protected with ELCBs. An eye-wash bottle should be mounted on a wall away from obstacles but within easy reach. A torch, covered with an amber (safelight) filter should also be similarly mounted for use in case of power failures. The darkroom door should either be fitted with a light trap or be a revolving type that can be pushed through in case of emergencies. If the door is a conventional type, it should open outwards to avoid possible obstructions in an emergency.

The enlarger should be mounted to an exterior wall, and fitted with a drop-baseboard. A box should be provided within easy reach of the enlarger for storing dodging tools. Darkroom layout should extend logically from the enlarger: the developer tray

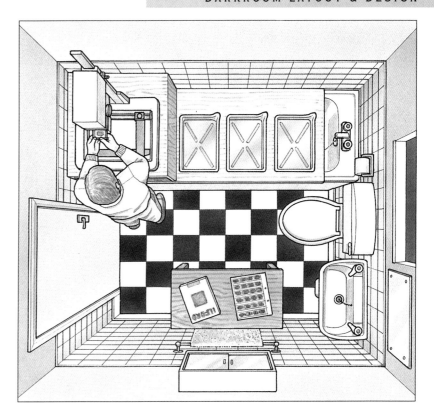

EXAMPLE LAYOUT FOR TEMPORARY DARKROOM, SET UP IN A BATHROOM.

should be nearest to the enlarger, unless this causes problems with safelighting spilling onto the baseboard and so reducing image visibility. Wherever the developer tray is placed, other trays should follow in logical order, with the fixer tray (second tray if using two-bath fixing) nearest to the running water wash. Safelighting should illuminate the developer tray and paper supply, but not the enlarger baseboard. A snooted white light (15W pygmy bulb within about 10" of plastic drain down-pipe and switched using a pull cord) can be positioned above the fixer tray to create a local pool of light that can be used for checking print density and contrast.

A means of drying hands should also be provided. If paper towels are chosen, they need to be of good quality to avoid small fibres sticking to skin and coming off when handling papers. Hot air driers are cleaner, but are noisy, create heat and circulate dust. Cotton towels are best, but need to be washed regularly.

FACILITIES AND PRINT QUALITY

It is tempting to think that the best prints are produced in the best equipped darkrooms, but this is simply not true. The basic items needed to produce good-quality prints can be found in almost every darkroom. With a good enlarger, correct safelighting and a comfortable environment, print quality comes down to a matter technical expertise and creative ability. It is therefore to these two factors that the rest of this book is devoted.

CHAPTER THREE

Papers & Processing

This chapter is about general aspects of print processing and is by way of background before launching into the practical details of darkroom work. It covers the different types of papers available and also explains the basics of good print processing techniques.

In the early days of photography, printing was a direct process based on the observation that certain substances change physical state (either colour or solubility) when exposed to light. Modern printing methods differ in that they make use of a latent image, which is invisible to the naked eye but can be developed and made visible by the action of appropriate chemicals. The nostalgic appeal and comparative novelty of older physical printing processes has led to a revival of interest in them of late, though this doesn't alter the fact that the vast majority of today's images are printed using the current generation of papers and chemistries. There is sometimes an implication that the ease of use of newer materials makes them in some way inferior. In part, this is simply untrue: it takes just as much skill to make a good print on modern materials as it does on those of old. And in part, it is totally irrelevant: what matters most is the final image, not the materials used in its creation. For these reasons, this book is confined to techniques for using modern printing papers.

THE CHOICES

Modern printing papers come as two types of emulsion on two types of paper bases. This gives four basic variations, each of which is further expanded by different surface finishes, base colours and image tones offered by different manufacturers. Even theoretically similar papers can show minor differences in image quality. The range of modern printing papers is therefore very wide indeed. This said, when setting out to master printing techniques it is important to learn the characteristics of a single paper in detail, rather than constantly flitting from one material to another.

RESIN-COATED v FIBRE-BASE

The image seen on a photographic print is contained entirely within the emulsion layer: the base material onto which the emulsion is coated is no more than a support. In view of this it would seem sensible to be able to confine the processing chemistry to the emulsion rather than letting it soak into the paper base as well. All that would be needed is an impervious barrier layer that sealed the paper before it was coated with emulsion. And that is exactly what is done in resin coated (RC) papers. This is such an obviously good idea that it is difficult to imagine why nobody came up with a workable implementation of this technique long ago. Instead, for many years printers had only uncoated fibre base (FB) papers to work with. Even with modern versions of such papers, processing solutions still soak into their paper bases and cause increased cross-contamination by substantial carry-over from one bath into the next. FB papers also require very long washing times to remove the last traces of all the chemistries used in their processing.

So why, given the processing disadvantages, should anybody still want to use FB papers? Firstly there is the fact that many professional printers cut their teeth on FB papers and have become accustomed to the working practices that they require. The second reason is that RC papers feel different to FB papers – the former having a tactile quality that is not liked by all printers. The third reason is that there is an important difference between the theory and practice of RC papers: although the front and back surfaces are sealed, the edges of the paper remain unprotected and still absorb chemistry that can then be difficult to wash out and may cause image deterioration in the future. Not only this, but prolonged washing of RC prints can cause cockling (edge wrinkles), and even delamination owing to the ingress of water into the unsealed edges. Fourthly, FB prints can be heat treated (glazed) to give a brilliant high gloss surface finish. Although there is an equivalent technique for RC papers, using non-contact infra-red heating, the glossy surface produced is far more delicate and more prone to scratching than that of a glazed FB print. And finally, there is a retouching consideration. Although retouching acts on the emulsion rather than the paper base, it is difficult to using knifing techniques on RC papers because this tends to damage the barrier layer and makes the retouching very obvious.

The case in favour of RC papers starts with greater ease of processing and washing, but extends much further. RC papers lie very flat and can therefore be used for borderless printing without resorting to vacuum easels or forcing time-consuming and

wasteful trimming of narrow borders required to hold FB paper flat. The same flatness also applies after processing and drying – almost regardless of how the drying is achieved. By comparison, FB papers need more sophisticated, or more time-consuming, drying methods if print curling is to be avoided. As well as being easier to dry, RC prints show a better air-dried gloss finish than that obtained on similar FB prints. Although not the subject of this book, RC papers can be processed through automated roller transport machines, something that is not possible with FB prints. Overall, therefore, RC papers give unprecedented ease of use on both small and large scales.

Some people, having heard all the arguments for FB and RC papers, reply simply that the image quality obtained from FB papers is always better than that obtained from RC papers. It is almost as if, being unable to balance the objective facts, they resort to subjective assertions that cannot be proved one way or the other. In reality, once a print has been mounted and framed, and its tactile quality is no longer apparent, the differences between RC and FB papers are negligible and it becomes impossible to tell an RC print from one made on FB paper. No matter how you decide to choose between RC and FB papers, be sure not to be fooled into believing that fibre-base papers give inherently better quality images. The ease of use of RC papers, especially when learning or practising new printing techniques, makes them by far the more sensible choice.

VARIABLE CONTRAST v FIXED GRADE

Traditional fixed grade papers have an emulsion that is of preset contrast and lies within the range Grade 0 (the softest, giving the greyest prints) to Grade 5 (the hardest, giving the starkest prints). Nowadays, few fixed grade papers are available in all these grades, and for those that are, the full range is restricted to a narrow selection of paper sizes. There is no getting away from the fact that fixed grade papers are becoming both less popular and harder to obtain.

The reason for this is that variable contrast papers, which were once inferior to fixed grade types, now offer just as much quality and with added flexibility too. While fixed grade papers have fixed contrast levels that are built into their emulsions, VC papers have multiple active emulsion layers that work in combination to provide a full range of contrasts on a single sheet of paper. One layer is sensitive to blue light (as is normal for printing papers) while another is dye-sensitised to respond to blue/green light. By varying the exposing light colour it is therefore possible to change the balance of contributions from these two layers, and hence the hardness or softness of the image.

It is important to realise that the one thing variable contrast papers don't do is adjust their contrast automatically. Rather, you must change the exposing light colour yourself to give what you think will give the right balance for the particular negative being printed. And herein lies perhaps the biggest danger when using variable contrast papers – the tendency to keep playing around with the light colour with less thought of putting extra work into the image at the existing grade. In short, VC papers can encourage lazy and bland printing. Despite this, there are several distinct advantages in favour of variable contrast papers, though the order in which these are ranked will vary for different users depending on the importance attached to considerations of economy and creativity.

Early adverts for Ilford Multigrade paper emphasised the fact that one box of variable contrast paper could do the job of many boxes of fixed grade paper. This was based on the fact that to get the full range of fixed grade paper contrasts, printers had to buy six separate boxes of Grades 0 to 5. Additionally, since the contrast changes were in whole grades, it was quite common to buy extra boxes made by another manufacturer whose grades fell mid-way between the first's. Multigrade paper, with variable contrast grades that could be set in half-grade steps, offered all this from one box. The advantages in terms of reduced stocks and greater throughput of paper by avoiding having very hard and very soft fixed grades go stale through lack of use, were immediately apparent.

An equally important, creative, advantage of variable contrast papers is that they allow different contrasts to be applied to different areas of the same print. With fixed grade papers, local contrast control is only possible through local development control – which is very limited. With VC paper it is possible to use the full range of contrast grades on a single print. This provides dramatic printing potential that was simply not available previously. It also allows easy incorporation of high-impact logos that can be printed at greater contrast for cleanest blacks and whites.

It is sometimes thought that the Grade 5 offered by variable contrast papers is not as punchy as that offered by fixed grade papers. This may be true in isolated cases, but the most likely cause of softer maximum contrast prints made on VC papers is incorrect safe-lighting. The importance of using the correct safelighting cannot be stressed enough: always follow the paper manufacturer's guidelines and be sure to do regular checks for safelight fogging (as detailed in Chapter 2).

SURFACE FINISHES

All types of paper, RC and FB, fixed grade and variable contrast, are available in a variety of surface finishes. To a large extent, it is surface finish – together with base/image colour and toning response – that give a paper its appeal. Surface finishes fall into three categories; glossy, matt and something between.

THE PRINTS HERE SHOW
THE COMPARATIVE EFFECT
OF PRINTING AT WHOLE
GRADE FILTRATIONS FROM
ONE ORIGINAL NEGATIVE.

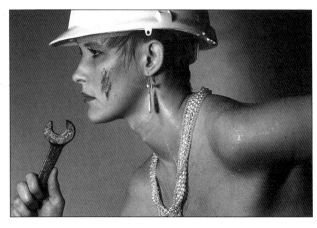

FILTER 0

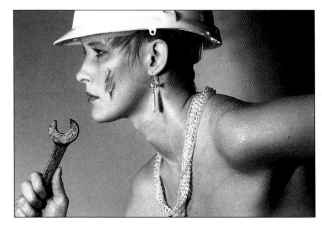

FILTER 3

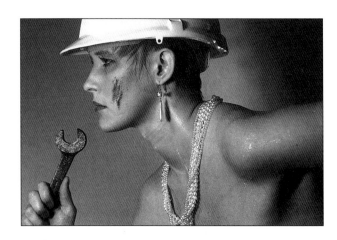

FILTER 1

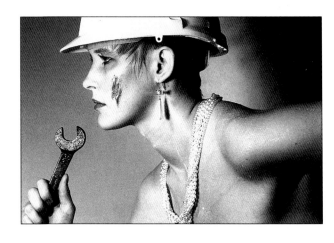

FILTER 4

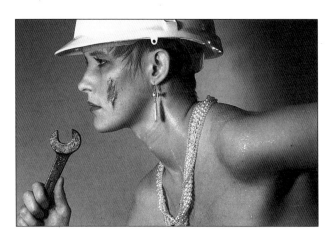

FILTER 2

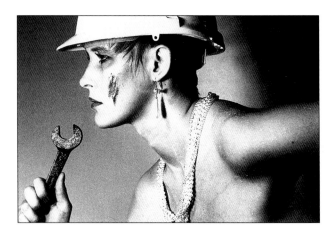

FILTER 5

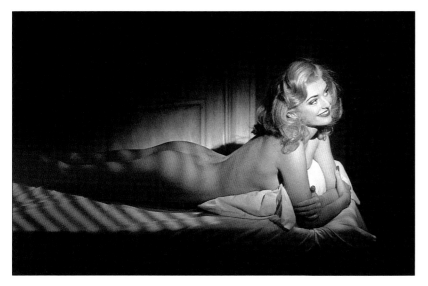

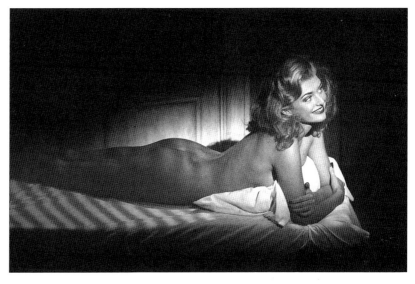

PHOTOGRAPHER: JOHN DOWNING

ONE OF THE BIG DIFFERENCES BETWEEN MODERN COLOUR FILMS AND THOSE OF OLD IS THAT THE NEW MATERIALS CAN BE VERY SUCCESSFULLY PRINTED ONTO VARIABLE CONTRAST B&W PAPERS AS THE EXAMPLE ABOVE SHOWS. ALMOST ALL COLOUR NEGATIVES PRINT AT GRADE $2\frac{1}{2}$ OR HIGHER (MOST OFTEN GRADES $3\frac{1}{2}$-$4\frac{1}{2}$) AND ARE VERY MUCH MORE SENSITIVE TO CHANGES IN CONTRAST AND EXPOSURE THAN ARE B&W NEGATIVES. IN GENERAL, COLOUR NEGATIVES DON'T PRINT AS WELL AS B&W NEGATIVES OF THE SAME SUBJECT, BUT THE DIFFERENCES ARE NOW VERY MUCH LESS NOTICEABLE THAN THEY ONCE WERE. THE ONLY REMAINING PROBLEMS ARE DUE TO THE UNEVEN COLOUR SENSITIVITIES OF B&W PAPERS. AS A RESULT, CYAN OR BLUE AREAS OF PICTURES TEND TO PRINT WHITE, WHILE REDS PRINT BLACK. THE ONLY WAY AROUND THIS PROBLEM IS TO USE A PANCHROMATIC B&W PRINTING PAPER.

The most popular papers are currently made in all three types (though matt surfaces are used least and may soon cease to become available). Less popular, or more specialist, papers are often available in only one surface.

Glossy prints always give the greatest apparent density of blacks, though checking with a densitometer may show there to be little actual difference between the blacks of glossy and non-glossy prints. But since prints are normally judged visually, this subjective advantage is enough to give glossy prints extra appeal. Against this, very smooth surfaces show surface reflections and so can sometimes be difficult to view. At the other extreme, matt prints don't look as punchy as glossy prints but are very much easier to handle and to view. The danger though is that matt prints can look lifeless. Matt is the most difficult to surface to use and is therefore not recommended for general work.

The best all-round combination of good subjective image quality and ease of handling/viewing is provided by semi-matt, satin, pearl or eggshell finish papers, and by glossy FB papers that have been left unglazed. Particular favourites amongst professional printers include the eggshell finish of Kodak Ektalure, which is generally felt to suit portrait subjects very well, and the smooth unglazed gloss of Agfa Record Rapid, which is considered by many to be a good all-round choice in fixed grade FB papers. Variable contrast papers are dominated by Ilford's Multigrade materials; Multigrade FB and the pearl-finish RC paper Ilford 44M.

IMAGE COLOUR

The as-developed tone of a paper is due to a combination of its emulsion and paper base colours. Warm tone papers tend to give brown-black images on an ivory paper base. Good examples are Agfa's Record Rapid, Portriga Rapid FB and Forte Fortezo fixed grade papers. In variable contrast versions, Forte PolyFibre Warm FB currently stands head and shoulders above all others. Neutral tone papers tend to give very deep brown blacks on just off-white paper. Viewed alone, they look neutral: the blacks would be described as being pure black, and the whites as pure white. Most RC and variable contrast papers fall into this category. Cold tone papers tend to have blue-whites and blue-blacks, with almost steely greys. Oriental Seagull and Agfa Brovira are the best known examples of this type. In general, there is a greater difference between neutral and warm tone papers than there is between neutral and cold tone papers.

Although it is possible to change the image colour of a paper by using developer additives, or the base colour by using dyes, it is more usual to limit any such variations to effects obtained by chemical toning (see Chapter 5). Warm-up toning is most effective

on intrinsically warm papers and cool-down toning on intrinsically cool papers. Neutral papers have the advantage of being open to both types of adjustment, but the disadvantage of being less responsive to each.

SPECIALIST PAPERS

All the papers mentioned so far are intended to produce prints which conform to an accepted standard of correctness in the way in which the image is shown. There are, however, other papers where this is not the case. One such type is lith paper, which has an emulsion that is capable of giving images of higher contrast than could be obtained on conventional materials. While this characteristic can be useful in itself, lith papers are more often over-exposed and snatched from the developer before they are fully processed. The resulting images exhibit colour differences between the various tone densities and often have a delicate pink tint. Another useful type of specialist paper is the Art Classic range offered by UK manufacturer Kentmere, which comprises four papers that have heavily textured paper bases and distinctive soft image qualities.

Kodak Panalure is the exception to these "creative" specialist papers. Panalure is intended for making b&w prints from colour negatives and differs from other b&w papers in that it is sensitive to all colours of light. Because Panalure is panchromatic, it gives a very much more accurate rendition of colour negatives in b&w. But by the same token, it must always be used in total darkness. To some degree, however, Panalure is less useful now than it once was because modern colour negatives print quite well onto the latest conventional b&w variable contrast papers. Panalure is also very expensive by comparison with other b&w papers.

CLEANLINESS

When it comes to processing prints, the golden rule is absolute cleanliness. This is both for reasons health and safety, and also to help ensure the very highest quality results. All other thoughts about the effects of different developers, special fixing and washing procedures, and complicated toning processes, will be totally wasted if solutions become severely contaminated with one another. To some degree contamination is inevitable, however. Every time you move a print from one tray of solution to the next, the latter becomes slightly contaminated with the former. This is acceptable when the solutions have been designed to withstand such mixing, but not otherwise. While developer can be allowed to contaminate stop bath, for example, stop bath must never be allowed back into the developer tray.

To avoid possible contamination from splashing during agitation, trays should never be filled to more half their depth; one litre is about the maximum for a 10x12" tray, six litres for a 16x20" tray.

The exact amount of chemistry used should reflect both the size of the tray (and therefore the amount of solution needed to cover the prints) and the number of prints to be processed during the session. Developers left in open trays go off quite quickly, so it is poor economy to make up greater volumes than are required. Toning, in particular, can be done using very much smaller volumes (as little as 600ml in a 16x20" tray) and tilting the tray more vigorously to ensure good coverage of the print.

DEVELOPERS

Although all developers share a common purpose, they don't all produce the same results. Differences exist in the speed with which developers work, the image contrast they give and the final print colours produced. Some of these differences can be exaggerated by changes in developer concentration and processing temperature. There are also developers specially formulated for use with variable contrast papers, though these may not always be the best choice for such materials.

For general use, the best print developers are those that use phenidone and quinol (hydroquinone) as their active ingredients. Ilford PQ Universal, which works well with all types of papers and gives a fairly neutral image colour, is one such developer. Ilford's dedicated Multigrade developer isn't as good because it is too aggressive, which makes fine tuning of the image during development very difficult. For warm image tones, Agfa Neutol WA is the recognised leader, though many developers can be made warmer simply by adding extra alkali such as sodium hydroxide (caustic soda). For cold tones, there is Agfa Neutol BL, which gives blue-black images. For even colder tones, small quantities of benzotriazole (which also acts as an anti-fog agent) can be added.

Developers are commonly used at about 20°C, though by varying the temperature it is possible to adjust the image colour. Higher temperatures, up to around 30°C, give warmer (browner) image colours. Reducing the temperature makes the image more blue-black, though it also slows down development so cannot be used to the same extreme as higher processing temperatures. Different paper/developer combinations respond differently to altered temperatures and it is therefore difficult to make generalisations. That said, chloro-bromide papers, such as Agfa Record Rapid, used with Agfa Neutol WA can give particularly pleasant warm tone images when over-exposed under the enlarger and given hot development for a shorter than normal time.

As to what constitutes "normal" development, the times used depend on the papers being processed. RC papers develop quicker than FB papers but can exhibit lower contrast if either over-developed or snatched from the tray too early. Recommended development times are published in developer manufacturers' data

sheets, and are usually about 60-90s for RC papers and 90-120s for FB papers.

Unfortunately, processing times get longer as the developer becomes more exhausted – the rate of increase of processing time being dependent on the exact chemical composition of the developer used. One way around this problem is to use factorial development timing. When using the factorial technique, the time taken for the image first to start to appear on the paper is noted, then development continued for a predetermined multiple of this time. Calibration is done using fresh developer and the manufacturer's recommended times.

If, for example, the image starts to appear in fresh developer after 15s and the manufacturer gives 90s as the total processing time, then factorial six development is being used. After having processed a number of prints, the appearance time might have gone up to 20s, in which case the total development time should be increased to 120s. In some cases it can be useful to prolong development by increasing the factor used to calculate the total time, but only do this when using fixed grade papers: variable contrast materials, especially on fast developing RC bases will only be degraded by extended developments.

It is worth noting that development can also be carried out using two developers rather than just one. In this technique, which was once very popular to control image contrast in the days before variable contrast papers, one bath contains an energetic developer (such as Kodak D163), which gives good black densities, while the other is a softer working type (such as Agfa Adaptol), which brings up the subtle tones. Although there are still printers who work this way, the latest types of variable contrast papers, especially Ilford Multigrade IV, render this technique redundant in many cases.

USING A STOP BATH

Development is halted by immersing the print in a stop bath, which is normally a dilute solution of acetic acid. It is sometimes said that the purpose of the stop bath is to prolong fixer life by avoiding carry-over of developer, but this is actually just a useful side-effect: stop baths are used primarily to stop development – as their name suggests. Commercial stop baths with in-built indicators that change colour from yellow to purple when the solution is exhausted seem to become exhausted more rapidly than those that contain just 2% acetic acid, though the latter do need more careful monitoring to maintain their effectiveness.

Whenever preparing stop baths and other solutions that are diluted down from concentrated acids, it is vitally important that the acid is added to water, and not the other way around. The reason for this is that if splashes occur they will be mainly water with just a little acid, so will be less hazardous than if they were mainly acid with just a little water. In all cases, safety goggles must be worn.

WASHING PRINTS

Because the plastic sealing layers of RC prints confine the processing chemicals to the emulsion layers, washing is very much more speedy in this case than it is for uncoated FB prints. Given a good flow of running water, as little as thirty seconds can be enough to wash an RC print. In early versions of variable contrast papers, long washes caused migration of the optical brighteners, giving a "bloom" in dark areas of the prints, though this is no longer a problem. But extended washing does still risk another problem, that of cockling (buckling) caused by water getting trapped within the unsealed edges of coated prints: wash times in excess of five minutes should therefore be avoided with RC papers.

FB prints absorb water and chemicals through all their surfaces and so need very much more thorough washing. The thickness of the paper base affects the exact washing time, with single weight papers needing less washing than double weight papers, and triple weight papers needing the most. Most FB papers are double weight types that, when washed in open trays, require about an hour in running water. Because this method uses a great deal of water, it is better to use a specially designed print washing tank in which each print has its own separate compartment to avoid cross-contamination from one to another.

Another means of speeding washing of FB prints is to use a hypo' (fixer) eliminator. This works by converting any residual fixer into a form that is much easier to wash out of the paper base. The resulting saving in both time and water consumption make hypo' eliminators almost essential when using FB papers, especially if a dedicated wash tank is not available. Somewhat confusingly, Ilford's Wash Aid, which is often thought of simply as a wetting agent that prevents drying stains, is actually a hypo' eliminator that can be used for the purpose just described.

Incompletely washed prints will suffer problems during toning by losing highlight detail when bleached. Local variations in washing efficiency, due to prints blocking each other's water flow when stacked in open trays, can cause blotchy toning. To help avoid this, when open trays are used the prints should be turned and cycled from the bottom of the stack to the top as often as possible. Fully washed prints that are subsequently toned must, of course, be thoroughly washed again afterwards to guarantee maximum longevity of the final image. Toners that require the use of brief washes in order to preserve their colour (such as one-bath blue toners) cannot be expected to give images that will last as well as those that allow prints to be more fully washed.

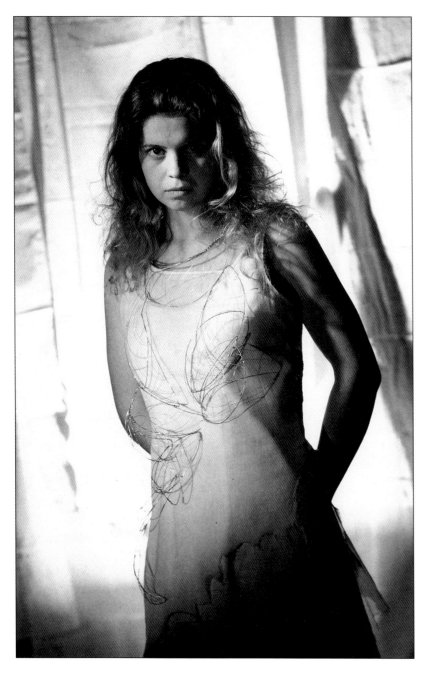

GOOD PICTURE QUALITY REQUIRES CORRECT USE OF FRESH WORKING SOLUTIONS. IN THE CASE OF VARIABLE CONTRAST PAPERS, HIGH CONTRAST GRADES ALSO NEED CAREFUL DEVELOPMENT TIMING, SINCE BOTH UNDER AND OVER DEVELOPMENT CAN PRODUCE SLIGHTLY FLAT RESULTS.

PHOTOGRAPHER: JON TARRANT

FIXERS

The purpose of the fixer is to remove undeveloped silver not used in forming the visible image. Unfortunately, residual silver is invisible to the naked eye so a fixer's performance cannot easily be monitored visually. Because of this, manufacturers tend to quote the number of prints that can be fixed in a given volume of working solution, but this can only ever be a rough guide since light tone prints, and those with wide white borders, have more residual undeveloped silver than those with dark images or black borders. It is therefore important to have a method of determining the state of the fixer.

One way of doing this is by using indicating papers that turn a colour dependent on the solution's state. Such papers sound very convenient, but are actually not very easy to judge. Alternatively, liquid fixer exhaustion testers can be used, either in the form of commercial off-the-shelf products or solutions made from raw chemicals. In the latter case, 10ml of a 4% solution of potassium iodide is added to 100ml of used fixer. If a yellow precipitate forms, and fails to dissolve when the mixture is shaken, the the fixer should be considered to be exhausted.

A more direct method is to time a visible fixing action with fresh solution, then to compare this time with that measured when the test is repeated after the fixer has been part used. A small piece of exposed but undeveloped film serves very well since it changes from opaque to transparent when fully fixed. When the time taken for the film to fix (clear) in used fixer is twice that taken in fresh fixer, the working solution should be considered to be exhausted.

Commercial fixers are supplied with information about dilutions and times for both films and papers. These are the conditions under which the fixer will work best in each situation and it is important to keep to these figures. In particular, using more concentrated solutions risks bleaching prints' highlight details, whereas over-diluted solutions risk incomplete fixing and failure to remove base dyes from films.

Some fixers are supplied with a hardener included. Hardeners make the emulsion more resistant to physical damage, but also slow down both washing and toning of the image. In the past, when printing papers were more fragile than they are today, the increased ease of handling outweighed the more difficult washing and toning. Today, rugged modern papers tip the scales the other way and hardening fixers are no longer a sensible choice.

The most obvious sign of poor fixing is staining of prints during toning. In its own way, this can be used as a fixer indicator: a drop of undiluted selenium toner placed on the white border of a washed print will leave a stain if there is any silver present. Assuming that the border is meant to be pure white, and therefore completely free of silver, paper that remains so is clearly fully

PRINTING PAPERS COME IN A VARIETY OF IMAGE TONES, BUT EVEN SO-CALLED 'WARM TONE' PAPERS DON'T LOOK TRULY WARM IN THEIR AS-DEVELOPED STATE. HERE, THE TOP LEFT HALF OF THE PICTURE HAS BEEN PRINTED ON 'NEUTRAL' PAPER, WHILE THE BOTTOM RIGHT HALF IS ON FORTE POLYWARMTONE RC. THE WARM TONE PAPER LOOKS SLIGHTLY OLIVE BY COMPARISON. HERE, THE DIFFERENCE HAS BEEN EXAGGERATED BY SELENIUM TONING, WHICH HAS MADE THE OLIVE PRINT TURN RUST COLOURED. SELENIUM TONER HAS ALMOST NO VISIBLE EFFECT ON NEUTRAL PAPERS.

fixed. By the same token, if it does become coloured, and the border is ruined, that is no great loss since the image would only have degraded at a later date anyway. To avoid any such problems, the print should be refixed in a fresh solution, then tested again as described. Provided that the print passes this second test, it can then be fully washed, dried and expected to survive for many years. (Note that the selenium test won't work with pre-flashed paper, where the whites are no longer totally clean.)

GOOD WORKING PRACTICES

Prints should always be handled with great care: a damaged print is of no use to anybody. You should NEVER introduce a print into the developer by laying it on top of the liquid and pushing down in the middle of the paper. Rather, prints should be slid into the developer from one side, and taken out from the other. Prints should always be put into the developer emulsion-side up to avoid trapping bubbles against the dry paper surface. If they are left in the developer for extended times (FB prints only), the safelights should be switched off to reduce the risk of fogging. It is not a good idea to turn the paper image-side down, as any slight roughness on the bottom of the tray will scratch the print's surface. When removing a large print from a liquid-filled tray

(processing solutions or wash waters), lift it slowly from one corner to prevent creasing.

For optimum fixing, a two-bath system should be used. The method of working is to fix prints for half the recommended time in each tray. The first fixer takes out the majority of the undeveloped silver and becomes exhausted more quickly. The second tray has a lower silver concentration and is therefore more effective in removing the final traces of undeveloped silver from the print. As the first tray becomes exhausted, the second is moved up to take its place and a fresh working solution is made up to become the new second bath.

In all cases, the secret of good print processing is to work cleanly, calmly and consistently. If an image seems to be rushing up very fast in the developer, then it is almost certainly no good: rather than snatching it from the tray, let it run for the full time then judge what exposure correction is needed. It is foolish to try to tell yourself that an obviously incorrectly exposed and developed image will look all right when dried off. This said, such prints should not automatically be discarded as they can prove useful when undertaking toning tests, when it can be helpful to have a range of different density prints to assess the full effects of a given toner.

CHAPTER FOUR

Basic Printing Techniques

All that has gone previously has been by way of general background: this is where the magic starts. The process of taking a blank piece of paper and seeing it transformed into a finished print is always amazing, no matter how many times it has been done before. Although this chapter is dedicated to the more basic aspects of b&w printing, it should not be skipped over by more experienced workers. There are fundamental points that are explained in this chapter and then assumed later. Failure to appreciate these points can severely limit ultimate print quality.

A WORD ABOUT NEGATIVES

All photographic prints start from a negative (or other film image). As such, the quality of any prints produced is directly related to the quality of the original negative. The best prints tend to be made from the best negatives. While there are many different negative exposure and development techniques, each designed to get the best image from a particular situation, you can never be entirely sure how your negatives will turn out until they are finished – and then you're stuck with them. The creativity of b&w photography therefore rests heavily on the printing process.

Some people may argue with this assertion, citing long-established methods for fine tuning negatives, but in so doing fail to notice that those techniques are no longer commonly used. Nowadays, only a very small proportion of pictures are taken on single sheets of film that are given individual processing to match a fixed, predetermined, grade of printing paper. The modern approach is to expose and process the film in a way that will suit the majority of commonly shot situations, then to fine-tune each image at the printing stage using different grades of paper.

Initially at least, films should be exposed and processed according to the manufacturers' recommendations. This said, the best negatives from a printing point of view are often those that have been slightly over-exposed and under-developed compared to the norm. As a starting point, try exposing the film at between two-thirds and half of the manufacturer's ISO rating and cutting the development back 10-20% respectively.

Another potentially useful variation is to use developers other than those recommended by the film manufacturer. As with paper developers, different formulae give different results. There is a slight danger of jumping from developer to developer and never mastering one, but there is nothing wrong with having two developers that suit two different situations. It is normal for one of these to be a good all-rounder, such as Ilford ID-11, and for the other to be a specialist brew, such as a push-process developer like Fotospeed's FD30 for example. Other alternative developers give greater actuance by using edge effects, improve sharpness by confining their action to the surface of the film, or give long tonal ranges by compensating their action on different exposure densities. If you want to experiment with such developers, by all means do so, but always keep detailed notes about the exposure and processing conditions used, and only judge the results by the final prints obtained. Remember, it is the quality of the prints that matters most.

PAPER SIZES

Printing papers should be chosen to match the format of the negatives in hand. Previously, 8x10" used to be suggested as the standard paper format, but the widespread use of 35mm film, which has a more elongated format, makes A4 ($8\frac{1}{4}$x $11\frac{5}{8}$") papers the more sensible choice nowadays. Equally importantly, and unlike the case with 8x10" paper, cutting A4 paper in half (across its longest side) doesn't change its proportions: 35mm negatives fit just as well onto half-size A4 as they do onto full sheets.

If A4 is to be adopted as the standard print size, it would be useful to be able to contact print onto this paper too. Unfortunately, many commercial contact printing frames are designed for 8x10" paper. While it is possible to trim a sheet of A4 down to 8x10", this is both inconvenient and wasteful. A better alternative is to use a home-made printing frame dedicated to A4 paper, as shown in Chapter 1. By using such a frame, and cutting 35mm films into seven strips of five negatives, it is possible to contact print an entire roll while it is still within its see-through storage page. Obviously, this means only shooting thirty-five negatives on a roll, but this is a small price to pay for the greatly reduced handling and ease of contacting that this approach gives.

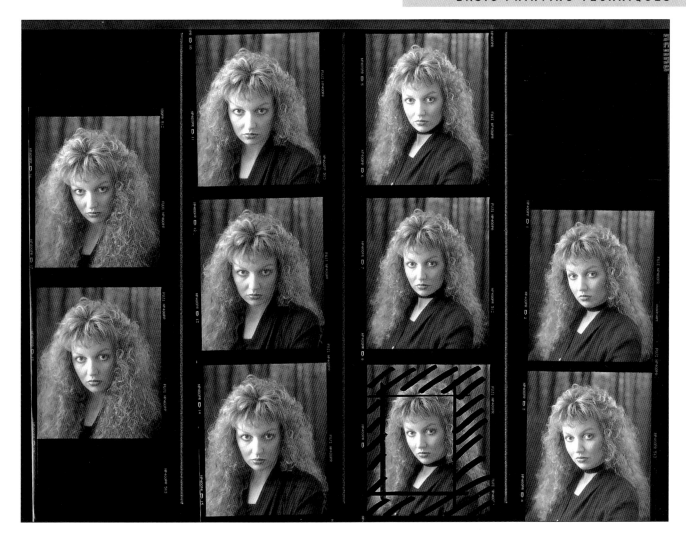

CONTACT PRINTS PROVIDE AN EASY MEANS OF VIEWING IMAGES, AND ALSO ELIMINATE UNNECESSARY HANDLING OF THE NEGATIVES. IN GENERAL, CONTACT PRINTS SHOULD HAVE SLIGHTLY LOWER THAN NORMAL CONTRAST IN ORDER TO SHOW AS MUCH DETAIL AS POSSIBLE.

BASIC CONTACT PRINTING

The easiest way to make contact prints is to use the light of an enlarger that has been set to give even coverage over the area of the contact printing frame. Provided that the same enlarger head height is always used for contact printing, similar exposure times should apply for all films. This time should be determined by trial and error using the same method as is explained later for making print test strips. Once determined, the contact printing exposure conditions should be written on a piece of card and stuck to the wall where it can be seen. All contact prints can then be made using these settings, with a very high proportion of first time successes.

If fixed grade paper is used for contacting, it should be Grade 2. If variable contrast paper is used, the appropriate filtration necessary to give a Grade 2 print should be selected. Thin negatives will tend to give dark contacts, though this is less of a problem than dense negatives giving light contacts. With experience, it becomes easy to judge when to increase exposure to allow for dense negatives.

CONTACT PRINTING VARIATIONS

There are two types of contact prints; those that are for your own use and those that are to be shown to others. It is enough for the former to give a good guide to the picture content without too much regard to picture quality, whereas contacts that are intended for more general viewing need good print quality too. To increase the percentage of first time successes, it is possible to over-expose contact prints for all but the thinnest negatives by about 1 f-stop, then to curtail the development. This is a particularly effective technique for when contacts will be examined back-lit on a lightbox alongside the original negatives – which is actually the very best way of viewing contacts. It should not, however, be used for making contacts that will be given to others for viewing under reflected light conditions as the results will look muddy and of low quality.

If you use a contact printer with a glass cover sheet, you can use Letraset or opaque ink to write your name onto the glass so that it is recorded on every contact sheet. In order for the text to be sharp, it should be written onto the bottom surface of the glass (the surface that comes into direct contact with the negative bag). The easiest way to do this is to write the text onto a piece of invisible tape that is then stuck to the glass. A thin-tip marker pen can be used to put film information (filing numbers, dates, etc) directly onto the rebate of individual strips. This too will show on the contact print, and will also be permanently recorded on the film for later reference.

Although contact prints are most commonly made by giving the same exposure to the entire sheet, if some negatives are of different densities to the remainder it may be desirable to vary the exposures to these areas. This is particularly useful if there is a whole block of negatives that are different to the rest, but is rarely worth doing if the entire film fluctuates in density. The latter case is best covered by settling on one average exposure and examining the images by making frequent reference to the negatives. In extreme cases it may be worth doing two contacts, one balanced for the thinner negatives and the other for the denser ones, but this is rarely the case.

MAKING SIMPLE ENLARGEMENTS

At one level, going from contact prints to simple enlargements is very straight-forward, but getting the best simple print takes a little more effort. If the enlarger head is kept at the same height as when doing the contact print, and the contact was of acceptable density and contrast, then an enlargement can be made using the very same settings as were used for the contact. If the contact was of the wrong density or contrast, then it might be possible just to guess at the correction needed to give a good enlargement, but it would be far better to have a way of determining the best settings as objectively as possible.

Unlike the situation when making contact prints, enlargements cannot be made with negatives contained in protective bags. Similarly, although there is no need to worry about small dust particles on the negatives when making contacts, these specks become much more obtrusive on enlarged prints. When the negative strip is removed from its bag for printing, it should therefore be gently wiped to remove as much of the dust as possible. A soft lens brush or de-greased chamois leather is ideal for this. Repeated wiping is to be avoided as this will increase the static charge on the film, and so make the dust problem even worse. The negative should then be placed in the negative carrier (which must also have been wiped free of dust), emulsion side down and with the bottom edge of the picture facing towards

the back of the enlarger. This will give a baseboard image that is the right way around, which means the picture can be judged without having to crick your neck at an awkward angle. When upright pictures are being printed, you should get in the habit of arranging the negative so that the top of the picture is always at the same end of the baseboard. If your enlarger is close to a wall on one side, it is normally best to have the top of the picture to that end of the baseboard so that there is the most room possible for viewing the print from its bottom end, when it can be inspected the right way up.

FOCUSING THE IMAGE

Without a sharply focused image, all subsequent actions are a complete waste of time. The image should therefore be focused very carefully, and checked for focus before making every print. Unfortunately, some writers have confused the focusing issue, suggesting that the image should be focused on a spare piece of printing paper rather than on the baseboard itself, and that a blue filter should be fitted over the lens for best results when focusing. In both cases it is suggested that doing otherwise makes the final print slightly unsharp, but in fact any unsharpness is more likely to be due to slipping of the focusing mechanism or inaccurate alignment between the enlarger and the baseboard (something that can be avoided – or corrected – by using high quality equipment). Another problem is that some lenses can shift focus slightly as they are stopped down. In this case, if the image is focused with the lens wide open, but the exposure made with it closed down, slight softness can result. To guard against this, continue to look through the focus magnifier to ensure that the image remains sharp as the lens is closed down, adjusting the focus if necessary.

There is no need to spend vast sums on a focus magnifier – even cheap ones work well, though more expensive models do have the advantage of being able to be used closer to the edges of the image. The efficiency of a focus finder, and the alignment of the enlarger, can be checked by placing a test image in the negative carrier and carefully inspecting the print produced from it to confirm that the image is sharp from edge to edge. Provided that the lens has been set to a mid-range aperture and the image accurately focused at this aperture, the print should be sharp. If it isn't, a visual check of the enlarger can be performed using a piece of black (fully exposed and processed) film across which lines have been scratched.

Load this into the negative carrier, then examine the projected image to discover any misalignment between the enlarger and baseboard, which will be evident as changing sharpness across the projected image. If the enlarger passes this test, and seems to be

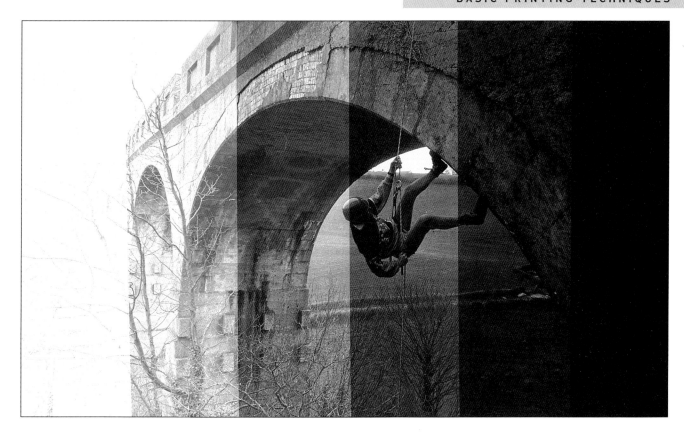

HOW TO TEST PRINT A PICTURE – THE WRONG WAY (PROGRESSIVELY ACROSS THE IMAGE).

in sharp focus when set using the focus finder, then it might well be that unsharp prints are due to slight movement in the enlarger. To minimize any such loss of apparent sharpness, the enlarger should be mounted on a very firm surface and must not be knocked during exposures.

PRINT EXPOSURE TEST STRIPS

Before making an enlargement, it is first necessary to determine the correct exposure for making a print of the desired density. In order for this to be a meaningful test, you must decide what is the most important part of the picture and base your exposure determination on this area. Failure to do this can result in an inferior quality print being produced. This is a particular problem when using the oft-cited progressive test strip method (shown above) if the important part of the picture falls in the first or last test areas. Not only that, but because the image is exposed in stages, the times given will be in a series of smaller steps, which can give a misleading result if the print is then exposed using a single, continuous, exposure time.

Fortunately, there is a single solution to both these potential problems, which is to use separate strips for each exposure test, with all tests made under the same area of the image (shown overleaf). Unlike progressive strip tests, there is no reason why loose strips have to be laid parallel to the edge of the picture.

Therefore, if the most important area lies at an angle, then the test strips can be placed accordingly.

For optimum image quality, the enlarger lens should be closed down slightly (typically to between f/5.6 and f/8) to give edge-to-edge sharpness. The test strips should then be given different exposures by altering the exposure time only. It is likely that five strips – given 3s, 5s, 10s, 15s and 20s exposures – will be sufficient to indicate the best exposure time. Some printers might object to this sequence of exposures because it does not form an F-stop pattern, but this is a misguided objection. Most A4 prints exposed through variable contrast filters under common enlargers from average negatives should have exposures of between 5s and 15s and this sequence of exposure tests concentrates on these times. The idea of giving exposures of $2^1/_2$s, 5s, 10s, 20s and 40s (the corresponding F-stop sequence) is just a waste of time: such a series of tests would give insufficient mid-range information and would almost be guaranteed to be useless at the longest exposure time. A test such as this is only useful when the likely correct exposure is less certain.

After exposure, all the test strips should be collected and developed together, face down, for the full processing time. The reason for placing them face down, when it has previously been said that to do so risks causing scratches on the image surfaces, is to avoid the temptation to pull them from developer a little early if

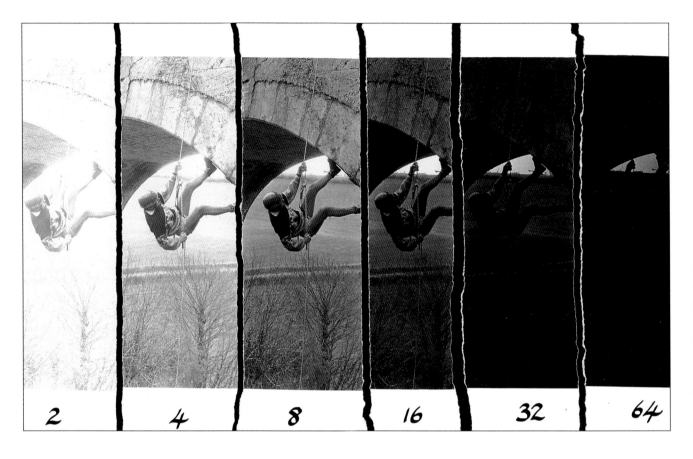

THE RIGHT WAY (TESTING THE SAME AREA AT EACH EXPOSURE TIME). NOTE: AN EXTENDED EXPOSURE SEQUENCE HAS BEEN USED HERE TO ILLUSTRATE THE WASTEFULNESS OF INCLUDING VERY LONG TEST STRIP TIMES.

they have been slightly over-exposed. In this case, accurate development is more important than avoiding minor scratches. After the full development time, the strips should be stopped, fixed, washed, dried and examined under normal room lighting before the best exposure time is chosen. If the best exposure seems to be in between two strips', take the average of their exposures. This procedure applies to both fixed grade and variable contrast papers.

It is vital that you check you have enough paper both to test and to print with. Tests made on paper from one box may not be reliable for prints made from another – though the differences, if any, should only be slight. Unless there is good reason for doing otherwise (based on previous experience), Grade 2 papers or filtrations should be used for density testing.

DETERMINING PRINT CONTRAST

Having found the correct exposure time, the test area should be evaluated again, this time to discover the correct contrast grade. Unlike exposure testing, the procedure is different with fixed grade and variable contrast papers.

Using fixed grade papers, it is necessary to test a sample from each different grade box. Within each manufacturer's range, all

but the hardest grades of papers should have roughly the same sensitivity so, with this exception, different grades will all be approximately correctly exposed at the setting determined in the initial (Grade 2) exposure test. The highest contrast papers are about one F-stop slower than the other grades, so should be exposed for twice the determined exposure time. It is also important to note that papers of different makes tend to have different sensitivities, so if you decide to do contrast tests on two brands, you will almost certainly need to have exposure tested with both too. As before, all the test strips should be collected together and processed in one batch, face down. Full fixing, washing and drying should follow before any attempt is made to decide on the correct grade for the final print.

Variable contrast papers are much more economic and easier to use than fixed grade types when it comes to doing contrast tests. There is, however, still a contrast/exposure variation to be taken into account. Filters such as Ilford's Multigrade set are balanced so that all the grades from 0 to $3\frac{1}{2}$ have the same exposure sensitivity, with grades 4, $4\frac{1}{2}$ and 5 requiring twice as much exposure. Dial-in Multigrade filtration heads follow the same pattern. The only difference in procedure comes with twin-lamp systems that are balanced to give the same exposure across the entire contrast range. With these enlargers, the same exposure

test time should be be used for all grades.

Six strips of variable contrast papers are needed, either from one sheet torn into narrow pieces or two sheets in wider pieces. One strip is exposed at each whole number grade from 0 to 5 with, where appropriate, the determined time given for grades 0, 1, 2 and 3, and twice the determined exposure given for grades 4 and 5. The strips are then processed together, face down, as before. When washed and dried, the strips should be examined to determine the best contrast grade to use for the final print.

MAKING THE PRINT

Deciding which grade, and even which exposure strip, is the "correct" one is really all a matter of personal taste and the effect wanted in the finished print. Some people say that a perfect print should have a full range of tones and show detail in both the highlights and the shadows, but such prints can sometimes look a little bland. It may well be that your style doesn't match theoretical perfection – and there is no reason why it should! Nevertheless, it is still important that you test the image before printing, for unless you do so you cannot be sure that your chosen settings really are the best ones to use.

With experience, testing becomes a matter of estimating exposure and contrast from the negative image seen on the baseboard. Even so, the first test print should still be processed face down for the full developing time, then washed, dried and inspected under white light, before deciding on the final print settings.

IMPROVING THE IMAGE

Although the procedure outlined so far should give prints that are technically sound, it is often possible to see ways in which such images could be improved still further. Even more importantly, simple prints that are technically correct very frequently fall short on artistic merit. The most common reason for both these shortcomings is that it is rare for there to be a single print exposure that perfectly suits all parts of the picture. This is the very reason why it is so important to do exposure and contrast tests on the most critical area of the image. Provided that other parts of the picture are reasonably similar to this part, the simple print technique will give an acceptable result. The more that other parts differ from the test area, the less acceptable the simple print will be and the more that additional work will be needed to give the best finished result.

DODGING

It may be the case that when you look at a print, you feel some areas are rather darker than they should be, even though the critical part of the image is of the correct density. If such areas

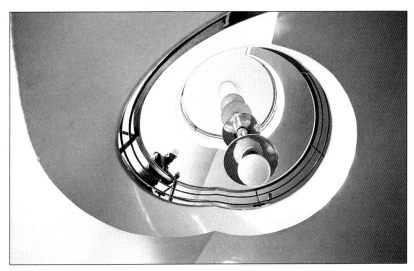

FULL-FRAME PRINT MADE USING BEST OVERALL EXPOSURE TIME (8S).

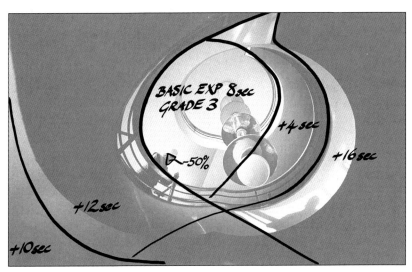

OVERLAY SHOWING PATTERN OF ADDITIONAL EXPOSURES.

RESULT OF USING BURNING-IN TO IMPROVE THE PRINT FURTHER.

PHOTOGRAPHER: ROGER BAMBER

33

are right at the end of the tonal scale, with details being lost in heavy shadow areas or highlights given a grey veil, then it could mean you have used the wrong combination of exposure and contrast. Reprinting the image on a different grade, and/or with a different exposure, might be all that is required to restore shadow detail or lift the highlights. If the critical part of the image is still recorded acceptably, then all is well. If not, another technique must be used, allowing the determined exposure to be given to the critical part of the image while lightening other areas of the picture separately.

To achieve this, there are two tactics that can be used. Either the non-critical parts of the image can be lightened while the critical area is left unaffected, or else the entire print can be made lighter and the critical area then darkened back to its original density. If the area to be lightened is well contained, the easiest approach is the former. The technique used is known as "dodging" and involves placing a small opaque obstacle between the enlarger lens and the baseboard during part of the exposure. Most often, this obstacle is a small mask, shaped to match the area to be affected and supported on the end of a thin wire. Such objects are known as "dodgers" or "dodging tools". The most convenient dodgers are your own hands and fingers.

BURNING-IN

If, on the other hand, several areas need to be lightened, it is often better to lighten the entire print then locally darken those parts that were correctly exposed originally. This is by far the easier, and more logical, approach. It is also the technique that has to be used if parts of the image require additional darkening over and above the simple print exposure. Once again, masks are used – this time to protect parts of the image that do not need darkening. In this case, it is not where the mask blocks the light, but where it lets the light pass that matters. Using additional local exposures is known as "burning-in" the image.

As with dodging, the most convenient burning-in masks are created using your own hands, which have a considerable advantage over all the other alternatives in being immediately available. Variable size and shape apertures are possible by adjusting the overlap between the hands or opening gaps between the fingers.

THE BASIC EXPOSURE

With the introduction of local variations in image density through dodging and burning-in, the whole concept of test strip exposures needs to be revised. The best overall exposure, as determined previously, may no longer be the best starting-point exposure for a more intricate print. This is because there is no reason to assume

DODGING THE EYES ON A PRINT USING TWO PIECES OF PLASTICINE ON A WIRE SUPPORT. SHOWN RIGHT ARE SECTIONS OF THE PRINTED IMAGE WITH AND WITHOUT THIS DODGING.

that it is easiest to find the best exposure for the most important part of the image first, then to apply local corrections to other parts of the image afterwards. It might be better to accept that the critical picture area will itself be given a local correction and that the remainder of the image can most effectively be recorded with an exposure that doesn't quite suit the critical area. It therefore becomes important to define a "basic exposure" that is a starting point from which the image can be built up.

Unfortunately, and unlike the simple print's critical area exposure, there are no hard and fast rules about how to find the best basic exposure. A good guide, however, is that the basic exposure is the maximum exposure that can be given before shadow detail is lost from an important area. This makes all local exposure variations burning-in operations, which simplifies life somewhat. It can get very complicated if you have a mixture of several dodging and burning stages, not least because all the dodging steps need to be done within a fixed time span (the basic exposure).

In dark moody portraits, the basic exposure more often than not lies on the darker side of the face, and is the time which gives best rendering of the shadow details. In a landscape, the basic exposure will frequently depend more on the land area than it will on the sky. In a wedding picture, it will be the exposure that keeps detail in the groom's dark suit or separation between the suit and a dark interior background.

The fact that the testing procedure is different for simple prints and for more artistic creations makes it essential that you decide

on the type of images you are hoping to produce before starting work. If you start off doing simple prints, then decide to print something more artistic, but try to do so without doing another test, you may make things unnecessarily difficult and will almost certainly fail to produce the best results. Of course, dodging and burning-in can still be used to lighten and darken local areas of simple prints, but to restrict the techniques to such instances would be to put severe limits on the creative possibilities that they offer.

The correct use of dodging and burning-in is not simply to alter density, but also to alter the balance of an image, emphasising important features and playing down irrelevances. Ultimately, the best print is one that shows no signs of dodging and burning-in, yet in which the viewer's eye is immediately drawn to the intended centre of attention and not diverted away by distractions.

DODGING TECHNIQUES

It is best to keep dodging in reserve as a technique that is used only when there is no other way of dealing with the image in hand. There are two main reasons for adopting this approach. Firstly, as already mentioned, dodging needs to be carried out within the basic exposure time, which could itself be very brief. Secondly, if the area being dodged is completely within the picture, then the mask needs to be suspended within the light path using a support that casts no visible shadow on the enlarger baseboard (or casts a shadow that can subsequently be hidden).

Whilst neither of these problems is insurmountable, they are both the opposites of the cases that apply when burning-in, which is therefore an altogether easier technique to master. This said, there are times when dodging really is the only sensible way of achieving the desired effect.

A simple dodging tool can be made using a blob or two of Plasticine on a thin piece of stiff wire. The thinner the wire is, the less of a shadow it will cast on the baseboard, though obviously it does need to be thick enough to support the weight of the Plasticine. Copper earth wire from low current wiring cable is a good choice and benefits from being supple enough to be bent to shape as required. Florists' wire can also serve well. Plasticine makes a good malleable mask because it keeps its shape, though it does have the disadvantage of going hard after some time, and so needs to be replaced periodically. A more serious potential disadvantage is that Plasticine contains oils that can leach out into absorbent materials with which it is in contact. For this reason, Plasticine should never be left on top of negatives or paper-based negative bags.

Some writers have suggested that the support wire should be bent into weird abstract shapes and kept moving during the dodging time, with the mask position held steady by being the pivot point of the movement. Whilst this is indeed one way of avoiding a visible shadow from the supporting wire, it does puts limits on how the dodging can be done. In particular, it precludes one of the best uses of dodging – that of lighten the eyes in a portrait, something that is easiest done treating both eyes at once. If the wire is to be kept moving about a pivot point, doing both eyes at once is just not possible.

A far better system is to bend the supporting wire into a shape that follows a natural boundary within the image. The wire can then be held reasonably still, with as many areas as are required masked off at once. Unlike when using abstractly bent wires, carefully shaped dodging tools need to be used the right way around. It is therefore important that the correct way of holding the wire, so that it aligns with the natural boundaries, is immediately obvious. For this reason, a directional handle should be bent into the wire.

As to how much dodging should, or can, be given to any area, it is again impossible to make hard and fast rules, though if over-done, dodging causes the areas affected to have a low contrast, grey, look. In the case of portrait eyes, dodging is usually done for between one-half and one-third of the overall exposure time. The dodging tool is held half way between the lens and the baseboard, with the covered part of the exposure given first. Depending on the overall time, it can be useful to split the exposure into two separate parts – one in which the dodging tool

is used throughout and the other in which no dodging is done. This makes the dodging much more controlled and repeatable.

Dodging should not be confined to lightening dark areas. Indeed, the idea behind dodging eyes is not to lighten their centres but to make the whites of the eyes even whiter. This helps to focus attention on the person's eyes – which are usually the most important part of a portrait. The same principle can also be applied to other parts of the image. Another use of dodging is to hold back small areas that will later be included in a larger burning-in area. This is particularly useful in scenic pictures where there is a person cutting across the horizon with a sky above that needs darkening. If the person is included in the basic exposure, then it can be difficult to burn-in the sky without creating a tell-tale halo between the person and the sky. By dodging the person during the basic exposure and restoring the dodged density as part of the burning-in stage, masking marks are avoided.

BURNING-IN TECHNIQUES

Since burning-in is the more logical way to proceed from the basic exposure, and is also very much easier to do than dodging, it should comprise the majority of the density adjustment work that is applied to a print. Burning-in is easiest done by cupping your hands close to the enlarger lens and creating a funnel through which light can be directed onto particular parts of the image. The process can be thought of as squeezing all the imaging light down into one small area at a time. It is very important that you look at the baseboard when using your hands to burn-in so that you can adjust the size and shape of the gap to ensure that the light goes only where it is wanted.

When burning-in larger areas, or areas that have angular rather than rounded shapes, it can be easier to use an appropriate card mask. Masks can either be hard-edged or soft-edged. The former are used to burn-in clearly defined areas using scalpel-cut cards that are held stationary in a position close to the baseboard. The latter are for more general use, have fuzzy torn edges and are placed closer to the enlarger lens and moved up and down slightly to give the softest results. The easiest way to prepare any mask is by stacking books or small boxes on the baseboard to the height at which the mask will be used, then resting a piece of card on top and tracing the area to be burned-in. That area can then be cut out, either with a smooth edge or a ragged one, as required. Although some writers advise otherwise, it is best to use light coloured card so that the projected image can be seen clearly, so aiding accurate and rapid positioning of the mask.

WORKING METHODS

Whereas dodging has to be done quickly, there is no rush when doing burning-in. In all cases, the most important thing is to be comfortable as you work. Part of this comfort comes from having careful notes recording the dodging and burning-in required. The easiest way to do this is not with words but with a sketch of the image, traced on a piece of plain paper laid on the enlarger baseboard and on which the basic exposure and local variations are all noted. It is also very useful to have on hand a full-area test print made using just the basic exposure. This provides a useful reference when looking at the contribution made by each additional exposure. Once the dodging and burning-in sequence has been perfected, the test print and working sequence sketch can be filed and subsequently used to produce repeat prints at any future date.

Another secret to being comfortable is to break down long burning-in exposures into shorter periods. Resting during the intervals between these periods helps avoid muscle fatigue and repositioning the hands each time reduces the risk of creating obvious edges around burned-in areas. The alternative tactic that is sometimes suggested, of opening up the lens aperture to reduce extended burning-in times, is not recommended here. Opening the lens aperture risks changing the grain sharpness in the print and so can make burning-in obvious even when great care has been taken to avoid edge marks. In more extreme cases, adjusting the lens aperture can knock the lens slightly out of focus. It is far safer, therefore, not to change the lens aperture in the middle of making a print.

Choosing the best aperture at which to work is a matter of lens quality and personal comfort. Best lens performance is usually obtained with the aperture closed down a stop or two, but if this gives very short exposure times, making dodging difficult, then you might close the lens down to a greater extent to give a more comfortable basic exposure. However, be aware that burning-in can easily involve exposures between twice and ten times as long as the basic exposure. If only a small amount of dodging is required, but there will be lots of burning-in, then it can be better to practise getting quicker at dodging than to endure long burning-in times.

Once quick working has been mastered, it is possible to consider the effect that the lens aperture has on shadows thrown onto the baseboard. As is the case in camera work, smaller lens apertures give harder edges whereas wider apertures make them softer. The latter are generally preferable because they give less obtrusive results with just gentle wiggling of the mask or dodging tool.

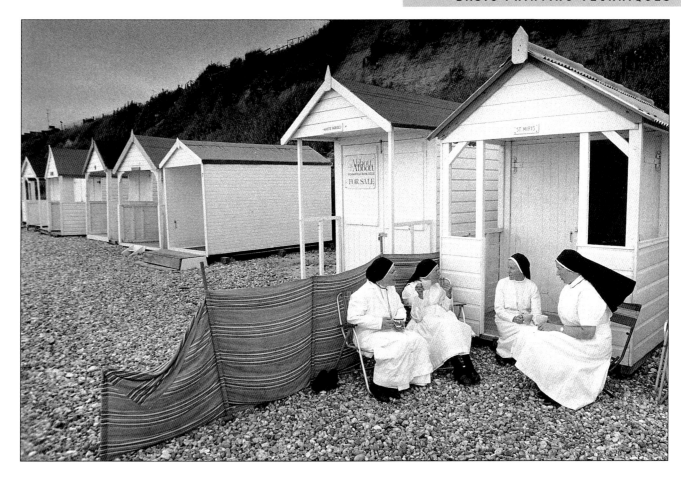

IN THIS PRINT, SOFT-EDGED
BURNING-IN HAS BEEN USED
TO GRADUATE THE SKY,
WHILE HARD-EDGED
BURNING-IN HAS BEEN DONE
FOLLOWING NATURAL LINES
WITHIN THE IMAGE (THE
SIDES OF THE BEACH HUT).

PHOTOGRAPHER: JOHN DOWNING

It is worth noting that dodging and burning-in can both be practised without any paper on the baseboard. The effects of different lens apertures, dodging tool wire thicknesses, heights of masks above the baseboard, edge hardnesses of masks and shadows cast by dodging tools can all be checked in this way. As you will discover, small lens apertures and large masks held close to the printing paper give sharp-edged effects, while the opposites give softer edged effects. Both types of working need to be mastered before top quality prints can be produced.

It is always a wise precaution to try out any dodging and burning sequence a few times before exposing the printing paper. Some people say that a foot switch makes dodging and burning easier, allowing masks or hands to be put in position before the enlarger light is switched on. This is true, but is also something of a red herring. What matters most in printing is that your working methods are consistent. Provided that the time taken to press the enlarger timer button and get your hands in position is always the same, this delay will automatically be allowed for in burning-in times.

PRINT EVALUATION

When assessing a burned-in and dodged print, you should always refer back to a straight print that should have been checked under normal room lighting and accepted as a good starting point. It can then be put in the wash tray and used for direct comparison with subsequent prints without them needing to be dried first. This makes life a lot easier and speeds up the printing process.

To evaluate a burned-in and dodged print, there are three questions that should be asked. Has the burning-in/dodging had enough effect? Has it had too much effect? And has it affected other, unintended, areas? The first and second questions are easily dealt with, but the third can be more involved. If other areas have been affected, this could either be because the masking used did not cover the image as well as it should have, or because the area being worked on was too similar in density to adjacent areas. This last situation can both increase the chances of spill-over across the areas and at the same time make the boundaries between them look strangely wrong in the final print. The best solution to this last problem is to use contrast changes when burning-in and dodging, which is exactly where the next, and final, chapter in this general section starts.

CHAPTER FIVE

Advanced Printing Techniques

Variable contrast papers enable different areas of the same image to be printed at different grades. In the same way that burning-in and dodging are used to manipulate local densities, so grade changes are used to manipulate local contrasts. This is an immensely powerful tool that can be used to improve pictures both technically and creatively – though not necessarily at the same time.

There are four reasons for using multiple-grade printing; to fine-tune the balance of an image, to exaggerate an image, to make burning-in easier and to create border effects. The first two are exact opposites and the choice between them is very much a matter of personal style and the image in hand. The third makes use of a little appreciated effect that will be explained in detail shortly, and the last provides almost unlimited creative potential for defining the way in which a picture should be viewed without the need for cumbersome mounts and frames.

In competition printing, integral border effects often give images much greater significance when spread out on a judging table, and are therefore sometimes said to give their printers an unfair advantage. The same can also be said of toning. Both are techniques that can enhance an image, and both need to be mastered before perfect prints can be made. To a large degree, that is what this final chapter is all about – making the very best of a negative so that the print produced is not just good, but a potential competition winner.

WHEN TO USE MULTIPLE GRADES

The most basic and obvious use of multiple grading is in bringing out highlight detail and opening-up shadow areas. Working from a well balanced negative, these aspects can be made to fall into place automatically by appropriate choices of exposure and contrast on a single grade of paper. But technically correct though such a print may be, it is also likely to be rather lacking in impact. Compressed mid-tones can be a particular problem in some cases; poorly separated highlight and/or shadow details can occur in others. All these difficulties arise simply because the printed image has been regarded as one entity, despite the fact that the scene portrayed was composed of many different areas, each of which would probably have been best printed in a different way. It is often the case that if a picture is printed on several different grades, the different prints will each be seen to suit different areas of the picture best. The perfect print would therefore be obtained by combining these elements from the different contrast prints. And that is exactly what variable contrast papers enable printers to do.

With fixed-grade paper, in order to get a more dramatic image, a print would sometimes be made on a slightly harder grade of paper than would be thought technically correct. Pure-white highlights would then be burned-in as required. Depending on the nature of the highlight detail, this may or may not have proved successful in itself. If not, local development would also have to be used. With variable contrast paper, it is a simple matter to select the most appropriate grade for each area of the print. The ability to change from, for example, the Grade 3 filter used for the overall exposure to a Grade 1 filter for the highlights makes life much easier and gives a more pleasing result.

Conversely, if a softer grade had been used initially, perhaps because the image had large highlight areas that required subtle treatment, the blacks could well have turned out only dark grey on a fixed-grade print. With variable contrast paper, the answer would be to burn-in the high densities using a harder grade and so ensure better blacks without degrading the highlights.

CONTRAST AND DENSITY

There is a useful general principle at work here. Harder grades affect darker areas more than they do light ones. Similarly, softer grades affect lighter areas more then they do dark ones. This is such a basic – and so very useful – fact that it bears repetition…

Harder grades affect darker areas more than they do light ones: softer grades affect lighter areas more then they do dark ones.

The same principle can also be expressed slightly differently: hard grades affect whites least and soft grades affect blacks least. This has always been true, but when applied to variable contrast paper this concept allows a totally new approach to burning-in.

THE EXCLUSION PRINTING PRINCIPLE HAS KEPT THE SKIER'S POLES VISIBLE AGAINST THE BURNED-IN BACKGROUND WITHOUT ANY NEED FOR DELICATE MASKING.

EXCLUSION PRINTING

With fixed grade papers, if one area has to be burned-in while another remains unaffected, a mask has to be made to match the intended part of the picture as exactly as possible. The burning-in then takes place through this mask – whether it is a piece of card or the printer's hands. Failing to mask sufficiently accurately usually means either a dark or light halo which immediately gives the game away and ruins the print. Even worse, in some such cases it simply isn't possible to make a mask that protects the smallest details. But by using variable contrast paper, and making use of the characteristics of different contrasts, a degree of automatic masking can be employed.

The system relies on choosing burning-in contrasts not just to match the areas being affected, but also to avoid affecting areas that should remain unchanged. Burning-in at high contrast will leave lighter adjacent areas unaffected, while burning-in at low contrast will leave darker surrounding areas unaffected. If, for example, you wanted to burn-in a low contrast sky which had a white-sailed boat cutting across the horizon, then a hard grade would be the best choice because it would make the sky more dramatic and at the same time be least likely to turn the boat's sails grey. Masking would be much less critical than it would using a softer grade, for even if the high contrast light spilt onto the white sails it would hardly have any effect on them. Similarly, in the case of a dark object, such as a semi-silhouetted tree, crossing the horizon, it would be better to burn-in the sky at a soft grade in order to prevent loss of shadow detail on the tree. If necessary, to give the sky more impact, local areas (away from the tree) could then be burned-in even more using a harder grade filtration.

JUDGING CONTRAST

One of the hardest problems is trying to decide which areas are high in contrast and which are low, especially if there is a big difference in density too. Skies, for example are low contrast areas. This is obvious when it is remembered that they are made up almost entirely of light tones, but because skies frequently print as white, and white is considered to be a high contrast tone, they are sometimes wrongly identified as high contrast areas. The best way to avoid this confusion is either by common sense and experience, or by looking in turn at individual parts of the negative without being influenced by others. The essential thing to remember is that contrast relates to the differences between tones, not to their absolute densities. As far as printing is concerned, contrast is relative. Since skies are generally low in

contrast, they are often best suited to high contrast burning-in. However, given that bright skies correspond to dense areas of the negative, it is unfortunate that high contrast slot-in filters require increased exposure times. This problem doesn't arise with twin-lamp variable contrast enlarger light sources, but is at its worst when using general-purpose colour enlargers. In all cases, the advantage of brief basic exposures, mentioned earlier, should now be obvious in trying to avoid long burning-in times at high grades.

If there is little difference in contrast between the foreground and the sky, you have two choices. Since a straight print will probably look very flat, the image should either be printed in two entirely separate areas, with appropriate grades used for the sky and the foreground, or with local burning-in applied to each area to create an illusion of depth. Local burning-in will often be rather limited, however, if the whole image has been substantially affected by the initial basic exposure. Indeed, here is a second general guideline: local burning-in can only create greater impact where there is a sufficiently low initial image density to accomodate extra exposure without losing detail. Although it is stating the obvious, it is worth noting that burning-in can never make areas lighter, regardless of what grade filtration is used.

PRE-FLASH

It is a failing of all photographic materials that they do not always give a density directly in proportion to the local exposure. In particular, print exposures must exceed a certain level before the first signs of density can be seen. In some images, subtle highlight details can fail to show on the print, requiring the paper contrast to be reduced or the print exposure to be increased over the test print conditions. Applied to the whole image, the first of these gives a less dramatic result and the second gives "muddy" mid-tones. Of course, there is a third option, which is to burn-in highlight areas individually without affecting the rest of the image, but this can be difficult and time-consuming if many parts of the image need to be treated in this way.

There is also a fourth technique that can be used, which gives the equivalent of a self-masking action that affects highlights more than any other part of the image. The name of this technique is "pre-flash", which refers to the fact that it involves giving the paper an overall exposure before laying down the image itself. The pre-flash exposure is calibrated to match, or slightly exceed, the paper's exposure inertia. This done, all the tones on any negative that is subsequently printed onto the paper will be visible in the finished print. As a very rough guide, if, for example, an enlarger needs an exposure of about 15s at f/11 to make 8x10" prints from 6x7cm negatives, then the pre-flash conditions

(with the enlarger head moved up to give coverage for a 20x24" print but with no negative in the carrier) are likely to be around 1s at f/22.

To find the exact conditions, place a piece of unexposed paper under the enlarger and lay a rule or other opaque object across the middle of the paper. Then make a step test along the length of the paper, revealing it in about half a dozen exposures (based on 1s steps at minimum aperture). When processed, the exposed part of the paper should be totally white at one end and show a faint grey at the other. If the paper is shades of grey right across, then the briefest exposure was too much and the test should be repeated using even shorter exposure times. Conversely, if the paper is totally white (the masked-off strip that corresponded to the position of the rule is invisible right across the paper), the test should be repeated with a larger aperture setting.

The starting point for pre-flash exposures is the last stage at which the paper is still white, immediately before the step when the faintest grey is just discernible from the pure white band that was covered-up throughout the test. The time and aperture used for this exposure should be noted as they will provide the basis for determining pre-flash exposures used for printing real images.

Contrary to what has been written elsewhere, it is not true to say that this pre-flash exposure is correct for all negatives. In particular, if the print is to be toned, a greater pre-flash will normally be needed since toner bleaches tend to destroy the most subtle highlight details. The only way to be sure of the correct conditions for a particular print is by doing tests – exposing the negative in question onto an unprocessed, pre-flashed test strip sheet. As before, part of the paper should be covered during the pre-flash stage, but uncovered during the image printing stage. By comparing the two parts of the picture (one pre-flashed and the other not), the best conditions can easily be determined. The ideal conditions are those that give the required degree of highlight detail without causing an overall grey veil.

As to when pre-flash should be used, this is very much a matter of individual style. Some writers have suggested that all prints should be pre-flashed to avoid losing highlight detail, but this also means that the images will lack clear white areas, which are often the most appropriate way of showing light sources included within the picture area. In general, if there are no light sources in the image, but there are large areas of highlight that need to show detail and would be tedious to burn-in, then pre-flash is ideal.

Pre-flash can be used at different contrast filtrations depending on the effect required, though most often it is done at a low grade. Negative printing contrasts usually need to be slightly harder on pre-flashed paper than they would be otherwise, though this is not

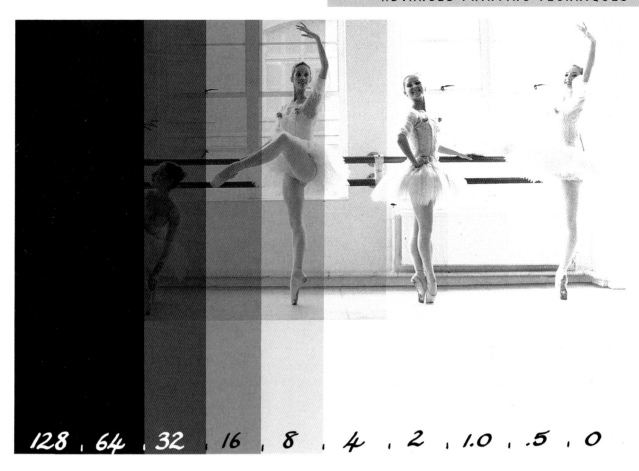

PRE-FLASH TIME IN SECONDS.

128 , 64 , 32 , 16 , 8 , 4 , 2 , 1.0 , .5 , 0

a problem given that the highlight details, which are most likely to be lost when using harder grades, have already been taken care of. The ability to pre-flash at one grade then print the image itself at another is unique to variable contrast papers and provides an exceptionally good case in favour of such materials.

A WORD OF WARNING

Some readers may have spotted that the pre-flash test is not unlike a safelight fogging test, with both seeking to check the effect of low intensity, overall exposures on the subsequent recording of images. This, and the previously made observation that pre-flashed paper has been brought right up to full sensitivity, means that pre-flashed paper is very much more vulnerable to safelight fogging than usual. Because of this, and the fact that the pre-flash effect diminishes if paper is left some time before it is used, it is better not to pre-flash paper in bulk.

BEYOND THE IMAGE

The creation of a top quality photographic image doesn't stop with the image itself. This final section therefore explains a few of the other factors that are important to the printing process.

It would be wrong to concentrate on these aspects at the expense of printing practice, for no amount of toning, nor any border effect, can rescue a badly printed image. That said, it is often attention to presentation that separates a competition winner from a print that is merely "good".

A common mistake made when thinking about pictures is to assume that only the image area matters. Were this true, art galleries around the world would be filled with unframed canvases, which is clearly not so. The simple fact is that framing completes the picture. In the case of photographic prints, there is the opportunity to use both conventional frames and integral border designs. The latter have a unique advantage in being inseparable from the image itself.

WHITE BORDERS

Before any image is exposed onto a sheet of printing paper, a decision has to be made about the border that will be used. At its simplest level, this can be just a matter of setting the width of paper that will be hidden under the easel blades and so remain as a white frame to the image within. While very basic easels have fixed locating lugs and fixed border widths, more sophisticated

MUCH OF THIS PRINT'S EFFECT IS DUE TO THE BOLD USE OF CONTRAST AND FRAMING ON THE PAPER. ALTHOUGH A HORIZONTAL FORMAT IMAGE, IT HAS BEEN PRINTED ON AN UPRIGHT FORMAT SHEET. THIS HAS LEFT PLENTY OF WHITE SPACE FRAMING THE IMAGE, SO ADDING TO THE STARK FEEL OF THE PICTURE. TO SEPARATE THE IMAGE FROM ITS SURROUNDINGS, A BLACK KEY-LINE HAS BEEN DRAWN ONTO THE PAPER USING A HIGH QUALITY DRAWING PEN. THE RESULTING OVERALL EFFECT IS VERY MUCH MORE DRAMATIC THAN WOULD HAVE BEEN OBTAINED FROM A LANDSCAPE PRINT WITH, FOR EXAMPLE, $\frac{1}{4}$" BORDERS ALL AROUND.

PHOTOGRAPHER: BRYN COLTON

types have movable bars that permit a range of border widths. In all cases, it is important to realise that the maximum border size is fixed by the greatest recess that can be set in the back corner of the easel. If this greatest recess is 1", then the fact that the easel has 2" movable blades is almost irrelevant as far as border widths are concerned. As a general guide, A4 format prints look good with approximately 1" borders, and 12x16" prints suit borders about 2" wide.

To create deeper borders without using a different easel, there are three methods that can employed. The first is to stick wide card strips onto both the static frame and the movable blades of the easel. The second is to make a card mask over-lay that has a fixed-size aperture cut into it. The third is to rely on negative carrier masking and simply frame the image well within the paper, leaving large areas of sensitive surface visible but not exposed by the negative. Of these options, the first is the one that offers the best combination of flexibility and print quality: the second is obviously very much less flexible and the last risks fogging the unused paper area to a light grey. The latter can become a particular problem during subsequent toning.

When extending border widths, rather than cutting a solid "L" shape piece to fit the fixed sides of the easel it is better to cut straight strips and butt them together. A precise right angle is much easier to create in this way than it is by cutting into a single piece of card. The join between the two strips should be covered with opaque tape to make it light-proof. In the case of the movable blades, the card strips should be stuck to their trailing edges so that the image area is still marked by the front edges of the metal blades. This ensures the hardest, and straightest, boundary to the image area.

Regardless of whether widening strips are used or not, it is very important to check that the easel is set to give a perfectly rectangular image area. The easiest way to do this is using a piece of plain drawing paper. The paper is loaded into the easel and an "L" drawn by tracing the lines of the two static sides of the frame border. The paper is then removed, turned through 180° and re-inserted into the easel. If the movable blades are set perfectly square, the "L" will align with them exactly. If not, the angle of the blades should be adjusted to match the drawing.

Although it has been assumed in what has gone before, there is no rule that says the border widths must be the same all around an image. Many pictures actually look better with a slightly wider border below their image areas, for example. Where this is the case, a wider edge is easiest created by extending just the appropriate movable blade. The wider edge need not be fixed to the easel blade, but rather can just be a spare piece of card that is laid over the part of the paper that protrudes beyond the blade width. Under no circumstances should such wide borders be left exposed during printing. If they are, light spill could well grey the paper and cause an obvious line between the area of paper that was protected under the blade and that which wasn't.

BLACK LINES ON WHITE BORDERS

A currently fashionable technique is to use an over-sized negative carrier and print part of the film rebate with the image area. This method takes two forms; one in which the rebate gives a thick, well defined black line around the image, and one in which the rebate is allowed to flare and so creates a softer, blurred black line. In both cases, the negative carrier is filed to give a larger than usual aperture. To keep the aperture square, it is best to file just two of the four sides. The edges must be smoothed off and painted black to avoid damaging negatives and causing reflections respectively. No such problems arise if a glass negative carrier is used, though there is a much greater need for cleanliness if dust marks are to be avoided on the print.

There is, however, an even easier way of putting black lines around print image areas, which is simply to draw them using a high quality pen. The widths of these lines are fixed by the width of the pen nib used and are commonly around 1mm. A drawing pen, preferably refillable rather than disposable and older rather than newer, should be used. Refillable drawing pens need to be shaken until a clicking sound is heard, indicating that the mechanism is moving freely, before use. Both types should be used with the pens held perfectly upright, at right angles to the paper surface, and each line drawn smoothly in a single movement. Water-based ink is a wiser choice than the permanent variety because it can be washed off if a mistake is made. Lines should be drawn using a top quality rule made of metal or very rigid plastic. If the rule has a bevel, this should face downwards so as to minimise the danger of ink seeping under the rule and causing a blurred line. A useful tip is to put a newspaper underneath the print to allow slight "give", so preventing the pen nib from scratching the paper.

It can be particularly tricky to put box lines around images that have very light edges. The best tactic here is to use a pin to prick the corners of the image, then line-up the rule on these marks. This even works when the edges of the image cannot be seen at all. Here, a box that corresponds to the printed image size is first drawn onto tracing paper, then centred over the picture and the corners pricked through to the print below. Alternatively, if the printing easel has not been disturbed, the print can be returned to the frame and the corners pricked using the blades as locating guides.

A final option for boxing-in prints is to use Letraline or a similar roll-on product. The advantage of this method is that the paper

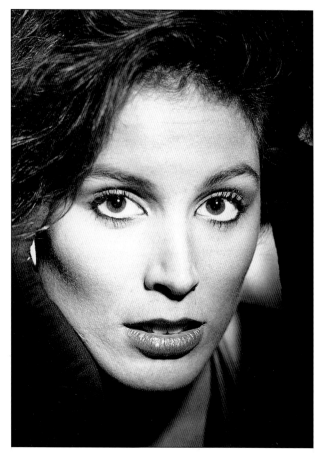

JON TARRANT
PHOTOGRAPHER

base remains unaffected: the disadvantage is that the lines always look over-laid, rather than being part of the print.

BORDER TEXT AND LOGOS

Although white borders of unprocessed prints remain unaffected by the image, they can still be affected by subsequent exposures if required. Thus, it is possible to mask-off the borders, expose the image, then mask off the image area and expose the borders to some other negative. In particular, the second negative can bear text, such as the name and telephone number of the photographer.

Border negatives are best made by copying original art-work onto high contrast film. The art-work can be created freehand, or with Letraset, or output from a computer DTP package using a high quality printer. The most suitable film, which is conveniently available in single rolls of 35mm and can be processed in normal developers, is Agfa Ortho. Alternatively, a local copy-shop may be willing to create the art-work and/or produce a high contrast negative for you.

No special precautions are needed when printing border text onto the paper other than to ensure that the image area is properly masked-off and that the lines of the text run parallel to the edge of the image. To avoid degrading the border whites, and also to give bold text density, the negative should be printed at maximum contrast using the minimum exposure that gives solid black (over-exposure will soften the edges of the text and give a blurred look).

CLEANING WHITE BORDERS

Two problems can afflict white borders; fogging and staining. In many cases, marks can be removed using a diluted solution of Farmer's reducer (a mixture of potassium ferricyanide and sodium thiosulphate in water – see formulary). The borders of the print can either be wiped over or each in turn be gently slid into a tray containing the solution, after which the print must be washed fully. Care must be taken to ensure that the solution doesn't splash onto, or flow over, the image area. In the case of toner stains, a similar procedure using print developer can work wonders.

The occurrence of fogging and/or staining is always a warning that something isn't right somewhere in the printing process. It may, for example, mean that the paper is stale, or has been fogged by the safelight, or that the chemicals are exhausted. Local staining may indicate contamination carried on tongs or fingers, or splashes from one tray into another. As has been stressed before, cleanliness is absolutely essential if the best quality prints are to be obtained. So if your print borders need cleaning-up, remember to find out what has caused the problem and rectify the situation at once.

BLACK BORDERS

For very many years, all prints had either white borders or none at all. It therefore seemed obvious, if prints were to stand out from the crowd in competitions, to devise a means of creating black borders. This was not, however, quite as simple as it sounds: large expanses of solid density lack subtlety and actually degrade, not improve, most images.

The first black/white-line border design, devised by Larry Bartlett and photographer John Downing, had the white line adjacent to the image area, with solid black beyond. It was created by first

printing the image, then covering the image area with a slightly over-size mask and exposing the border areas to solid black. Although this was different enough to stand out from the crowd, it wasn't as aesthetically pleasing as was hoped. A revised design, and method of creation, was then devised, resulting in the now well-known Larry Bartlett Black Border.

There is no secret in how the effect is done, though many people do seem to have difficulty understanding the process. A master border is first made by creating a box frame on a sheet of glass. The box can be made using Letraline or car coach-line tape: the tape doesn't have to be black, just opaque. A centre area, corresponding to the picture area of finished prints, should be masked using a sheet of black card. This master is then contact printed onto normal b&w paper. The print, which should show a white centre area surrounded by a white line in an otherwise solid expanse of black, is then photographed onto high contrast film. The negative so produced will have the required black centre with a surrounding black line.

Border negatives should always be printed before image negatives so that the effect of any minor amount of light spill will be taken into account when testing the image itself. They must be kept scrupulously free from dust to prevent white specks showing in the expanses of black, and must be printed with minimum exposure at maximum contrast to avoid flaring the blacks and degrading the whites respectively. Different border formats are required for different aspect ratio images, but a single design can be scaled up or down to suit different enlargement sizes.

BLACK OR WHITE?

The choice between white and black borders should be made to suit the image being printed, and not fixed in advance as a matter of routine. The black/white-line border has become very much associated with Larry Bartlett's printing, but, as the examples in this book show, it is not used indiscriminately. Furthermore, the range of border options is not limited to just black or white, and readers are encouraged to devise schemes which particularly suit their own images.

TONING

There are three reasons to tone a b&w print; to increase longevity of the image, to add colour for aesthetic reasons, and to correct a printing problem. The last of these is to be avoided as far as possible, though it is true that some toners reduce contrast and/or maximum density, whereas others have an intensifying action.

As far as longevity is concerned, the life of a photographic print is limited by attacks to both the paper base and the image itself.

LOOKING AT THE STRAIGHT PRINT SHOWN HERE, IDENTIFY THE TECHNIQUE THAT SHOULD BE USED TO MAKE FINAL PRINTING AS EASY AS POSSIBLE, AND DECIDE WHETHER THE IMAGE SHOULD BE FRAMED WITHIN A WHITE BORDER OR A BLACK ONE. NOW TURN THE PAGE...

The former is minimised by careful processing, fresh solutions, sufficient washing and proper storage. Attack to the image takes place because silver is not stable and, in particular, can be converted into silver sulphide. Whereas finely divided silver has a black colour, silver sulphide – which is the tarnish that forms on silver cutlery left unpolished for a long time – is brown. If the conversion takes place unevenly, the print will seem stained in areas.

One way of avoiding this problem is to convert all of the silver image into silver sulphide at the outset, and this exactly what is done with sepia toning. There are two common types of sepia toner; sulphide sepia toner, which gives off a "stink bomb" smell, and thiocarbamide sepia toner, which doesn't. Sulphide toners are capable of giving truer sepia (purple) browns, whereas thiocarbamide toners, which are made-up from two parts, can give a range of colours from yellow-brown to warm-brown. It is by altering the proportions of the two components (sodium hydroxide

and thiourea) that the colour is varied. Both types of sepia toners are available in off-the-shelf kits which include the toners themselves and the necessary pre-toning bleach baths.

For those who prefer the DIY approach, details for making-up the bleaches and toners from raw chemicals are given in the formulary that appears at the end of the book. Another method of prolonging the life of a silver image is to convert it to something even more

stable than silver sulphide. This is what is done in selenium toning, which gives silver selenide. Unlike sepia toning, selenium is a single bath toner that needs no prior bleaching. As a result of this, silver selenide is formed over the top of the silver image, so giving an increase in density that is most obvious in the already dense shadow areas of the print.

The colour produced by selenium toning ranges from pure black, through purple-black, to a deep red. Printing papers that are true bromides, such as Agfa Brovira, tone blackest, whereas papers that contain a great deal of chloride, such as Forte Fortezo, give the brightest red. The exact colour also depends on the toner dilution and temperature: more concentrated, warmer, solutions give stronger colours, while the most diluted, coldest, mixtures can provide image protection without any visible colour change. Selenium toners are not normally made from raw chemicals owing to the high toxicity of the materials used. Even off-the-shelf selenium toners must be used with extreme care. Under no circumstances should the liquid be allowed to come into contact with skin, eyes or mouth. Protective clothing should always be worn at all times when handling selenium toner.

TONING FOR COLOUR

Although sepia and selenium toners can be used to increase the life of a photographic print, they can also be used simply for the colours they produce. Two other toners that are used solely for this purpose, and are usually said to degrade, not improve, the life of an image, are blue and copper-red. Formulae for these toners are given at the end of the book.

Attention is particularly drawn to the two-bath blue toner. This toner was devised by C. Winthrope Somerville and was disclosed in his 1907 book "Toning Bromides". For whatever reason, the toner has been largely ignored by writers of late and has all but fallen from use. This is very unfortunate since the colour produced is a soft steel-blue, and not the harsh electric-blue given by most one-bath blue toners. Also, because the process uses two baths, the toner does not produce intensification caused by overlaying blue onto the silver image. In addition, the colour resists washing. The drawbacks are that prints must be made slightly darker than usual (to allow for the loss in density caused by replacing the black image with a delicate shade of blue), that the prints must be very thoroughly washed between the bleach and the toner, and that the colour is sensitive to the acidity of the wash water. Subject to taking care over these points, blue toned prints of exquisite colours can be produced using Somerville's technique.

Copper toners, like selenium toners, give different effects at different dilutions. As concentrations increase, highlight bleaching becomes more acute but the colour produced is more vibrant. By making minor changes to the basic Ferguson copper toner, it is possible to alter the image colour towards stronger reds (see formulary).

Toners can be combined by part-toning first in one bath, then washing and finishing-off in a second. Some methods and combinations are more successful than others, though this is an area for experimentation rather than following fixed rules. Yet another possibility lies in local toning, by masking-off parts of the image using commercial liquid or film products and toning just the exposed areas of the print. This process can then be repeated on different areas to obtain multi-colour images.

There are no rights and wrongs of toning. As a general guide, however, if the final print looks good then the toning was a success. If it doesn't, the whole thing was a failure, regardless of how much work went into the print.

SPOTTING AND RETOUCHING

After everything else has been done – a perfect image has been printed inside exactly the right border and toned appropriately (or not, as the case may be) – it only remains to ensure that there are no dust specks or other small distractions on the print. Not all prints require full retouching, but it is very rare for any print to need not even the slightest spotting. The difference between retouching and spotting is one of degree: spotting involves just the removal of minor blemishes due to dust and scratches, whereas retouching involves changing the image itself.

While it is possible to use ordinary inks, dedicated commercial dyes, such as the Spotone products, are best for spotting and retouching photographic prints because they are easily absorbed into the emulsion and gives invisible, permanent, results. Some printers find untoned prints easier to work on than those that have been toned, but this is mostly just a matter of practice. Colour print dyes, particularly Ilford Cibachrome Dyes, are ideal for retouching toned prints.

The basic Spotone dye set has three colours; blue/black, neutral black and olive/brown. Although the instructions supplied with the set give colour mixtures for different papers, the neutral black dye is by far the most useful for the vast majority of common papers. A useful trick is to leave the bottle open for some time before use, so thickening the dye. The right consistency is obtained after about one-third of the bottle's contents have evaporated.

To use the dye, a small amount should be transferred to a saucer, from which it should be picked up on an 00 pure sable brush. Rather than working close-up to the print, it is better to spot at arm's length so that the overall effect on the image can be seen at all times. Spotting is often not so much a matter of removing

As is often the case with hand coloured prints, this picture was toned (using a sulphide sepia toner) before being dyed. The colouring inks used were Ilford Cibachrome dyes, which are actually intended for spotting colour prints but which work particularly well on b&w prints too.

Photographer: Denis Jones

faults as of camouflaging them. Because of this, brush movements should follow the lines of the surrounding image areas. Dark areas should be built up in stages. If over-done, spotted areas can be lightened either by extended washing or by applying a little mild ammonia solution to the area concerned, but it is always better to avoid such problems in the first place.

Retouching extends these principles to elements of the image that detract from the overall print, and is carried out using the same methods. Another use for retouching is in improving the image beyond its true state. This is particularly true of portraits, which can be made more flattering to the model. Taken to the extreme, retouching can be used to colour a b&w print either completely or just in part. Full hand colouring, however, requires a completely different approach to b&w printing. Because colours show best on light tones, it is often necessary to print images specially for this technique. But before attempting such prints, be sure that you have mastered all the essentials of conventional printing. No amount of retouching or hand colouring can rescue an image that has been badly printed.

THE PERFECT PRINT

The secrets of successful printing are a total mastery of the basic techniques and a good eye for pictures.
Learning the basic techniques of b&w printing is relatively easy: becoming a master of them takes years of experience.
No matter how complex a print may appear to be, the techniques used in its creation are none other than those already explained. It is not closely-guarded techniques, but ordinary practice that makes perfect prints.
The examples that follow in the second half of this book, particularly those using multiple negatives,
may lead you to think otherwise, but this is not the case.
The difference between a good print and a bad one is often down to the finest details
and the most discerning eye, nothing more.

FORMULARY

The following formulae are presented to provide you with a means of obtaining greater control over your prints. There is generally no advantage to be had in mixing your own solutions other than the fact that you know exactly what has gone into them. Ready-made solutions are much more convenient, but their formulae are rarely announced. If a favoured product is withdrawn or changed, you may have no way of recreating its original effects. By mixing your own solutions you avoid any such problems.

Great care must be taken when handling raw chemicals: gloves, goggles, protective clothes and dust masks should all be worn. It is worth remembering that there are no such things as "safe" and "dangerous" chemicals, only different levels of toxicity. Cautious workers will therefore treat all chemicals as potential hazards. This is certainly the authors' attitude.

While every effort has been made to ensure accuracy, readers choosing to use the following formulae are advised that they do so entirely at their own risk.

All the following solutions should be used under normal room lighting and under good ventilation. Sulphide sepia toner in particular should never be used in the darkroom since its fumes will degrade unused printing papers.

Where 10% solutions are specified, these can be prepared by dissolving a weight of the substance in a volume of water that is numerically equivalent to ten times the weight used (eg. dissolve 10g in 100ml). Although this does not give solutions that are of 10% strength in the strictest sense, it is at least a convenient and consistent method of preparation.

FARMER'S REDUCER

(Used to lighten prints, either locally or overall, and to clean white borders. Its effect is irreversible.)

PART A

Sodium Thiosulphate (Hypo') crystals	100g
Water	1000ml

PART B

Potassium Ferricyanide	100g
Water	1000ml

Immediately before use, mix five volumes of Part A with one volume of Part B and then double the total volume by adding an equal quantity of water. The mixture goes off within a few minutes, though the separate stock solutions have good keeping properties.

SULPHIDE SEPIA TONER

(Produces a deep brown colour. Smelly, so ensure good ventilation.)

BLEACH

Potassium Ferricyanide	100g
Potassium Bromide	100g
Water	1000ml

This solution, which must be stored in an opaque bottle, can be re-used repeatedly until it is ceases to have any further effect. Prints should be immersed in the bleach until the desired action is seen. They must then be washed until the paper base is white, after which they are toned in the following solution.

TONER

Sodium Sulphide	200g
Water	1000ml

Hot water must be used when dissolving the sulphide. The toner should be diluted with nineteen parts of water and can be re-used until exhausted.

THIOCARBAMIDE SEPIA TONER

(Can give a range of colours from yellow to brown - see below.)

First, bleach the print using the sulphide sepia toner bleach, then tone using a mixture of the following two components.

PART A

Thiocarbamide (Thiourea) . 100g
Water . 1000ml

PART B

Sodium Hydroxide (Caustic Soda) . 100g
Water . 1000ml

For a yellow colour, use five volumes of Part A with one volume of Part B and fifty volumes of water.

For a brown colour, use one volume of Part A with five volumes of Part B and fifty volumes of water.

For colours in between, use intermediate mixtures.

SOMERVILLE'S TWO BATH BLUE TONER

(Subtle blue-grey colours and split tone effects are both possible using this system, which, unlike commercial blue toners, uses separate bleaching and toning baths.)

BLEACH

Potassium Ferricyanide . 20g
Ammonia solution (10% strength) 100ml
Water . 1000ml

TONER

Ferrous Sulphate . 20g
Hydrochloric acid (10% strength) 100ml
Water . 1000ml

It is absolutely essential that prints are thoroughly washed before being immersed in the toner bath. Even the slightest traces of bleach will cause a vivid Prussian blue precipitate that is impossible to remove. Provided that contamination is avoided, the solutions can be retained and re-used until exhausted.

DIRECT BLUE TONER

(Single-step process that gives strong blues and intensified images.)

PART A

Potassium Ferricyanide solution (10% strength) 20ml
Sulphuric Acid (10% strength) . 35ml
Water . 1000ml

PART B

Ferric Ammonium Citrate solution (10% strength) 20ml
Sulphuric Acid (10% strength) . 35ml
Water . 1000ml

Immediately before use, mix equal volumes of the two parts. Discard mixed toner after use. Toned prints can be difficult to wash because the image colour is reduced by alkalis found in tap water. The easiest solution to this problem is to add a little mild acid to the wash water.

FERGUSON'S COPPER TONER

(Single-step process that both colours and bleaches the image. More diluted solutions cause less bleaching but also tone more slowly.)

Potassium Citrate . 40g
Copper Sulphate solution (10% strength) 35ml
Potassium Ferricyanide solution (10% strength) 30ml
Water . 1000ml

For a more subtle effect, reduce all the concentrations by a factor of ten. At this extreme level of dilution, toning will take 20-40 minutes though bleaching will be negligible.

BRIGHT RED COPPER TONER

(Single-step process that gives a Bartolozzi shade of red.)

Ammonium Carbonate (saturated solution) 200ml
Copper Sulphate solution (10% strength) 40ml
Potassium Ferricyanide solution (10% strength) 100ml

This toner is quite expensive and does not keep well, so should only be made to the required volume. If toned prints are seen to have a persistent pink stain in their whites after washing, they should be treated with a 1% ammonia solution: using a stronger solution will destroy the toned colour.

PHOTOGRAPHIC PRINTING WORKSHOP

MOTHER THERESA

Photographer: John Downing

This portrait was taken under dim interior lighting using a hand-held 400mm lens. Yet despite these difficult conditions, the picture has obvious dramatic potential as can be seen even from the straight print.

Up to this stage, the success of the image is entirely due to the skills of the photographer. From here on, it is up to the printer to hone the picture to perfection.

ORIGINAL PRINT - A DIRECT (POSITIVE) COPY OF THE NEGATIVE AS SHOT.

FINAL PRINT - AFTER ALL THE DARKROOM MAGIC HAS BEEN WORKED.

THE TECHNIQUES USED TO CREATE THIS FINAL IMAGE ARE EXPAINED IN DETAIL ON THE FOUR FOLLOWING PAGES.

INSPECTING THE IMAGE
PRIOR TO MAKING A
STRAIGHT PRINT.

DODGING THE EYES
USING TWO PIECES OF
PLASTICINE ON A
SINGLE WIRE SUPPORT.

DARKENING THE
SHOULDER AREA.

DARKENING THE TOP
OF THE PICTURE.

PRINTING TECHNIQUES

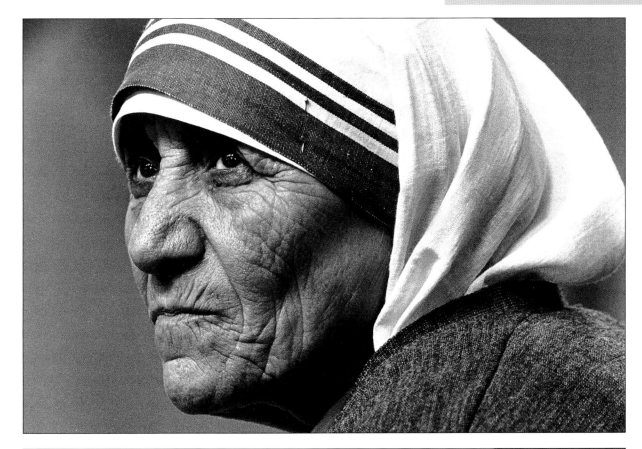

THE FIRST STEP IN IMPROVING THE PICTURE IS TO CROP THE IMAGE SLIGHTLY. ALTHOUGH THIS IS CLEARLY MUCH BETTER THAN THE ORIGINAL PRINT, THE EYES ARE OBVIOUSLY TOO DARK AND THE SHOULDER, LESS OBVIOUSLY, TOO SIMILAR IN TONE TO THE FACE.

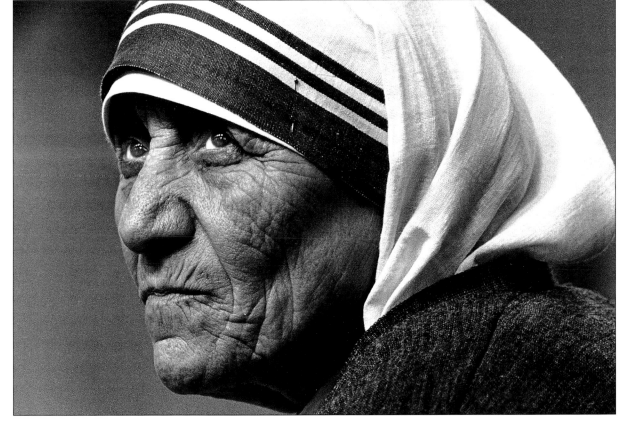

TO LIGHTEN THE EYES, THE BASE EXPOSURE WAS SPLIT INTO TWO HALVES AND A DODGING TOOL THAT HELD BACK BOTH EYES AT ONCE WAS USED FOR THE FIRST EXPOSURE. NO ATTEMPT WAS MADE TO HIDE THE TOOL'S SHADOW AT THIS STAGE. IN THE SAME PRINT, THE SHOULDER WAS DARKENED TO AVOID HAVING IT COMPETING WITH THE SKIN TONES. AS WELL AS THE DODGING SHADOW, THERE IS A PROBLEM WITH THE TOP RIGHT CORNER OF THE PRINT, WHICH IS TOO LIGHT.

TAKING THE
BACKGROUND TO
ALMOST BLACK.

TONING DOWN THE
FRONT OF THE
HEADSCARF.

DARKENING THE LEFT
OF THE PICTURE TO
ADD WEIGHT AND HIDE
SHADOW MADE BY
EYE-DODGING TOOL.

FINALLY FAR LEFT OF
PICTURE TAKEN
ALMOST TO BLACK.

THE NEXT STAGE WAS TO DARKEN
THE TOP OF THE PRINT ALMOST -
BUT NOT QUITE - TO BLACK.
THE SCARF HAS ALSO BEEN
DARKENED, BUT IS STILL TOO LIGHT.

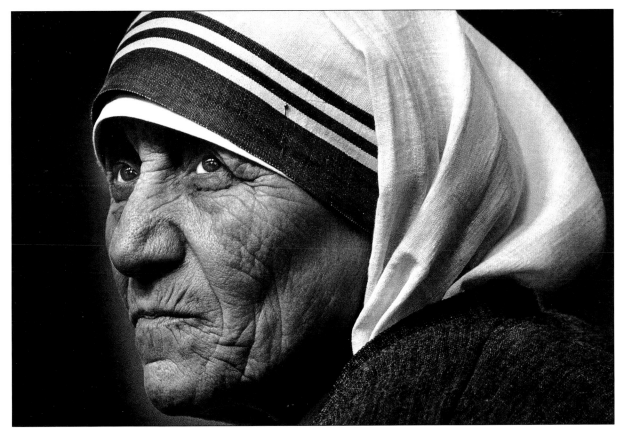

FINALLY THE SCARF HAS BEEN
DARKENED, AS HAS THE
BACKGROUND TO THE LEFT OF THE
PRINT. THE DODGING SHADOW IS
NO LONGER VISIBLE. A SUBTLE
HALO HAS DELIBERATELY BEEN LEFT
TO SEPARATE THE SKIN TONE FROM
THE BACKGROUND: WITHOUT THIS,
THE PRINT WOULD LACK DEPTH.

Nuns on Beach

Photographer: John Downing

This picture has an "observed" quality reminiscent of the great documentary photographers. There is humour in the situation, and a second story in the background "For Sale" sign. Printing is quite straight-forward, being simply a matter of focusing attention within the main picture area.

Printing Techniques

Although a variable contrast paper was used here, this print could just as easily have been made on a fixed grade type.
Testing showed the best overall density and contrast to be given by using 6s on Grade 3. A second exposure of 4s was given to the sky area above the nearest two beach huts and through the more distant huts out to the picture's vanishing point.
Another 10s was then given to the top of the sky alone to give a greater impression of depth.

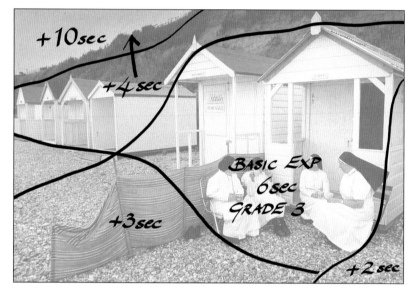

+10sec

+4sec

+3sec

BASIC EXP
6sec
GRADE 3

+2sec

OVERLAY

A 3S EXPOSURE WAS GIVEN TO THE FOREGROUND ON THE LEFT OF THE PRINT, WITH THE HANDS HELD CLOSE TO THE ENLARGER LENS TO GIVE A SOFT TRANSITION.
THE SIDE WALL OF THE NEAREST BEACH HUT AND THE STEPS BELOW IT WERE THEN DARKENED WITH A BRIEF 2S EXPOSURE TO COMPLETE THE EFFECT.

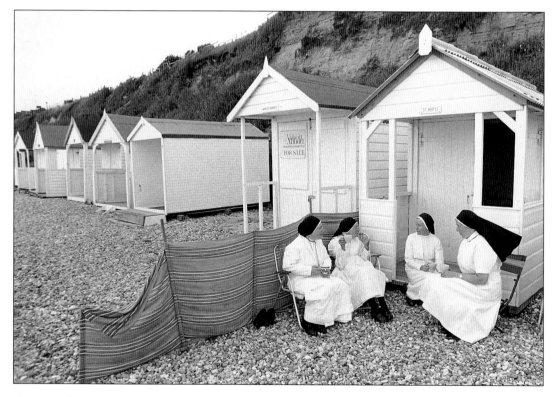

ORIGINAL PRINT

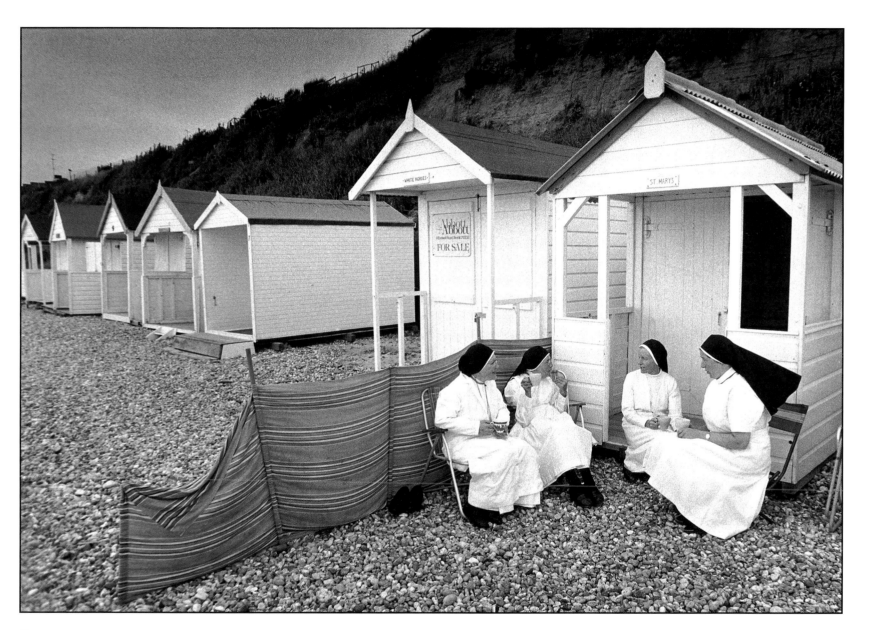

FINISHED PRINT, WITH KEYLINE DRAWN AROUND IMAGE AREA TO COMPLETE THE EFFECT.

GIRL AT WINDOW

Photographer: Paul Massey

A picture shot at a fashion photo-call and suffering slightly from the limitations imposed at such events. In particular, light has spilled under curtains in the background and created a distracting area in the bottom right corner of the image.

PRINTING TECHNIQUES

Fixed grade paper could be used for this picture since the print was made at Grade 3 throughout. Testing was done to find the exposure that gave best separation between the hair and skin tones on the shadow side of the face. The highlight side of the face and dress were then burned-in to balance. These were very critical exposures: too little burning would leave highlight details bleached out and too much would ruin the look of the picture. For the dress, the burning-in was done along lines that followed the fall of the fabric both to hide the transitions and to enhance the clothes. The hat was given a separate extra exposure to avoid it competing with the model's face. The curtains to each side were then taken to maximum black. This is a case where detail in the original negative is deliberately lost in order to create a more dramatic print.

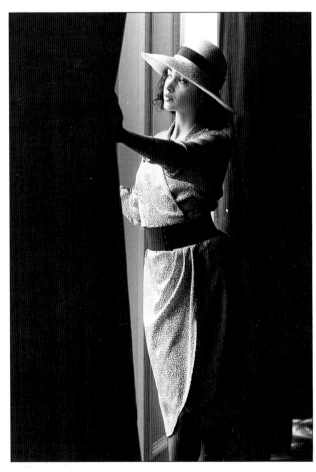

ORIGINAL PRINT

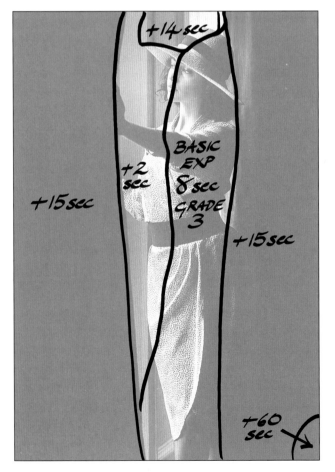

OVERLAY

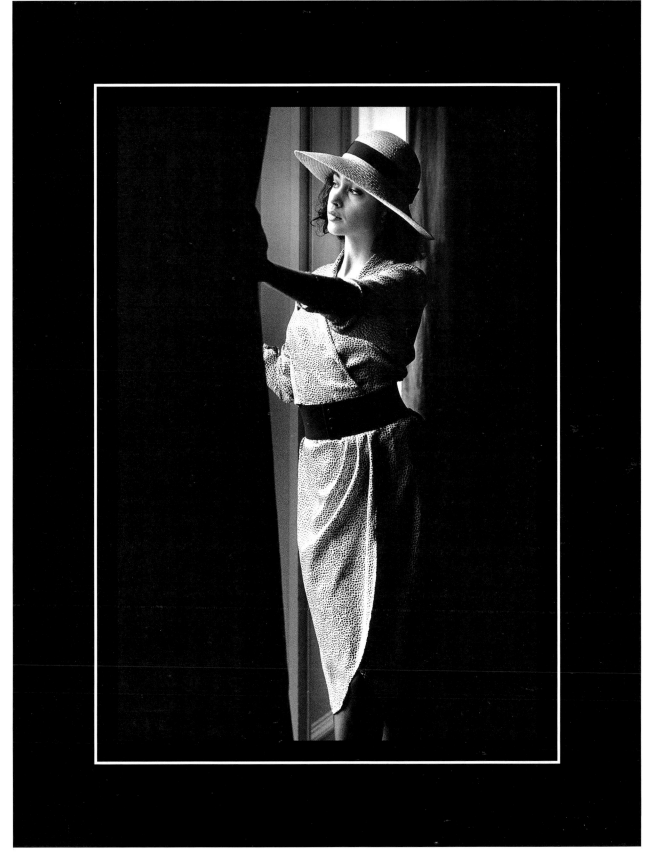

THE BOTTOM RIGHT CORNER OF THE PRINT, WHERE LIGHT HAS SPILLED UNDER THE CURTAINS, WAS DARKENED WITH A 60S BURN-IN EXPOSURE. IT MIGHT HAVE BEEN TEMPTING TO OPEN THE LENS APERTURE TO REDUCE THIS TIME, BUT TO DO SO ALMOST ALWAYS SEEMS TO CHANGE THE SHARPNESS/GRAIN OF THE PRINT - WHICH IS COUNTER-PRODUCTIVE IN EXAGGERATING THE FACT THAT THE AREA HAS BEEN TREATED DIFFERENTLY TO THE REST OF THE PRINT. IF 60S SEEMS LIKE AN UNCOMFORTABLY LONG WORKING EXPOSURE, THE BEST SOLUTION IS TO BREAK IT DOWN INTO A SERIES OF SHORTER EXPOSURES, TAKING A REST BETWEEN EACH.

FINISHED PRINT

UNION LEADER

Photographer: John Downing

Taken at a press photo-call, this is potentially a very dramatic portrait but is ruined somewhat by the background. The print therefore needs to lose all this detail, allowing the portrait to stand alone without distractions. Technically, this is not quite as easy as it might sound because there is an area of background visible through the spectacle frame that must be darkened without losing the edge of the frame itself.

PRINTING TECHNIQUES

This picture was printed entirely using the hands to burn-in local areas - even the small area behind the spectacle frame. The base exposure was found for the shadow side of the face, with Grade 3 being used to give gritty skin tones, and then split into two equal parts to allow the eyes to be dodged for half the base exposure time. An additional exposure was then given to the highlight side of the face to provide a better balance at the grade used.

The left hand side of the print was taken to total black, carefully avoiding any spill of light onto the glasses. The small background area behind the glasses was darkened to give a more natural look than would have been obtained otherwise. It is important to note that this area has not been made totally black, even though this would have been more technically correct, because to have done so would have meant losing the edge of the spectacle frame. Technical correctness must always be balanced with the needs of the image itself: in this case, burning-in to black would have given a less pleasing - and therefore less good - result.

Finally, the right hand side of the print was faded to solid black. This was done using a series of exposures that overlapped towards the edge of the print and had least effect closest to the face. By holding the hands very close to the enlarger lens, the boundaries between these separate burn-in areas were made very soft.

THE ALTERNATIVE BURNING-IN TECHNIQUE OF CONTINUOUSLY MOVING THE HANDS BACK AND FORTH BETWEEN THE FACE AND THE EDGE OF THE PICTURE IS LESS CONTROLLED AND WOULD THEREFORE HAVE BEEN MUCH HARDER TO REPRODUCE IN SUCCESSIVE TEST PRINTS. BY USING SEPARATE STEPS OF KNOWN TIME, IT WAS A SIMPLE MATTER TO MAKE ADJUSTMENTS AND SO ALTER BURNED-IN DARKNESS AND GRADUATION.

ORIGINAL PRINT

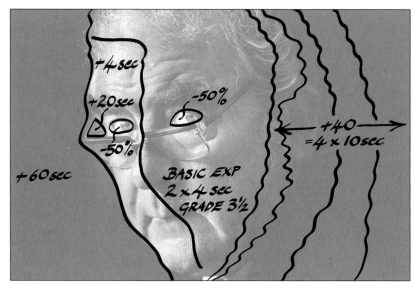

OVERLAY

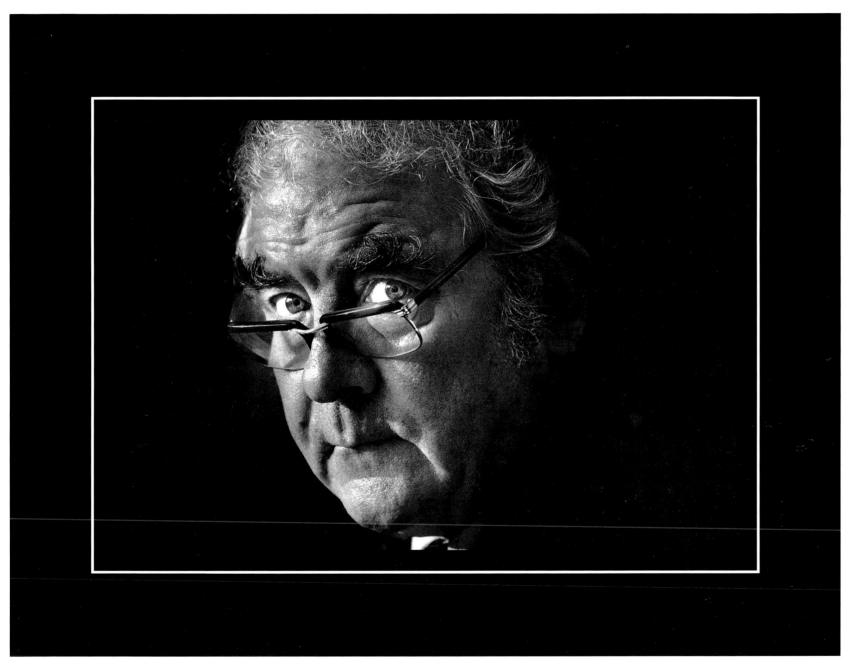

FINISHED PRINT

HORSE IN STABLE

Photographer: Jon Tarrant

This was one of those "discovered" pictures that come and go in the blink of an eye. It was taken in an instant, when the photographer noticed that his wanderings around a stable had caught one of its occupants' attention. Immediately after the picture was taken, the horse turned away, never to be attracted back for a second exposure. The lens used was a Nikkor 28mm f/2 set to maximum aperture: the film was Kodak Tri-X.

PRINTING TECHNIQUES

The most obvious thing about this negative was its very low overall contrast. In fact, so low was this that there was no point in doing the initial straight print on Grade 2 (as would be usual). Instead, the starting print was done on Grade 3, with the final image printed at Grade 5.

In its raw form, the negative has poor composition. The horse is almost exactly in the centre of the frame and there are unnecessary picture elements to the left. Cropping corrected both of these failings, repositioning the horse slightly off-centre and removing unwanted areas from the picture. This gives a much more intimate feel as a result. In order to prevent the print becoming too dark on the left, it was decided to lighten the horse's neck and mane during the basic exposure. Rather than doing this by dodging just the area concerned, a band from the edge of the picture inward was lightened and the side of the stable door subsequently darkened back again afterwards. This technique gives much more consistent results than trying to lighten isolated areas that are of similar density to their surroundings.

The top and bottom left hand corners were both darkened down, the latter to solid black since detail here was so weak that it was better totally lost. The ceiling in the top right hand corner of the picture was also darkened, as was the pool of light on the floor below. Note that the window that cast this pool has been cropped out of the final print, with the result that the light looks as if it has come from a doorway into the stable rather than from a window.

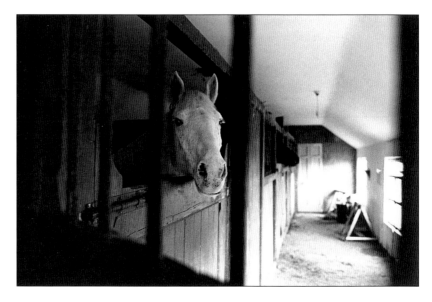

ORIGINAL PRINT

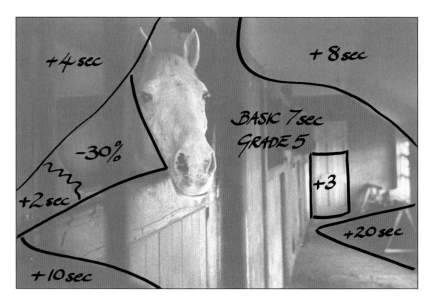

OVERLAY

66

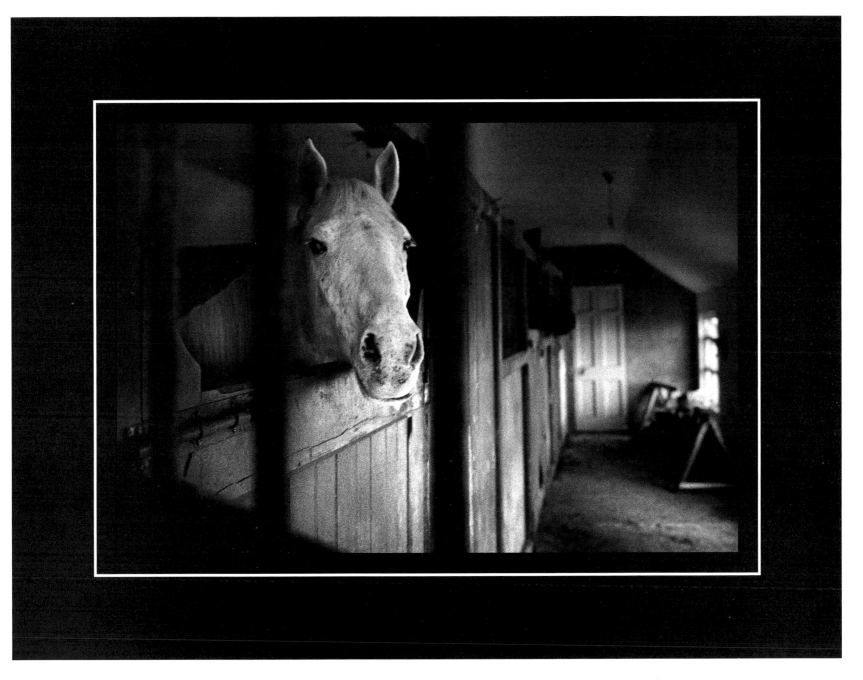

FINALLY, THE BLACK BORDER
(WHICH WAS EXPOSED ONTO THE
PAPER BEFORE THE IMAGE WAS
PRINTED), IS ESSENTIAL TO THE
SUCCESS OF THIS PRINT.
HAD A WHITE BORDER BEEN USED,
THE PHOTOGRAPH COULD NOT
POSSIBLY HAVE BEEN PRINTED AS
DRAMATICALLY AS IT HAS.

SHOTGUNS IN SEPIA

Photographer: Roger Bamber

This picture was shot to illustrate a newspaper story about a sale at Sotheby's auction house. The image is potentially very moody, with a strong texture of wood, but careful printing is needed to bring out the best in the negative.

PRINTING TECHNIQUES

Although this is seems to be a simple image, it isn't enough to use simple printing techniques. If the print had been made using a single exposure and contrast grade that held both shadow and highlight detail, the overall picture quality would have been very poor - despite being technically correct within the basic definitions of photographic printing. To produce a more dramatic print, different printing contrasts must be used for the stocks and for the engraved metal plates. Being strong in darker tones, the stocks suit a harder grade (Grade 3), whereas the brighter metal plates suit a softer grade (Grade 1).

The basic exposure was found for the harder contrast acting on the darker tones, giving 8s at Grade 3 for best shadow tone separation. The overall balance of the print was then refined by darkening the area above the shotguns, matching the stocks to the barrels, and burning-in the foreground to show heavy texture in the wood.

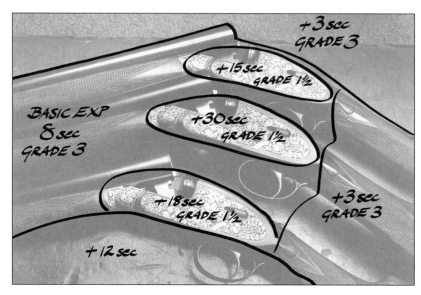

OVERLAY

The contrast filtration was then changed to Grade 1 to allow the engraved metal plates to be burned-in to reveal detail. Different exposures were used for each of the plates to bring them to a uniform brightness in the finished print.

ORIGINAL PRINT

FINAL B&W PRINT

FINALLY, IN KEEPING WITH THE
LOOK AND FEEL OF WOOD, THE
PRINT WAS BROWN-TONED USING
THIOCARBAMIDE TONER. THE PRINT FOR
TONING WAS MADE RATHER DARKER
THAN USUAL TO ALLOW FOR SLIGHT
BLEACHING THAT OCCURS AS PART OF
THE PROCESS. GOOD DENSITY WAS
PARTICULARLY IMPORTANT IN THE
HIGHLIGHT AREAS TO AVOID CLEAR
WHITES DEVOID OF DETAIL.

GYMNAST'S HANDS

Photographer: Tom Stoddart

This close-up study is another image taken from the photographer's detailed photo-story about young gymnasts in China (see also "Chinese Gymnast"). Despite the boy's eyes being cropped out of the picture, the photograph conveys a powerful sense of concentration that must be capitalised on during printing.

PRINTING TECHNIQUES

A straight print, made at Grade 2 with a white border, lacks impact. Contrast was therefore increased to Grade 3 for the next test, then another $\frac{1}{4}$ grade higher for the final print. The second increase in contrast may sound very slight, but it is vital to the finished result. One of the main advantages of using dedicated dial-in variable contrast enlarger heads is this ability to control the paper grade to such a fine degree. Slot-in filter kits do not have this flexibility, and nor do dial-in colour heads where every change to the light colour alters the exposure too.

Although the hard printing grade chosen was essential in order to achieve the desired skin tone, it caused problems with both shadows blocking up and highlights remaining devoid of detail. The former was countered by holding back the gymnast's face during the basic exposure, while the latter was corrected by giving hefty additional exposures to the bandages afterwards. Lesser local highlight areas on the arms and at the bottom of the picture area were darkened with more modest burning-in times.

Finally, the printing contrast was increased to Grade 5 to allow the background to be taken to solid black without degrading adjacent mid-tones.

Compared to the straight print, the finished image has a much more pronounced grain pattern. This is not because the straight print was poorly focussed, but rather because the higher contrast used for the final print has made its grain more obvious. In this case, the grain is an intrinsic part of the overall effect, giving the skin tones a gritty feel. This will not always be true, however, and for images that need a softer, smoother look, lower contrast grades are preferred. This said, grain does help to make an image look sharper (as should be obvious by comparing the straight print and the finished print reproduced here).

ORIGINAL PRINT

OVERLAY

FINISHED PRINT

PRINTS THAT APPEAR SHARPER
TEND TO HAVE MORE IMPACT, SO
DON'T ALWAYS ASSUME THAT GRAIN
IS SOMETHING TO BE AVOIDED.
GRAIN IS NOT JUST A FUNCTION OF
THE FILM USED, IT CAN ALSO BE A
USEFUL CREATIVE ELEMENT IN THE
PRINTING PROCESS.

SEASCAPE

Photographer: John Downing

Political conferences usually produce a host of highly predictable images, but this is something of an exception. Here, while members of the Labour Party were deciding on who should be their new leader, the photographer has gone outside and captured an image that is both graphic and poignant.

PRINTING TECHNIQUES

Given the strong back-lighting, it was decided to move the out-of-frame sun into the picture. This was done using two dodging tools, both made from blobs of plasticine, one sized about 5mm and the other twice as large. The larger mask was mounted onto a wire frame and fixed above the paper to cast a shadow where required. To avoid having the wire support frame show, the top of the "sun" was chopped off by the easel. The second mask was mounted on another piece of wire and used hand-held, being moved up and down above the fixed mask to create a soft edge.

The basic exposure was 15s, with the sun masks used throughout. The top right side of the picture was then balanced with the left by darkening in stages using a series of discrete exposures shaded by holding the hand very close to the enlarger lens.

ORIGINAL PRINT

DIAGRAM SHOWS USE OF FIXED AND MOVING (HAND HELD) MASKS TO CREATE 'SUN' EFFECT.

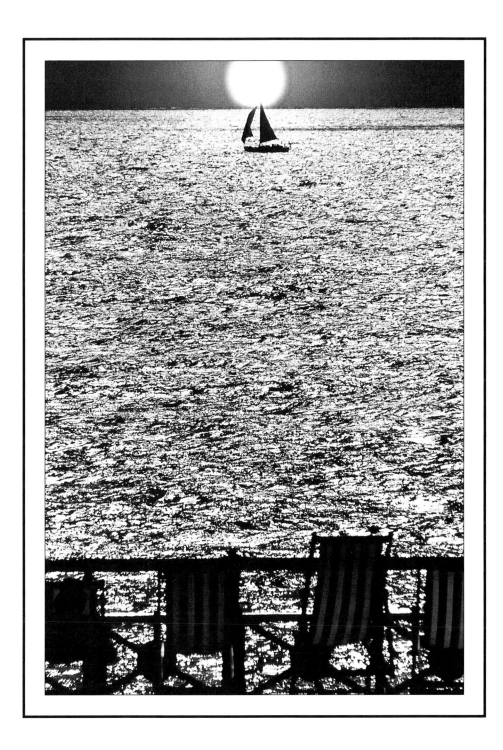

FINALLY, AFTER THE PRINT HAD BEEN FIXED AND WASHED, BUT NOT DRIED OFF, THE LINES ON THE DECK-CHAIRS AND THE OUTLINE OF THE LONE SILHOUETTED FIGURE WERE LIGHTENED USING DILUTE FARMER'S REDUCER (A MIXTURE OF FIXER AND POTASSIUM FERRICYANIDE IN WATER - SEE FORMULARY). THE PRINT WAS THEN THOROUGHLY WASHED AND DRIED.

ROWING ON THE THAMES

Photographer: Paul Massey

T aken from a boat following the crew as they travelled the route of the annual Oxford v Cambridge Boat Race. This is a deceptively simple image, but one that is very effective nevertheless.

PRINTING TECHNIQUES

A test strip was exposed through the middle of the image area, checking detail in the rower's tops and in the shadow areas to the left of the print. This gave 4.3s at Grade 3. To make the print more dramatic, the water to each side of the boat was then darkened slightly, emphasising the wake and therefore giving a stronger sense of movement to the picture.

TEST STRIP

Print contrast was increased to Grade 4 for burning-in the sky. Rather than burning-in from the water/sky horizon, the sky was darkened along the line through the bridge. This left a lighter area beneath the bridge that formed a distant point of focus, which increases the apparent depth of the print. Over-light areas, however, need to be avoid. A further additional exposure was given to a distracting area towards the right-hand end of the bridge.

Because a dedicated multigrade system was used for this (and all the other prints explained in detail), all exposure times are on the same scale. In this case, the 7s and 3s exposures made at Grade 4 were both on the same scale as the original 3.5s made at Grade 3. If slot-in filters been used, the times would have to have been doubled, to 14s and 6s respectively, to achieve the same effect.

Clearly, using a dedicated multigrade system, and not having to double exposure times above Grade 3, makes life much simpler. It also encourages the use of harder grades, which are sometimes shunned under other circumstances when their use requires extended exposure times.

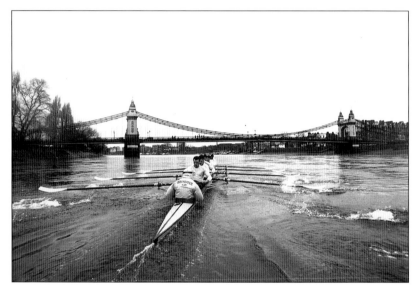

ORIGINAL PRINT

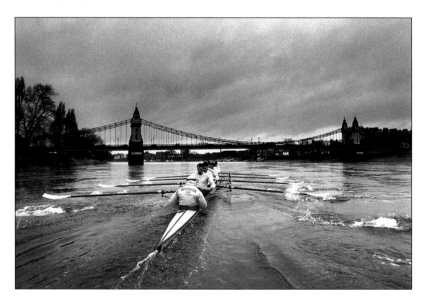

ALTHOUGH THE FULL-FRAME PRINT PRODUCED IS WELL BALANCED, IT SOMEHOW STILL DOESN'T QUITE WORK.

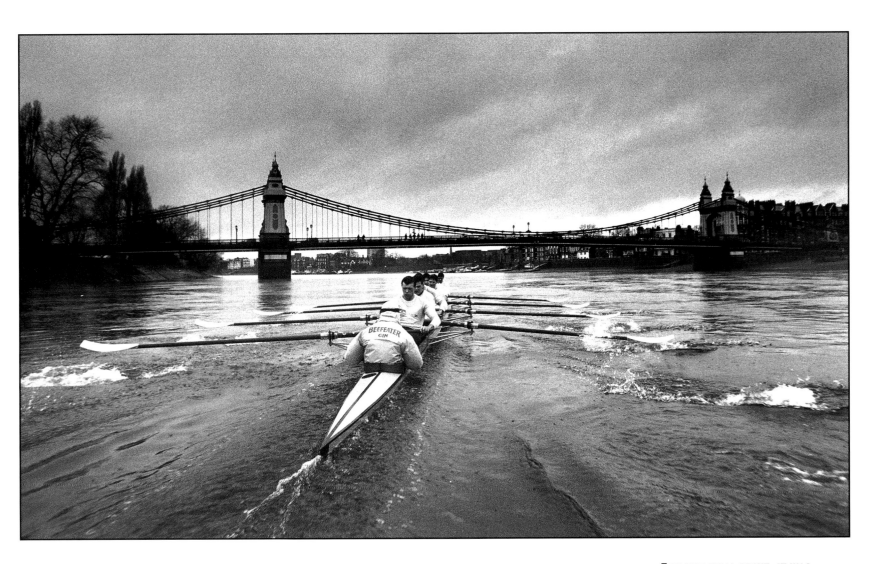

FOR THE FINAL PRINT, IT WAS
DECIDED TO USE A PANORAMIC CROP,
WHICH PROVED TO BE VERY MUCH
MORE SYMPATHETIC TO BOTH THE
PHOTOGRAPHER'S COMPOSITION AND
THE SUBJECT ITSELF.

SINCLAIR C5

Photographer: Roger Bamber

Attention to detail is the key to this picture: the obvious difference in size between the vehicles is contrasted with the subtle sideways glances of the bus passengers. It was a set-up, with the C5 electrically-powered car positioned on the brow of a hill waiting for a passing large vehicle to draw alongside. The passengers were an added bonus, but one without which the picture would have been very much less successful. It is therefore vital that the passengers are clearly visible in the finished print.

PRINTING TECHNIQUES

The first test strip showed the correct exposure for the C5 driver's face, but left the C5 itself too light. Rather than having to burn-in the vehicle, it was decided to re-test for the car and accept that the driver's face would have to be dodged. It also turned out to be necessary to dodge the passengers on the bus. The same plasticine/wire tool was used for all three areas.

At first, the passengers and the driver of the bus were all dodged, but since the driver is looking straight ahead it was then decided he would be better left darker, letting the highlighted passengers

direct the viewer's attention towards the C5. Because all the dodging operations were on similar areas, they were all done within a single base exposure without any need to break the time time into shorter components.

THE SIDES OF THE PICTURE TO THE LEFT AND RIGHT OF THE BUS WERE DARKENED DOWN TO TAKE OFF THE WHITE EDGE. THIS BURNING-IN INCLUDED BOTH THE C5 AND THE C5 DRIVER, WHOSE PREVIOUS DODGING HAD BEEN DELIBERATELY OVER-DONE TO MAKE THIS BURNING-IN EASIER. IT IS OFTEN MUCH EASIER TO USE THIS TACTIC OF OVER-LIGHTENING SMALL AREAS THEN ALLOWING THEM TO DARKEN BACK AS PART OF LARGER BURNED-IN AREAS.

TEST STRIP

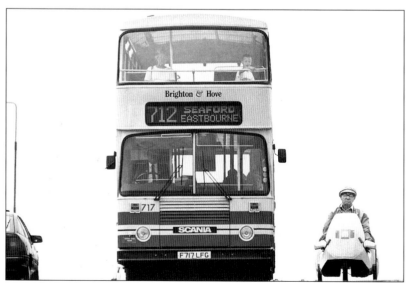

ORIGINAL PRINT

OVERLAY

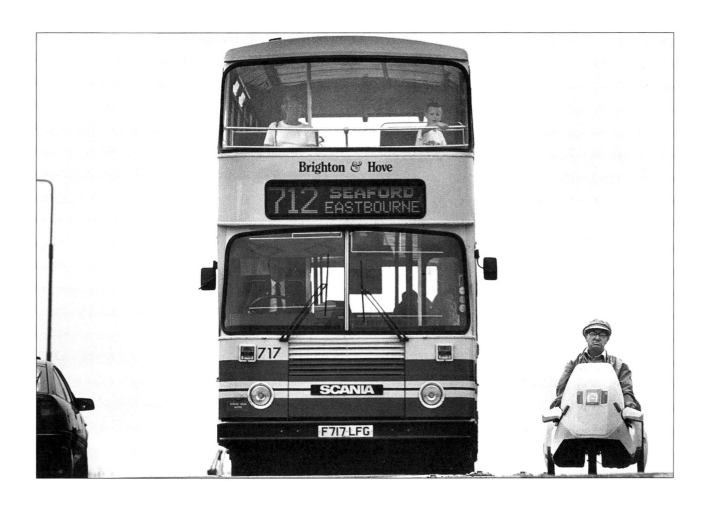

A WIDE WHITE BORDER HAS BEEN USED AROUND THIS PICTURE IN ORDER TO COMPLIMENT THE AIRY FEEL OF THE IMAGE. THE BLACK KEY LINE IS ESSENTIAL TO SEPARATE THE IMAGE FROM THE BORDER, AND ALSO SERVES TO GIVE A HIGH CONTRAST BOUNDARY THAT EXAGGERATES THE SOFTNESS OF THE PICTURE WITHIN.

HOT AIR BALLOON

Photographer: Jon Tarrant

Subjects such as this are difficult to photograph because the high contrast makes exposure a problem. Too much exposure would cause the logo on the balloon to burn-out, and too little would lose detail on the ground. Unless the camera exposure is right, detail will be missing from the negative - and can never be replaced. The same problem also applies at the printing stage, though here it is possible to split the exposures and so produce a print that is balanced for both extreme highlights and extreme shadow details.

PRINTING TECHNIQUES

It is useful to think of this picture in two parts, one comprising the balloon and sky, and the other the ground. Both can be printed at the same grade, using a fixed grade paper, but with very different exposures. Two test prints, made one each for the balloon and the ground, show the different correct exposures. All that needs to be done at the printing stage is to combine the parts into one print - an operation that is made easier by the fact that the night sky is fully black.

An alternative approach to printing this picture would have been to test for the ground and give this exposure overall, then burn-in the balloon area alone. The problem with this method is that the sky would not be totally black and burning-in the balloon would risk creating a black halo that gave the game away. One of the skills of a good printer is knowing how to work on a print without leaving any trace - something that, in this case, is much easier with a black background.

The third alternative, that of printing on a grade soft enough to show both highlight and shadow detail in a single exposure, just gives a flat lack-lustre picture. It is often the case that the contrast grade which prints the picture all at once is too soft for dramatic impact. Putting extra effort into a print, rather than settling for the easiest option, almost always gives a better result.

PRINT EXPOSED FOR BALLOON 10S GRADE 3.

PRINT EXPOSED FOR FOREGROUND 4S GRADE 3.

FINISHED PRINT HAVING BEEN GIVEN ONE EXPOSURE OF 4S THEN A SECOND EXPOSURE OF 6S TO TOP HALF OF PICTURE ONLY.

No Surrender

Photographer: John Downing

One of the challenges often faced by press photographers is that of trying to find a new angle on a well covered and long running story. In the case of the long-running miners' strike, many of the published pictures had concentrated on the immediacy of the picket lines and violent confrontations between the police and the miners.
An alternative approach is shown in this image, which uses much more subtle tactics to captures the tension and gloom that surrounded the story.

Everything is in the negative, but as a straight print the balance of the picture is all wrong. In particular, the bright highlights caused by the sun and its reflection in the wet road distract from the central elements. The printer's job is therefore to get the balance right and so create the most evocative final picture.
This photograph is a perfect example of how a well made print can "sell" the original negative. The printer's input isn't immediately obvious, but without it the photograph would fall far short of its potential.

PRINTING TECHNIQUES

A test strip made across the central part of the negative gave an optimum exposure of 5.7s on Grade 4 (separating the policemen from the sky whilst also making the writing on the wall clear, but not artificially so). Using such short exposures speeds the printing process - a very important factor in press darkrooms - and also makes burning-in much easier. It does, however, require greater accuracy in timing, hence the strangely exact 5.7s exposure time.

That said a simple single exposure print from this negative would have been made using a longer exposure time. This is because the print would be too light overall if exposed at 5.7s, though this time is actually the correct starting point for building up a burned-in image. It is very important to remember that the "best" test exposures differ with the style and amount of work that will be given to the final print.

Having found the base exposure, the sky was first burned-in overall then even more so in the area around the sun. The horizon to the right was heavily burned-in to subdue this potentially distracting area, after which the mirror image area of the sun was darkened. To complete the balance, the bottom part of the print was darkened, with the reflection of the lamp-post merging to black rather than being left to point straight out of the picture.

ORIGINAL PRINT

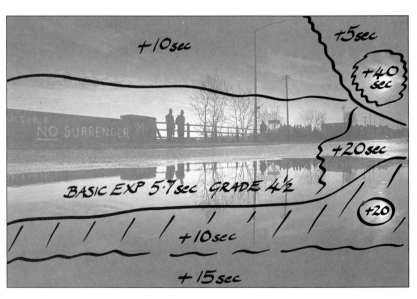

OVERLAY

80

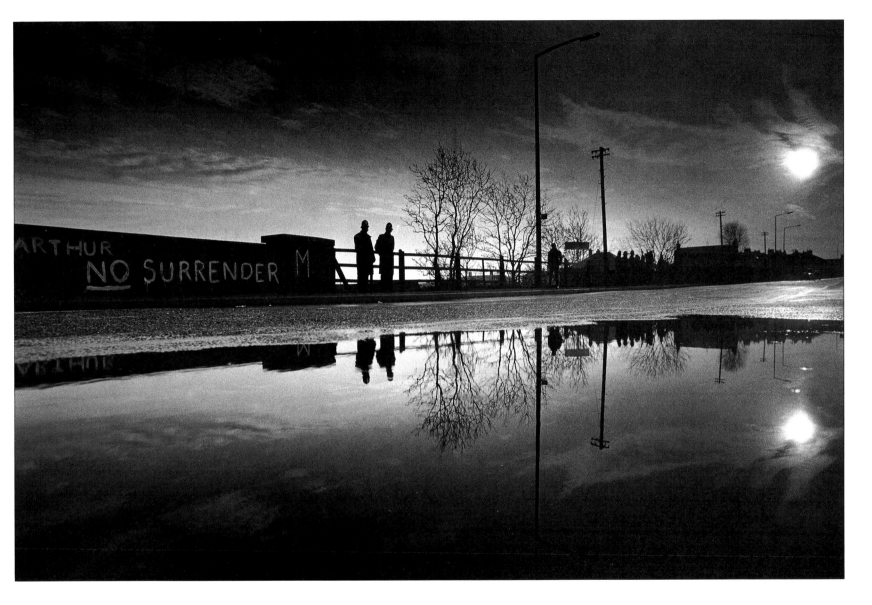

To burn-in the sun (both in the sky and reflected in the road), a white card mask was used. Card is better than hands in this case because the shape being worked on is very regular and small in size.

Although some people say that black card is best, in fact it is far easier to use white card. A hole should be punched using a biro that is rotated to give a smooth edge. The hole size should match the burn-in area when the card is held 8-10" above the baseboard. When burning-in, the mask can be aligned by judging the negative image seen on the white card. If using black card, alignment has to be judged by peering beneath to see the baseboard image which is unnecessarily awkward.

To prevent haloes, the card mask is raised and lowered, not shaken from side to side at a constant height. The reflection is burned-in with the mask held slightly lower to give a smaller (less flared) naturalistic effect.

THE PREACHER

Photographer: John Downing

OVERLAY

Another example of how a good association between printer and photographer helps to produce the very best result. The negative was exposed with emphasis given to the shadow areas, carefully developed, then printed to restore just the right amount of highlight detail. If the negative had been exposed differently, or printed by somebody who tried to give the image a different feel, the picture would have produced a poorer print.

PRINTING TECHNIQUES

As usual in portraits where there are distinct shadow and highlight sides of the face, the test exposure was found for the shadow area. This gave 5.4s at Grade 3. The first additional exposure was then used to balance the lighter side of the preacher's face and body with the darker side.

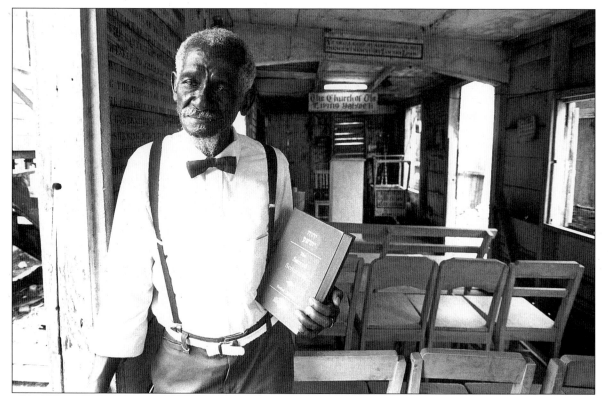

ORIGINAL PRINT

A HEAVY BURN-IN WAS GIVEN TO THE DOOR FRAME AND THE AREA OUTSIDE TO THE LEFT OF THE PICTURE, ALLOWING THE PREACHER'S SHIRT AND ARM TO DARKEN ALSO WHERE THEY CROSS THE DOOR FRAME. A DIAGONAL EXPOSURE WAS THEN APPLIED ACROSS THE BOTTOM LEFT OF THE PRINT, TAKING-IN THE BOOK, SHIRT AND LOWER AREA OF THE DOORWAY.

THE BACKGROUND WAS THEN BURNED-IN SEPARATELY, TAKING CARE TO ENSURE THAT THE FURTHER, SMALLER, DOORWAY TO THE RIGHT REMAINED VERY LIGHT SO AS TO BALANCE THE LARGER FOREGROUND AREAS.

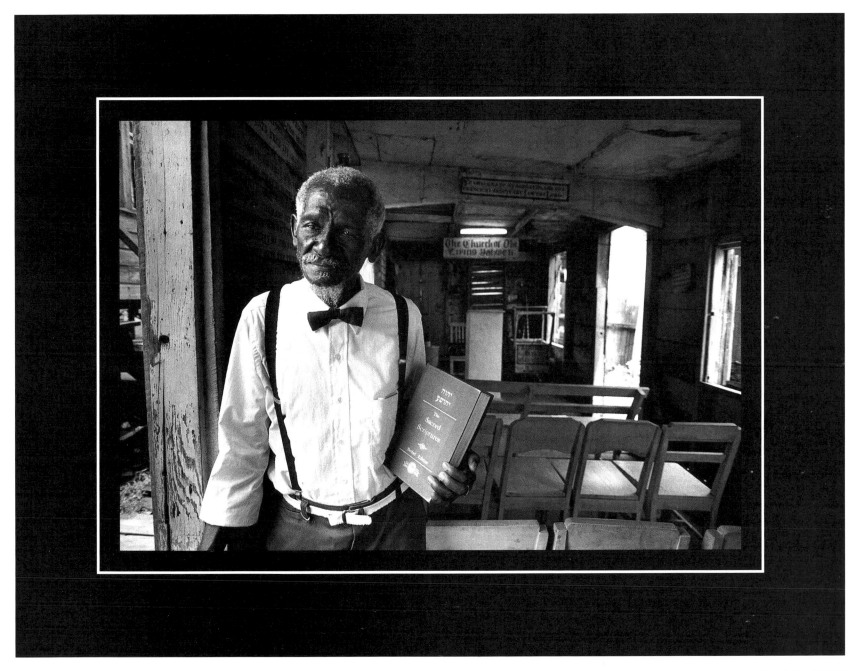

FINISHED PRINT

AFGHAN WITH DOVE

Photographer: John Downing

One of a series of images shot as part of an extended story on the warriors and tribesmen of Afghanistan. It is one of those negatives that just cries out to be printed - you can't wait to get it into the enlarger. As a straight print, it looks quite difficult to work on, but natural boundaries within the image make life much easier than it would be otherwise.

PRINTING TECHNIQUES

All parts of this print were exposed at Grade 3. The 8.4s basic exposure was determined for the face as a whole, there being no real "shadow side". To allow the Afghan's eyes to be lightened, the basic exposure was divided into two 4.2s halves, with the dodging done throughout the first of these. As usual, both eyes were dodged at once using a wire with two blobs of plasticine arranged at an appropriate spacing and held quite close to the enlarger lens.

The top of the print was darkened, going around the dove's head and through the man's hair, taking-in his hat with the background. The bottom of the picture was then darkened in two stages, starting from above the bird's head and down through the man's beard. After this, the man's wrists and shirt were burned-in, giving added weight to the very bottom of the image area and ensuring that the dove was the lightest part of the finished print. The result is an image that possesses luminance and gives greater significance to the white bird, while still looking natural.

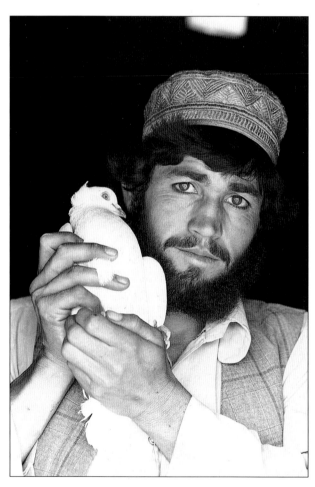

ORIGINAL PRINT

OVERLAY

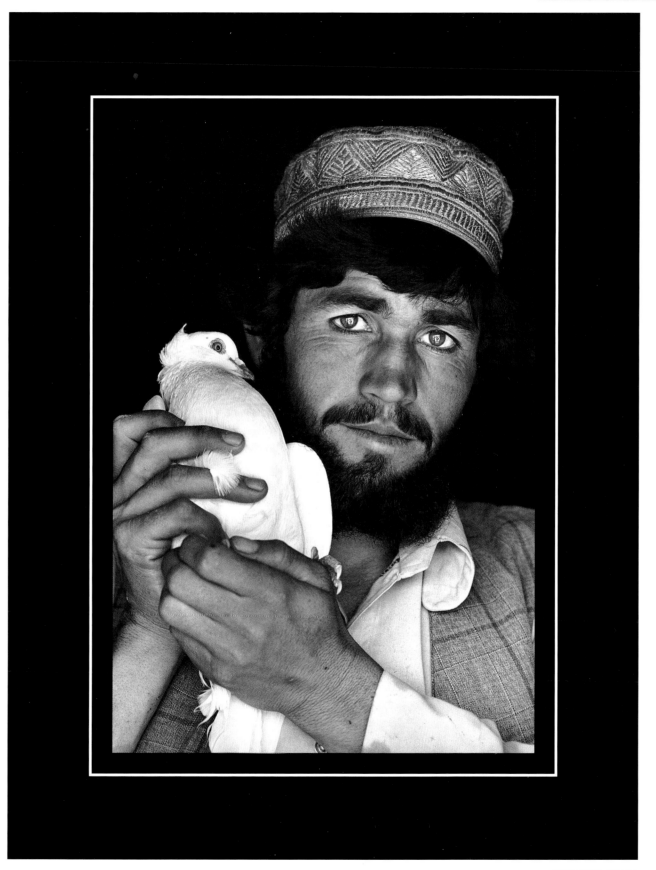

FINISHED PRINT

WALKING THE DOG

Photographer: Paul Massey

Another typical fashion photo-call, with a potentially promising subject weakened by a distracting background. Photographers often use long lenses at wide apertures to throw such backgrounds out of focus, but this can sometimes isolate the subject too much. In pictures such as this, where the street scene is important, isolation would have worked against the picture so it was necessary to leave playing-down the distractions until the printing stage.

PRINTING TECHNIQUES

Getting this print right is all about putting luminance into the image so that the umbrella glows with sunlight. A harder than usual grade was used (Grade 4) with the same contrast filtration applied to the whole image. Inevitably, this meant more burning-in, but the final result does justify the extra effort.

Importantly, it turns out that there are two ways of printing this image …

ORIGINAL PRINT

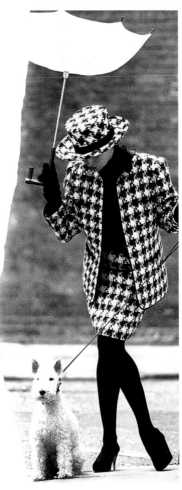

TEST STRIP

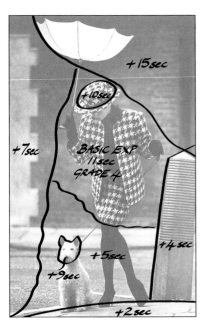

THE TEST AREA WAS BASED ON THE MODEL'S FACE, ACCEPTING THAT BECAUSE THIS IS A SHADOW AREA IT WOULD BE NECESSARY TO BURN-IN THE REST OF THE PICTURE. THE LEFT HAND SIDE WAS DARKENED TO TAKE THE WALL DOWN. TWO DIFFERENT TACTICS WERE TRIED HERE; ONE IN WHICH THE WALL WAS ONLY SLIGHTLY DARKENED USING THE HANDS AS A ROUGH MASK AND THE OTHER USING A CARD MASK THAT ALLOWED A GREATER DEGREE OF MORE PRECISE BURNING-IN (SEE OVERLEAF).

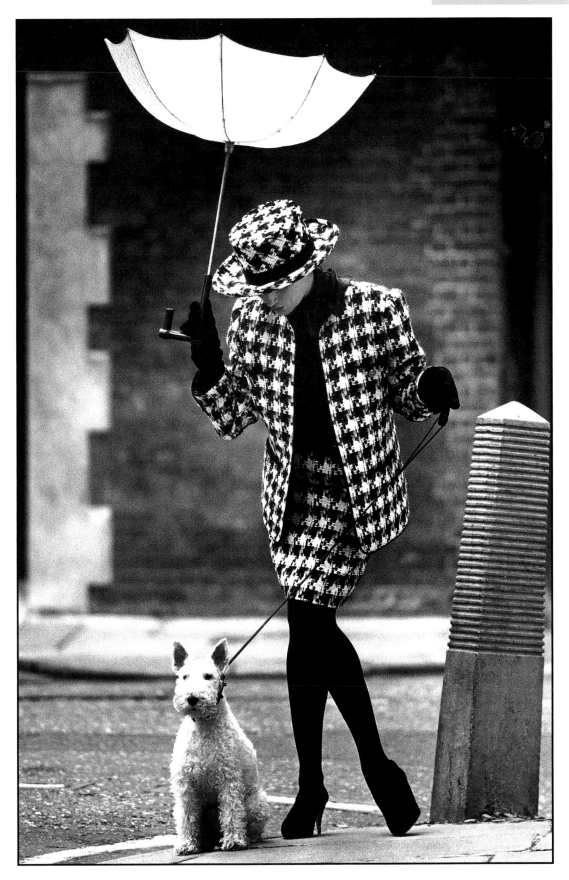

To produce this version, the working diagram shown opposite was used. After giving the basic exposure, the left hand side of the picture was darkened generally. The top right hand corner was then darkened to balance the left side and make the umbrella stand out against an almost black background.

The bottom third of the picture was darkened to build density after the slightly short basic exposure and also to balance the top of the picture. The very bottom of the frame was made darker still to provide a more substantial edge to the picture. Finally, local burning-in was applied to the bollard, the dog's face (to match the density of the woman's) and the model's hat.

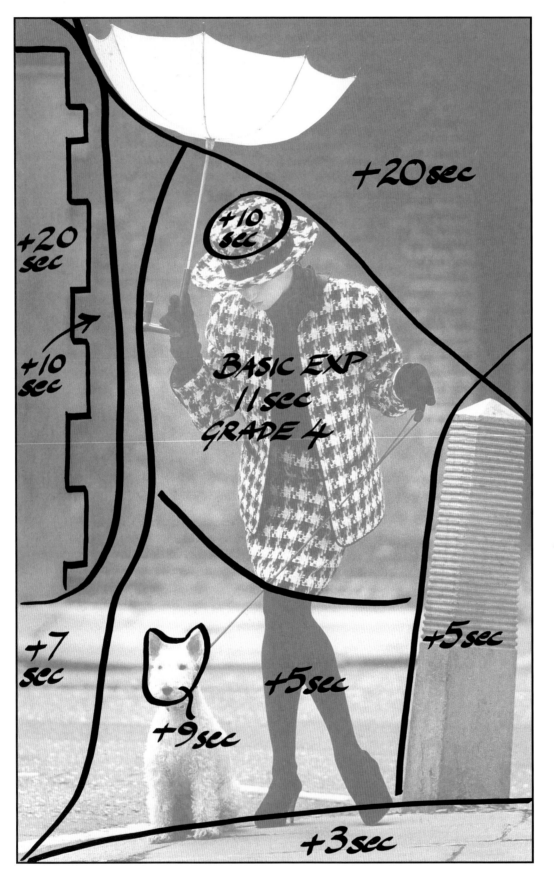

THE ALTERNATIVE METHOD FOR
DARKENING THE DISTRACTING
BACKGROUND WALL IS TO CUT A MASK
THAT ALLOWS JUST THE CRUCIAL AREA
TO BE DARKENED. THIS TECHNIQUE IS
EASIER TO CONTROL AND ALLOWS A
GREATER DEGREE OF DARKENING
THANKS TO THE PRECISION WITH WHICH
THE MASK CAN BE POSITIONED OVER
THE PRINTING PAPER.

IN USE, THE MASK IS SUPPORTED JUST
SLIGHTLY ABOVE THE PAPER IN ORDER
TO SOFTEN THE BURNED-IN BOUNDARY
TO MATCH THE OUT-OF-FOCUS SOFTNESS
OF THE BACKGROUND.

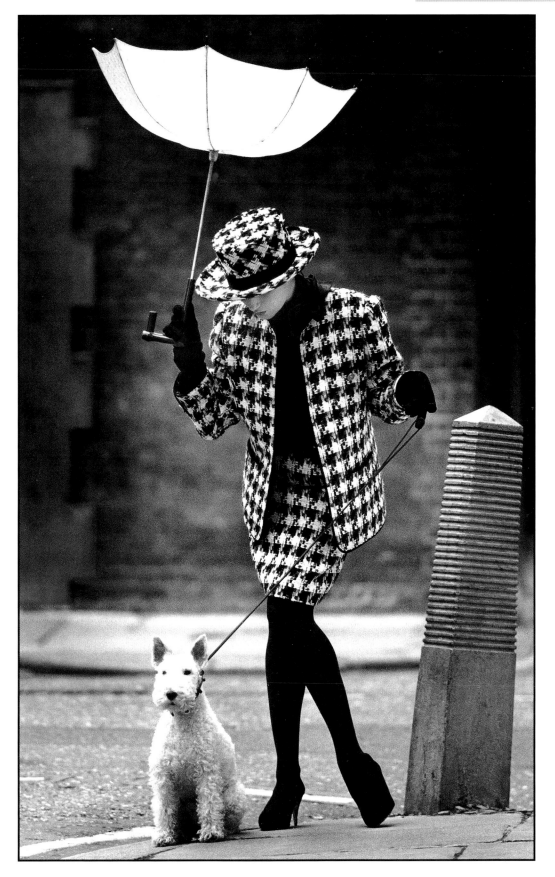

Having produced the final image in both its forms, with the two alternative methods of darkening the background wall, it is important to look at the results and ask which is the more successful. Were it just a matter of darkening the wall, the card would clearly have been more effective, but that isn't the end of the story. This picture contains a potentially unsettling mixture of angles, with the bollard leaning one way, the pavement sloping another and the line between the model and the dog pulling in a third.

The background wall therefore serves as a reference point, letting the viewer know that the picture has been correctly framed and allowing the angled lines to create interest without becoming confusing. In view of all this, the less severely darkened background is preferred.

89

COLLECTING COCKLES

Photographer: Colin Davy

This is the type of photograph that can be printed in many different ways - making it a particularly nice picture to work on. There is no need to rectify problems, instead it is all a matter of bringing out the atmosphere that is already present. The main intention was to soften the local brightness caused by the sun and replace it with a diffused bright horizon.

PRINTING TECHNIQUES

Scenes such as this often benefit from being printed in several different contrast areas, so variable contrast paper is essential. The test exposure was made at Grade 3, giving 4.4s as the time that matched the desired horizon brightness. Next, the foreground was substantially darkened, keeping the hands constantly moving to give a soft graduation. The very front of the picture, between the mass of shells and the edge of the frame, was then burned-in even more.

To create a suitably moody sky, the filtration was changed to Grade 5. An overall sky burn-in was followed by local darkening of the corners of the picture to focus attention within.

TEST STRIP

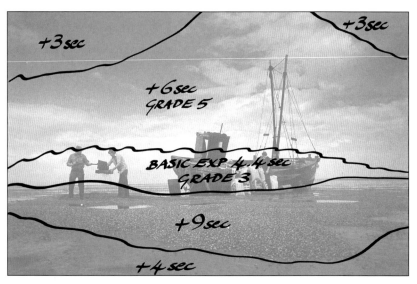

OVERLAY

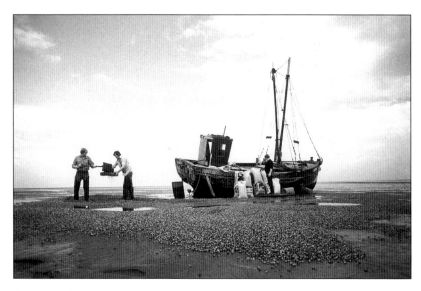

ORIGINAL PRINT

THE IMPORTANT THING ABOUT ATMOSPHERIC PRINTING IS THAT YOU MUST KNOW WHAT YOU WANT TO ACHIEVE BEFORE YOU START WORK ON THE PRINT. IT ALSO HELPS TO BE OBSERVANT OF THE REAL WORLD SO THAT YOU KNOW WHAT ELEMENTS ARE NEEDED TO CREATE THE DESIRED EFFECT.
WHILE THE PRINT DOESN'T HAVE TO MATCH THE NEGATIVE, IT DOES HAVE TO LOOK CONVINCING!

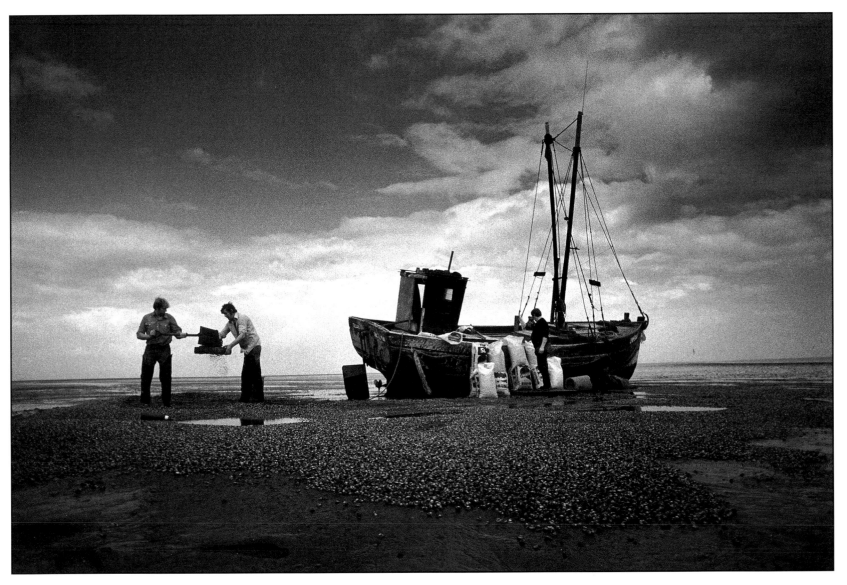

FINISHED PRINT

SHOREHAM CHIMNEY

Photographer: Roger Bamber

The last remaining chimney from the former Shoreham power station. It was shot through a deep red filter to emphasise the drama of the sky. In the print, this drama has been recognised and enhanced. A minor change has been introduced by lightening the centre of the sky, and darkening the area to the right, to make the sun seen more central in the image.

PRINTING TECHNIQUES

To create the necessary drama, high contrast grades are needed. The test strip was made at Grade 4 and was adjusted to give the best shadow detail in the base of the chimney. Because the sun comes from behind, it is natural for the chimney to be dark - though not too dark at the testing stage because it will darken further when the sky is burned-in.

For the sky, contrast was increased to Grade 5 and an overall 7s exposure given to almost the entire area, following the line of the cloud base but leaving a central area unaffected to provide a natural highlight. The top of the chimney was included in this exposure. The right hand sky area was darkened in two stages to compensate for the increasing brightness nearer to the true position of the sun. Holding the hands very close to the enlarger lens has ensured soft edges to these burned-in areas. Finally, the left hand side of the picture was burned-in to balance. During this operation, the lines of the clouds were used as natural boundaries in order to emphasise the formations.

Although the chimney works well darkened down, some printers might prefer to keep it lighter. To do this, rather than burning-in the sky around it, the best approach is to dodge the tower during the initial exposure, to make it artificially light, then let it darken again when the overall sky exposure is given.

OVERLAY

ORIGINAL PRINT

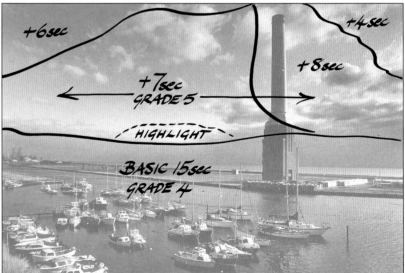

OVERLAY

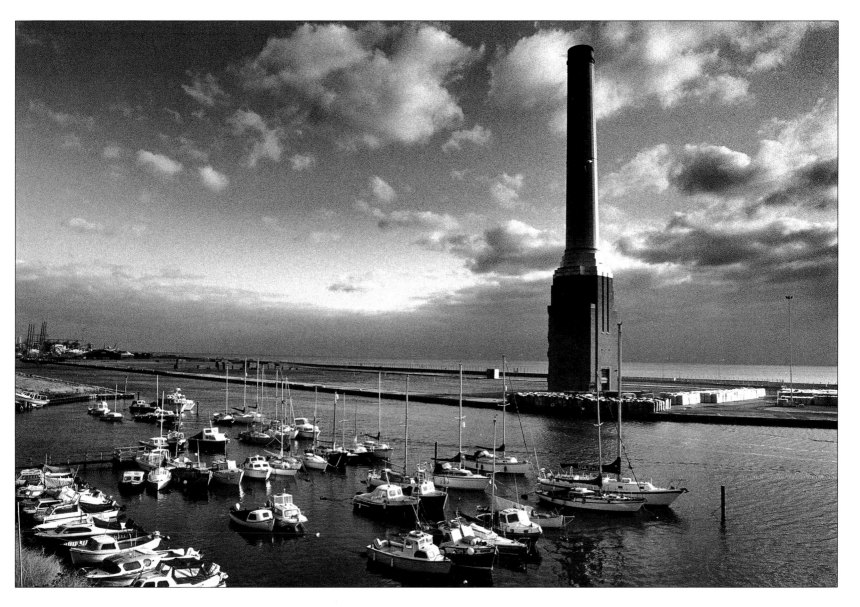

AN INTERESTING PROBLEM ARISES
WITH THE SMALL HIGHLIGHT ON THE
STACK IN THIS PICTURE. THE SPECK
IS ACTUALLY A SEAGULL AND
THEREFORE BELONGS IN THE
PICTURE, BUT COULD EQUALLY WELL
BE SPOTTED OUT IF THOUGHT TO
LOOK TOO MUCH LIKE AN
IMPERFECTION ON THE FILM.

ON THE NEXT TWO PAGES, THREE
"NEAR MISS" VERSIONS OF THIS
PRINT ARE SHOWN.

93

THIS PICTURE WAS PRINTED AT GRADE 4 THROUGHOUT. THE BOTTOM OF THE CHIMNEY STACK IS A SHADE LIGHT BUT OTHERWISE EVERYTHING IS TECHNICALLY CORRECT. DESPITE THIS, THE PRINT LOOKS BLAND.

HERE, CONTRAST IS RIGHT BUT DENSITY IS WRONG. THE PRINT IS TOO DARK OVERALL, CAUSING THE HIGHLIGHTS AND CLOUDS TO GO GREY. COMPARED TO THE FINISHED PRINT ON THE PREVIOUS PAGE, THIS ONE LACKS SPARKLE.

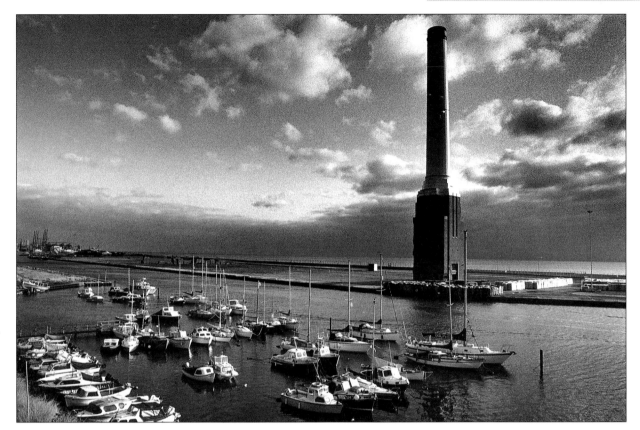

This is an example of over-printing. By taking the print slightly too dark, while keeping a good central highlight, the apparent contrast has been increased – but in a way that looks distinctly artificial.
The sky is out of balance and the print seems altogether unconvincing.

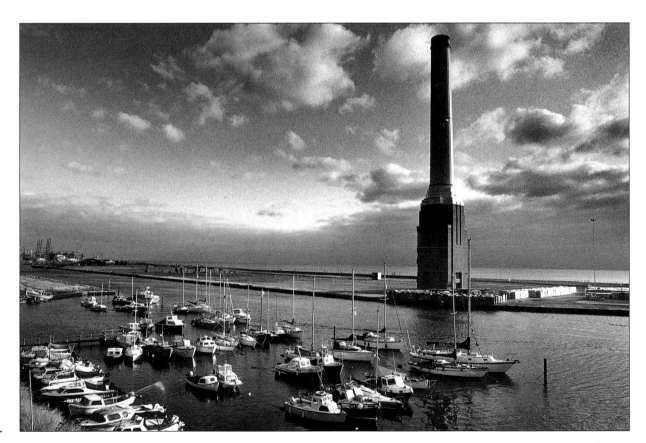

Once again, the correctly balanced, finished print, shown here for comparison with the 'near miss' versions.

CHARIOT ON BEACH

Photographer: Roger Bamber

This picture was shot on a bright sunny day and had no detail in the sky whatsoever. While the picture is dramatic just as a semi-silhouette against a white sky, it can be made even more striking in combination with an appropriate cloud formation. Fortunately, the photographer had such a sky that had been shot on the same type of film (to ensure consistent grain and sharpness between the foreground and background).

PRINTING TECHNIQUES

If the foreground had been a true silhouette, the combination print would have been very easy, with the foreground image printed to black and the background superimposed on top. In this case, however, there is detail that must be retained, making the combination slightly more complicated. Although two enlargers were used to print this picture, it could still have been done, albeit slightly less conveniently, with just one. In both cases, the method is similar.

The easel was first set to give required composition with the foreground negative, which was test printed as usual (using Grade 3 filtration). This exposure served only as a rough guide because, since the foreground was not solid black, the second negative's exposure would also affect the first's. If the picture had been printed using just one enlarger, the head height and lens aperture would have been noted at this stage. A baseboard drawing was then made of the first negative's image, particularly noting the position of areas of visible detail, before moving the easel to the second enlarger (or placing the second negative in the negative carrier).

The sky negative needed to be framed to have a white area (dense part of the negative) over the important foreground details. Since the negative used didn't quite fit the required composition, hand shading was required. Grade 4 filtration was selected and the sky tested using the previously exposed foreground print. There was no point testing the sky on a virgin sheet of paper since, as has already been noted, the foreground exposure would contribute to the sky's density. Adjustments to the density of the foreground and background were made after checking this test print.

ORIGINAL PRINT

ORIGINAL PRINT

Eight sheets were then exposed using the foreground image negative, with slight darkening used for the pebbles at the bottom of the picture. These sheets were then marked, to show their right way up, and boxed for subsequent over-printing with the sky negative. While it shouldn't take all eight attempts to get a good print, it is much better to have spare sheets than either to settle for a poor print or to have to keep returning to the first negative.

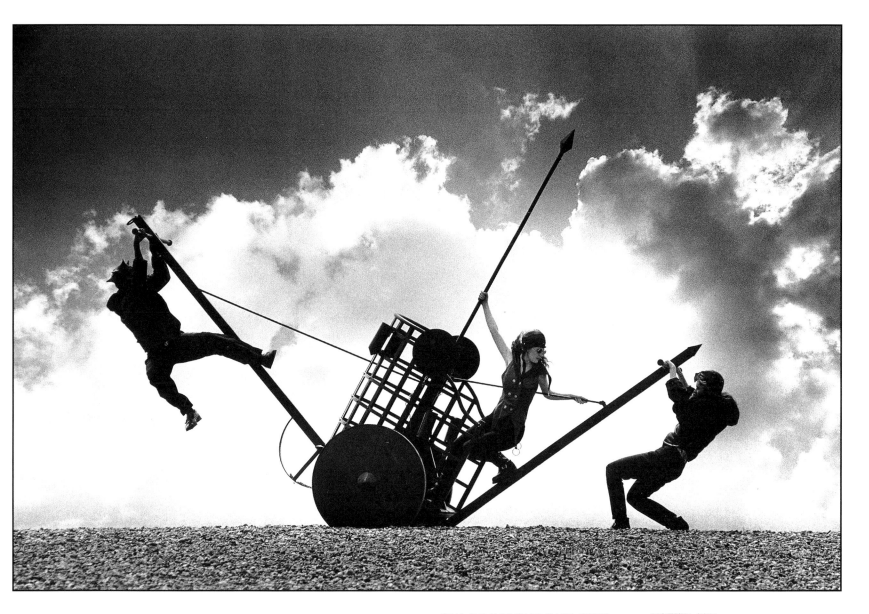

IT IS IMPORTANT TO NOTE, WHEN
USING VARIABLE CONTRAST PAPER,
THAT THE TWO NEGATIVES DON'T
HAVE TO BE EXPOSED AT THE SAME
GRADES. THIS ALLOWS AN ELEMENT
OF CONTROL NOT AVAILABLE WITH
FIXED GRADE PAPERS AND IS AN
ESPECIALLY GOOD REASON FOR
USING SUCH MATERIALS WHEN
MAKING MULTI-PART PRINTS.

USEFUL TIP

ANY SLIGHT MISMATCH IN THE
EDGES OF COMPOSITE PICTURES
SUCH AS THIS, CAUSED BY SLIGHT
MISALIGNMENTS WHEN THE PAPER
IS INSERTED INTO THE EASEL FOR
PRINTING THE TWO PARTS OF THE
IMAGE, CAN BE DISGUISED BY
DRAWING A BOX LINE AROUND
THE IMAGE.

CHAMPION BOXER

Photographer: Tom Stoddart

Shot only by natural lighting, this portrait of the WBO light-middleweight boxing champion Duke McKenzie conveys feelings of both physical power and mental concentration. It was taken using a Leica M6 rangefinder camera.

PRINTING TECHNIQUES

The straight (Grade 2) print taken from the original negative shows good rendition of skin tones, but clearly needs work in highlight areas to bring out the necessary detail. It might be tempting to switch to a softer printing contrast, but this would be wrong as it would weaken the skin tones. In fact, it was a harder contrast, not a softer one, that was used to make the final prints.

THE BASIC EXPOSURE WAS SPLIT INTO TWO HALVES, WITH THE BOXER'S EYES DODGED FOR ONE OF THESE STAGES. THE BRIDGE OF HIS NOSE WAS GIVEN AN EXTRA EXPOSURE TO BALANCE THE TONES OF THE FACE, AND HIS HAND WAS DARKENED SLIGHTLY TO STOP IT COMPETING FOR ATTENTION. THE TOWELLING WAS DARKENED IN TWO STAGES, ONE TO THE LEFT AND THE OTHER TO THE RIGHT, USING A CREASE IN THE TOP OF THE HOOD AS A NATURAL PRINTING BOUNDARY. FINALLY, THE DARK BACKGROUND WAS MADE TOTALLY BLACK.

HAVING PRODUCED THE FINISHED B&W PRINT, IT WAS THEN DECIDED TO TRY A TONED VERSION. THIS COULD NOT BE DONE USING THE PRINT ALREADY MADE BECAUSE THE LARGE AREAS OF DELICATE HIGHLIGHT DETAIL WOULD HAVE BEEN DESTROYED IN THE BLEACH. A SECOND PRINTING SCHEDULE WAS THEREFORE DEVISED, USING PRE-FLASH TO GIVE THE HIGHLIGHTS THE REQUIRED BASE DENSITY AND MAKING THE PRINTING EXPOSURES AT A HARDER CONTRAST (GRADE 3) TO MAINTAIN IMPACT. THE AMOUNT OF PRE-FLASH USED WAS ABOUT 50% MORE THAN WOULD BE APPROPRIATE FOR A PLAIN B&W PRINT, CAUSING THE HIGHLIGHTS TO LOOK SLIGHTLY GREY. DURING THE TONING, THIS GREYNESS CLEARED TO GIVE THE FINISHED RESULT SEEN HERE.

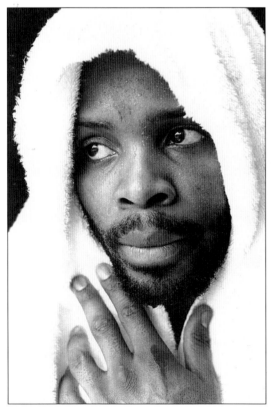

ORIGINAL PRINT

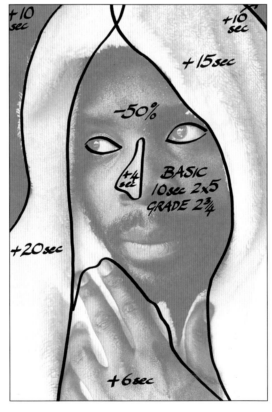

OVERLAY

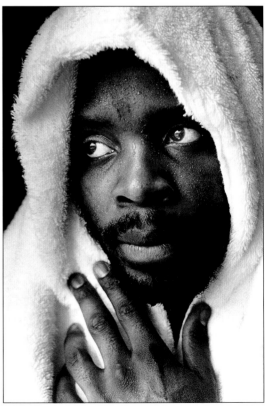

FINISHED B&W PRINT

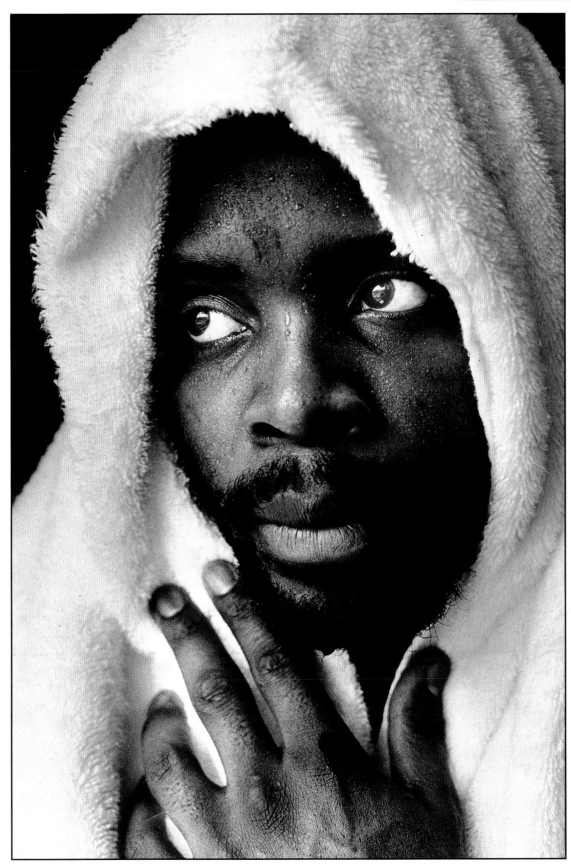

USEFUL TIP

AS WITH OTHER PICTURES WHERE DEEP BLACKS ARE USED FOR DRAMATIC EFFECT, THE PRINT WAS BRIEFLY BATHED IN THE THIOCARBAMIDE TONER BATH FOR ABOUT 5S BEFORE BLEACHING. THIS TECHNIQUE PROTECTS HIGH DENSITY AREAS AND SO PREVENTS A LOSS OF D-MAX DURING TONING. THE BLEACHING TIME USED HERE WAS ABOUT HALF THAT REQUIRED FOR THE FULL EFFECT, AFTER WHICH THE PRINT WAS RETURNED TO THE TONER BATH TO REVEAL THE FINAL IMAGE COLOUR.

FINISHED PRINT

THE SINGER

Photographer: Roger Bamber

S hot by available light in a small jazz club. The haze is evaporating sweat coming from the singer Ian Dury's body. As often happens with concert lighting, hard shadows have been cast. In this case, a particularly unfortunate shadow falls across the eye and cheek, losing detail in the straight print.

PRINTING TECHNIQUES

As an exception to the usual tactic, the basic exposure was found not for the critical shadow area, but rather for the rest of the face, with subtractive printing (dodging) was used to lighten the shadow.

The basic exposure was found to be 6s, which was then broken down into two 3s parts. During the first of these, an irregularly shaped dodger was moved up and down through the line of the shadow. Constant movement was used to prevent the shape of the dodger being seen on the print.

The extreme left and right areas of the print were darkened to blend the image into the black border. This created a more intimate atmosphere and gave more shape to the steam cloud.

TEST STRIP

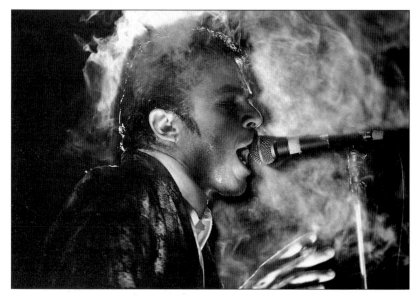

ORIGINAL PRINT

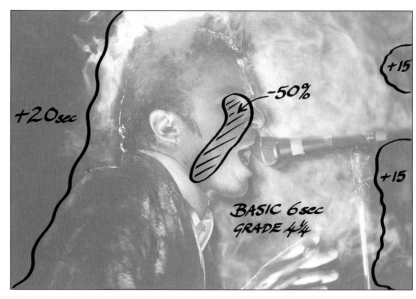

OVERLAY

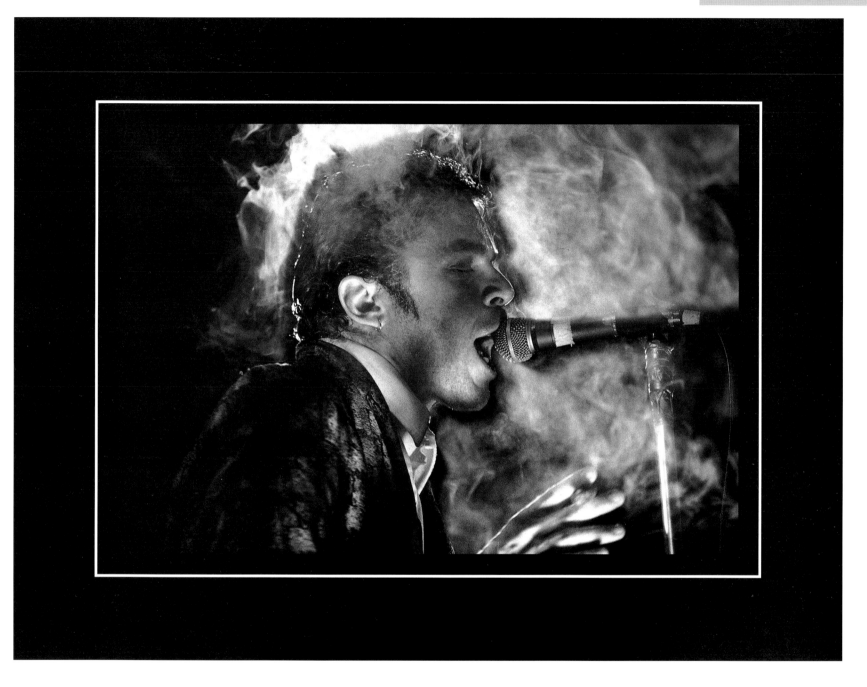

A LINE OF SWEAT SEEN RUNNING DOWN THE SINGER'S CHEEK WAS RETOUCHED ON THE FINISHED PRINT TO REMOVE THIS POTENTIAL DISTRACTION. THE MICROPHONE CABLE WAS DARKENED BY RETOUCHING FOR THE SAME REASON.

RETOUCHING IS OFTEN JUST THOUGHT OF AS SOMETHING THAT IS USED TO REMOVE DUST AND BLEMISHES FROM THE PRINT, BUT IT IS IMPORTANT TO REMEMBER THAT IT CAN ALSO BE USED AS A LAST RESORT TO "BURN-IN" AREAS THAT CANNOT BE TREATED UNDER THE ENLARGER.

Tree Warden

Photographer: Jon Tarrant

This picture stemmed from a pictorially uninspiring local newspaper story about a resident who had written numerous letters to his council complaining of vandalism to trees in a nearby park. The brief was to photograph the man with a huge pile of letters, but this seemed less appropriate than recording the damage itself. Although an entire roll was exposed, there was only one frame with the dog looking on from the corner of the picture. Without this element, the picture lacks depth and interest.

PRINTING TECHNIQUES

The straight print, made at Grade 2 as usual, shows a total lack of detail in the sky. This is a common sight with some types of film (in this case, Kodak Tri-X) where sky detail that exists on the negative fails to show on the print. Burning-in is used to reveal this detail, though the problem that then arises is how best to handle objects that cross the horizon and extend into the sky area, where poor burning-in causes either a halo around the object or undue darkening within it. In this case, it is relatively easy to make a suitable mask by protruding the thumb of one hand from behind the outstretched other, as shown in the diagram.

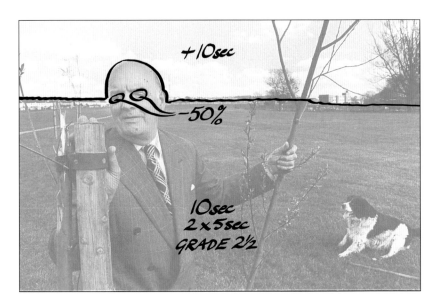

OVERLAY

ORIGINAL PRINT

TONED PRINT SUFFERING FROM BORDER STAINS

FINISHED PRINT

The final print was made at Grade 2, with the basic exposure split into two halves, allowing the man's eyes to be lightened in the process. The sky area was burned-in, using hand masking, for an additional 10s. No attempt was made to mask the twigs that cross the sky area: masking on such a fine scale is very difficult and rarely justifies the effort involved.

Although for newspaper use a strong b/w print is all that is needed, this image clearly benefits from gentle toning. Unfortunately, the first print that was toned suffered from severe staining in the border areas (due to incomplete fixing). The second print was therefore refixed and rewashed before toning, giving totally clean white borders as a result. Since the toning procedure used involved pre-bathing the prints in thiocarbamide solution before bleaching, it was at this stage that the border staining became apparent. Had the prints been placed directly into the bleach, the staining would not have been seen until the final thiocarbamide bath.

IN SOME INSTANCES, SUCH AS THE STAINED PRINT SHOWN HERE, THE IMAGE COLOUR PRODUCED BY TONING MAY BE ATTRACTIVE EVEN THOUGH THE PRINT ITSELF IS, TECHNICALLY, A FAILURE. WHEN THIS HAPPENS, IT IS SOMETIMES POSSIBLE TO MOUNT THE PRINT BEHIND A CARD WINDOW SO THAT ONLY THE IMAGE AREA IS VISIBLE. IF THE EFFECT IS PARTICULARLY ATTRACTIVE, BUT THERE IS A DANGER OF THE IMAGE FADING OR DETERIORATING IN SOME OTHER WAY, THE PICTURE SHOULD BE COPIED ONTO TRANSPARENCY FILM FOR FUTURE REFERENCE.

MOTHER & CHILD

Photographer: Tom Stoddart

This is a well balanced, almost timeless, image, that manages to convey a strong sense of suffering without any resort to unsubtle devices. It was shot on Ilford XP2 because this film can be processed through minilabs that are to be found almost everywhere in the world. A conventional b/w film would have been less convenient to process: colour was not appropriate to the photographer's treatment of the subject.

PRINTING TECHNIQUES

The important thing with this image is to give priorities to the elements within the picture. One way to do this is by darkening the various areas, but this causes those parts to become "muddy" through a loss of contrast. A far better technique is to darken the areas around the important elements.

Testing gave 8.5s on Grade 4 as the best balance for the mother's and the child's faces. To subdue the mother's face, the adjacent areas of wall were then darkened slightly. Working down the print, from top to bottom, the bed linen was next darkened by giving a 3s additional exposure. This may seem very short for a highlight burn-in, but XP2's highlights are much less dense than conventional b/w films'. The bottom of the picture was then taken-down in two stages. First, 4s was given to the valance of the bed. Then, 5s was given to the cat and floor.

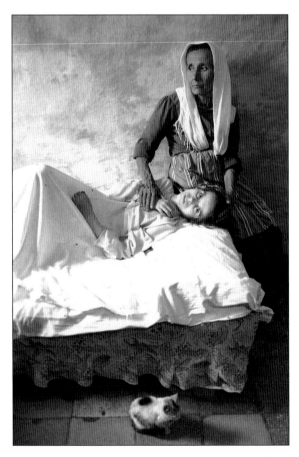

ORIGINAL PRINT

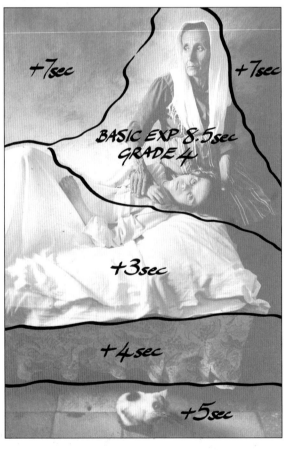

OVERLAY

A GOOD QUESTION HERE IS TO ASK WHY THE FLOOR AND VALANCE WERE DARKENED SEPARATELY WHEN A SINGLE 4S EXPOSURE FOR BOTH, FOLLOWED BY JUST 1S FOR THE CAT AND FLOOR, WOULD SEEM EASIER? THE ANSWER IS THAT BY TREATING THE AREAS INDIVIDUALLY, A SUBTLE HIGHLIGHT BOUNDARY HAS BEEN CREATED BETWEEN THEM. THIS HELPS GIVE THE PICTURE MORE DEPTH BY STOPPING THE VARIOUS ELEMENTS MERGING INTO ONE ANOTHER. SUCH HIGHLIGHT BOUNDARIES ARE THEREFORE NOT PRINTING MISTAKES, BUT USEFUL DEVICES FOR IMPROVING THE LOOK OF AN IMAGE.

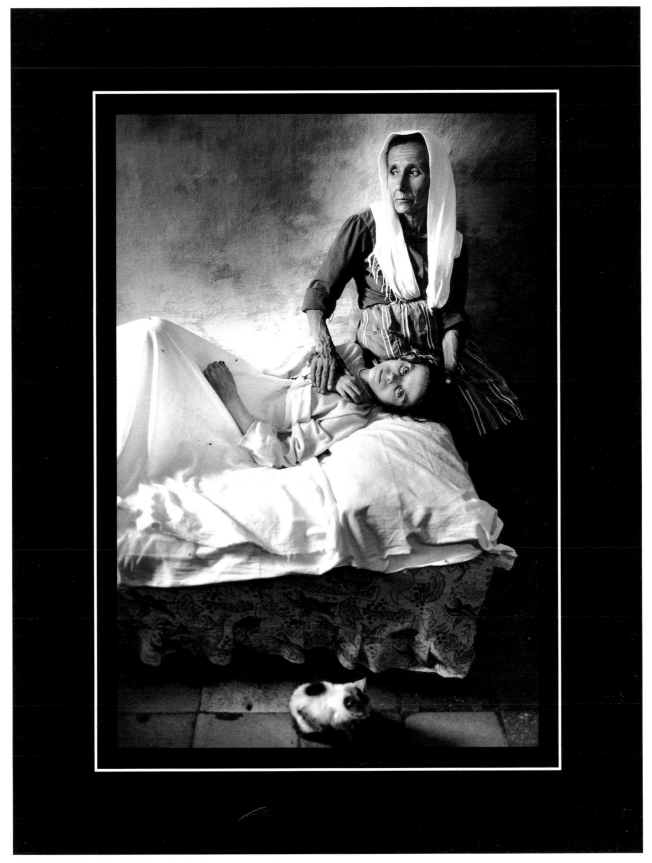

FINISHED PRINT

POWER BOAT

Photographer: John Downing

Dramatic boating pictures are usually shot from close to sea-level and often focus on spray caused as a massive hull slices through the waves. Here, a totally different approach has been adopted; the angle is over-head, the boat is small in the picture and the sea is graphic rather than realistic. In printing an image such as this, it is therefore especially important to appreciate what the photographer has envisaged and to work in sympathy with this intention.

ORIGINAL PRINT

PRINTING TECHNIQUES

THIS IS NOT AN EASY PICTURE TO ASSESS FOR PRINTING. THE PROBLEM IS THAT THE SEA HAS HIGH LOCAL CONTRAST WHEREAS THE BOAT DOES NOT. AN AVERAGE IMAGE, AS SHOWN IN THE STRAIGHT PRINT, LOOKS TOTALLY WRONG - DESPITE BEING IN ACCORDANCE WITH THE NORMAL RULES OF MAINTAINING DETAIL IN BOTH SHADOWS AND HIGHLIGHTS. ASIDE OF ANY IMAGE CONSIDERATIONS, ONE REASON FOR THIS FAILURE IS THAT THE STRAIGHT PRINT IS THROWN OFF-BALANCE BY THE WHITE BORDER USED.

A TEST WAS THEREFORE DONE USING GRADE 5 FILTRATION ON BLACK-BORDERED PAPER. THIS HAS TRANSFORMED THE PICTURE INTO A GRAPHIC IMAGE, BUT THE CONTRAST IS A SHADE TOO HIGH AND THE HIGHLIGHTS OF THE SEA TOO LIGHT.

TO DARKEN THE SEA WITHOUT AFFECTING THE BOAT, A CARD MASK WAS CUT TO FIT THE BOAT'S OUTLINE AND HELD A LITTLE WAY ABOVE THE PAPER FOR HALF OF THE BASIC EXPOSURE. HOLDING THE MASK ONLY SLIGHTLY ABOVE THE PAPER HAS GIVEN AN APPROPRIATELY HARD EDGE TO THE DODGED AREA.

TEST STRIP

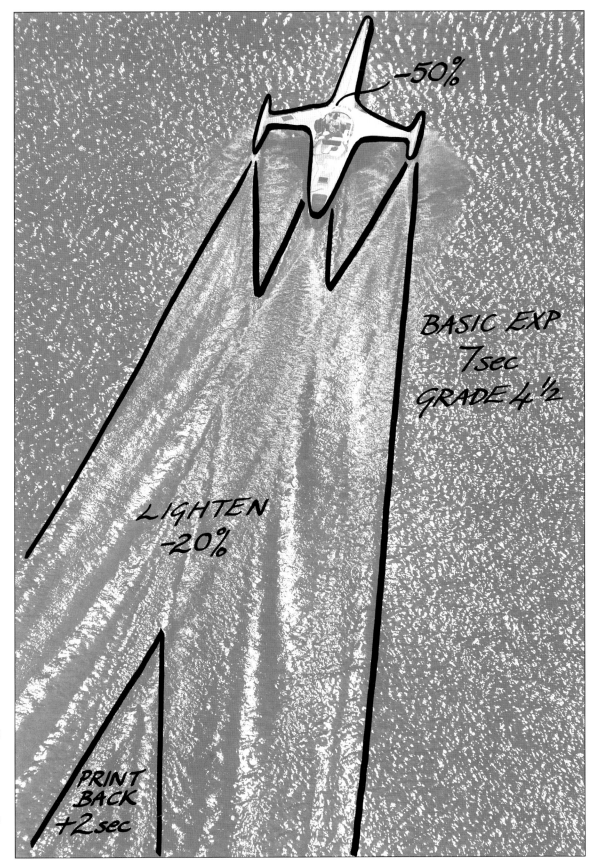

-50%

BASIC EXP
7sec
GRADE 4½

LIGHTEN
-20%

PRINT
BACK
+2sec

DURING THE SECOND HALF OF THE BASIC EXPOSURE, THE CENTRE OF THE WAKE BEHIND THE BOAT WAS SLIGHTLY LIGHTENED. THE BOTTOM LEFT CORNER OF THE PRINT WAS THEN SUBSEQUENTLY DARKENED TO GIVE THE WAKE A MORE DEFINITE 'V' SHAPE.
SEE OVERLEAF FOR ILLUSTRATIONS OF HOW THIS WAS DONE, AND THE FINAL EFFECT PRODUCED.

OVERLAY

CUTTING CARD MASK TO USE AS DODGING TOOL.

USING CARD MASK TO DODGE BOAT.

DODGING THE BOAT'S WAKE WITH MOVING HAND.

BURNING IN CENTRE OF WAKE AFTER DODGING.

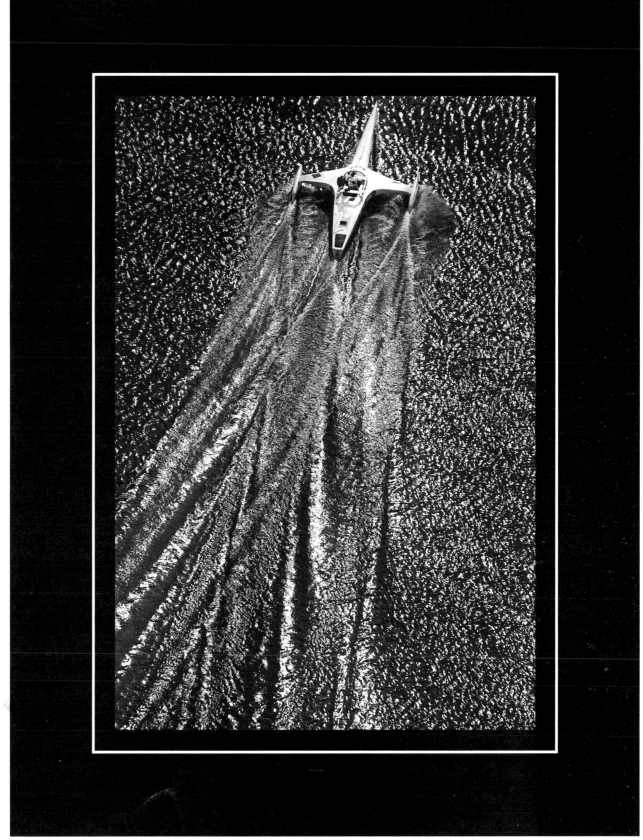

In the final print, the sea has an inky blackness that some people may say looks artificial, but this is hardly surprising given that the overall effect is meant to be more graphic than natural. As is also the case with several other example images in this book, by leaving aside preconceptions of naturalism it is possible to create very much more impactful pictures than would be possible otherwise.
And impact, of whatever sort, is what printing is all about.

GIRL ON A MOTORCYCLE

Photographer: Chris Bennett

Shot by a photographer who is better known for pictures of military jets, Formula 1 motor-sport and off-road rallying, this picture was taken during a session testing ideas intended for a series of posters.
Although this frame is the photographer's favourite, it was one of the others that got accepted by a poster company and turned into a limited edition print.

PRINTING TECHNIQUES

In the original negative, the picture area is very much divided into two parts: the girl is in the top half and the motorcycle is in the bottom half. Because of this, the picture lacks direction. Is it a photograph of a girl with a motorcycle, or of a motorcycle with a girl? By cropping the image, this question is easily answered. A secondary effect of the squarer crop is that it makes the composition appear more strongly off-centre, even though the position of the girl's head across the width of the picture is actually exactly the same as it was in the full-frame image.

The basic exposure was tested for the face skin-tones, bearing in mind that these needed to be darker than usual to allow for slight bleaching during toning. The areas of wall in the background were darkened individually, and the entire bottom section was burned-in to add weight to the print. The natural line provided by the girl's arm was used as the edge of the burned-in area, with the bright handlebars included in the darkening. Finally, the area of wall to the bottom right of the picture, where a brake cable is visible on the straight print, was darkened to solid black in order to remove this potential distraction. The finished print density was such that before toning there were no areas of clear white in the picture.

Toning was done using three baths; one bleach and two toners. The bleach used was a standard sepia type, in which the print was bathed for a short time until the mid-tones had been affected but keeping the blacks solid. After thorough washing, the print was then toned in a proprietary (one bath) blue toner. This affected the unbleached areas of the image and was followed, after washing, by a weak thiocarbamide toner that affected the bleached areas. It was essential to use the second toner very diluted, otherwise it would have removed the blue colour from the previous stage.

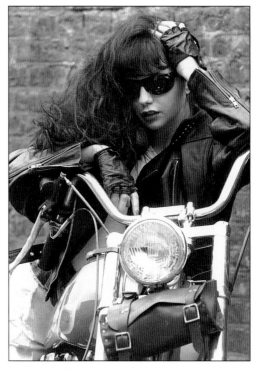

ORIGINAL PRINT

+10sec

+6sec

BASIC EXP 8 sec GRADE 3½

+7sec

+30sec

OVERLAY

110

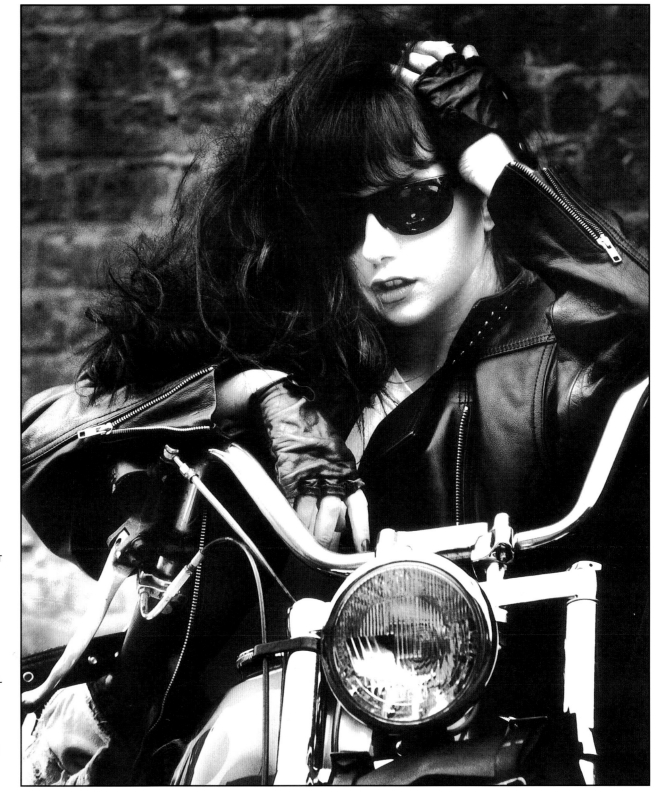

DOUBLE TONING IS A VERY HIT AND MISS AFFAIR, MAKING IT ABSOLUTELY IMPOSSIBLE TO PRODUCE REPEAT PRINTS. IN THIS CASE, TWO PRINTS WERE TONED AT THE SAME TIME: THE ONE SHOWN HERE WAS A GREAT SUCCESS, BUT THE OTHER WAS SO DISMAL THAT IT WAS IMMEDIATELY CONSIGNED TO THE BIN. BECAUSE OF THE DIFFICULTY OF MAKING TONED PRINTS, IT IS ESSENTIAL THAT EXTREME CARE IS TAKEN AT ALL STAGES OF PROCESSING SO AS TO ENSURE GREATEST QUALITY AND LONGEVITY OF THE FINAL IMAGE. EVERY TONED IMAGE IS UNIQUE AND, THEREFORE, ESPECIALLY PRECIOUS.

BATTERSEA DOGS' HOME

Photographer: John Downing

L ike many press photographs, this negative showed a cleverly conceived and well composed image, but one that was made less inspiring by flat natural light. This image is a particular favourite, both for its quirky treatment and the fact that the final picture owes so much of its success to the collaboration between photographer and printer.

PRINTING TECHNIQUES

Looking at a straight print, it is obvious that the negative contains a series of natural boundaries that can be used to separate differently burned-in areas. It is also obvious that the base exposure will be critical if detail is not to be lost in the dog's right eye. As is often the case in such prints, the test exposure that is "correct" on its own may not be correct when additional burning-in exposures have been applied to other areas of the picture. This is because, no matter how carefully you work, some stray light will always scatter into unwanted areas when doing burning-in. In this case, the original test exposure was about 8s, reducing to 7s for the fully worked-on print.

Variable contrast paper and dial-in multigrade filtration were used for the print in order to obtain an intermediate Grade 3¼. With slot-in filter packs it is only possible to fine-tune contrast down to half grades, and with fixed grade papers the steps are, of course, even wider. Although there are processing tricks that can be used to adjust print contrast, using variable contrast papers and dial-in dedicated multigrade heads is the easiest method of working.

Following the natural lines within the picture, the first burn-in was given from above the top line of writing and around the dog's head up to the top of the image. A heavier burn-in was then given to the bottom part of the photograph, extending from below the top line of writing to the bottom edge. It is important to note that the top line of writing has therefore not been burned-in at all, whereas the bottom line was darkened with the lower part of the image. This has emphasised the "Battersea Dogs Home" text and created a highlight underlining those words. In the printing process, these two burn-ins constituted the second intermediate print (after the first overall test).

It was then apparent that the sky areas needed further darkening and that the right hand edge of the print needed to be made slightly more solid to hold attention over the important parts of the picture. These changes were made to produce the third intermediate print. Finally, on the fourth print, an additional burn-in was given to the top left sky area so that it balanced the opposite corner.

ORIGINAL PRINT

TEST STRIP

OVERLAY

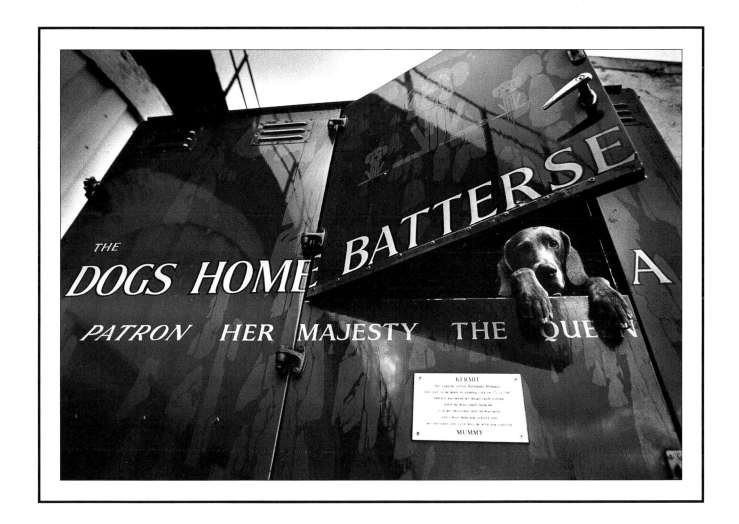

FINISHED PRINT

Young Warrior

Photographer: John Downing

Shot as part of an extended project on the Mujahadeen Afghan fighters (see also 'Afghan with Dove', page 84), this negative was very nearly perfect as-shot, yet is still significantly improved with just the most subtle printing work. It is sometimes the simplest things that make the difference between a good photograph and a great print. Here, it was a matter of lightening the boy's eyes slightly and lightening the first finger of his left hand, which otherwise disappears into shadow.

PRINTING TECHNIQUES

With two dodging operations to be performed, it is easiest to split the base exposure into two stages and dodge one area each time. Obviously, the total dodged time cannot exceed the overall exposure. In this case, the base exposure (tested to give the best skin tones) was 8s on Grade 4¼ which automatically gave the correct balance between highlight and shadow tones.

Two tools were made for performing the dodging. The eyes were lightened together using one piece of thin wire with two blobs of

plasticine on it. The wire was held about 12" above the easel and kept short to ensure that the blobs could be accurately aligned with the baseboard image. Long pieces of wire that oscillate from side to side are useless for this purpose, causing haloes around the eyes. Slight movement is needed to soften the edge of the dodged area, but this should always be under careful control rather than being due to an inability to keep the wire still.

The finger was lightened similarly, using a piece of plasticine moulded to cover the desired area. The wire was held slightly lower for this stage to create a harder boundary between the dodged and undodged areas, which was more desirable in this case.

ORIGINAL PRINT

TEST STRIP

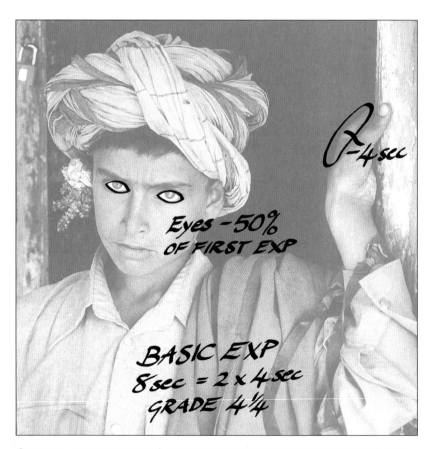

OVERLAY - ONLY PRINTING ADJUSTMENTS REQUIRED WERE IN THE TOP HALF.

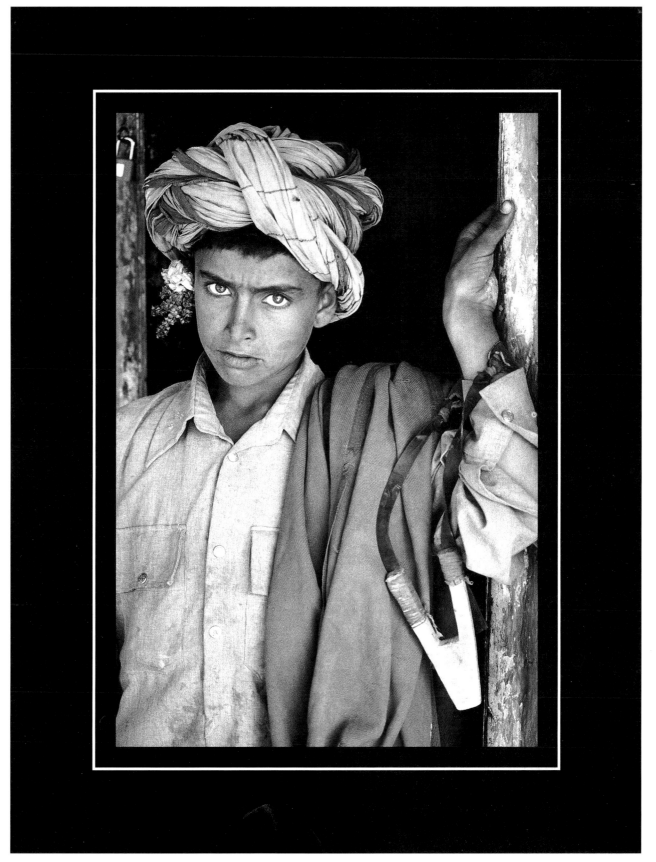

FINISHED PRINT

Portrait of a Miner

Photographer: John Downing

Nothing is wrong with the original negative in this case - the background is uncluttered, the crop is perfect and there are no distractions within the frame. And yet, a good print can still improve the image further. In this case, the print is a less natural, but much more dramatic, version of the portrait.

Printing Techniques

To emphasise the gritty skin texture and coal dust, a hard grade of paper (Grade 4) was chosen. As usual, the test exposure was made looking for the best separation of tones and detail on the shadow side of the face. This turned out to be 10s, which was then split into two 5s components to allow dodging of the miner's eyes throughout the first half of the base exposure. The wire of the dodging tool was bent to follow the line of the miner's head and hard hat. Although it is possible, and often advised, to avoid shadows from the burning-in tool by keeping the wire moving, this isn't a viable method when burning-in both eyes at once.

After the base exposure, the highlight side of the face was darkened to balance the shadow side. (Note that the two sides were not made equally dark, but rather brought to an acceptable and pleasing difference in brightness.) The back of the miner's head, his jacket, helmet and the right hand edge of the picture were all then burned-in. A distracting area under the miner's left eye was darkened, and the print finished-off by balancing the two sides of the print (one having been given a single 25s exposure, and the other 10s + 15s).

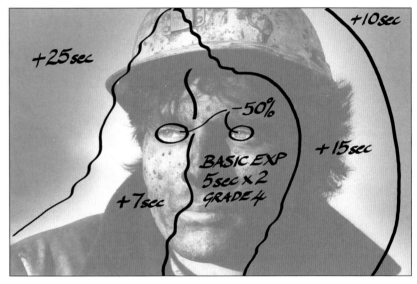

OVERLAY

THIS PRINT IS A GOOD EXAMPLE OF HOW TECHNICAL AND ARTISTIC ASPECTS CAN SOMETIMES PULL AGAINST EACH OTHER. SPECIFICALLY, THE HALO AROUND THE MINER'S FACE IS NOT A PRINTING ERROR, BUT A DELIBERATE ATTEMPT TO MIMIC STUDIO RIM LIGHTING. IT IS POSSIBLE THAT SOME VIEWERS, WHO CONCENTRATE ONLY ON TECHNIQUES, COULD BE MISLED INTO ASSUMING THAT THE HALO IS A FAULT. IN FACT, THE FAULT COMES IN VIEWING THE PRINT WRONGLY, FOR TECHNICAL CORRECTNESS SHOULD ALWAYS BE SECONDARY TO ARTISTIC CONSIDERATIONS.

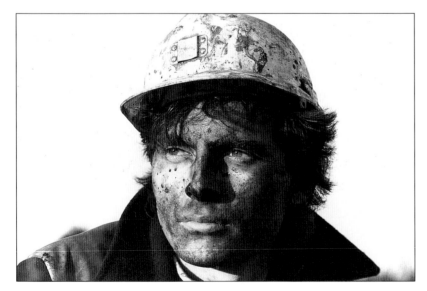

ORIGINAL PRINT

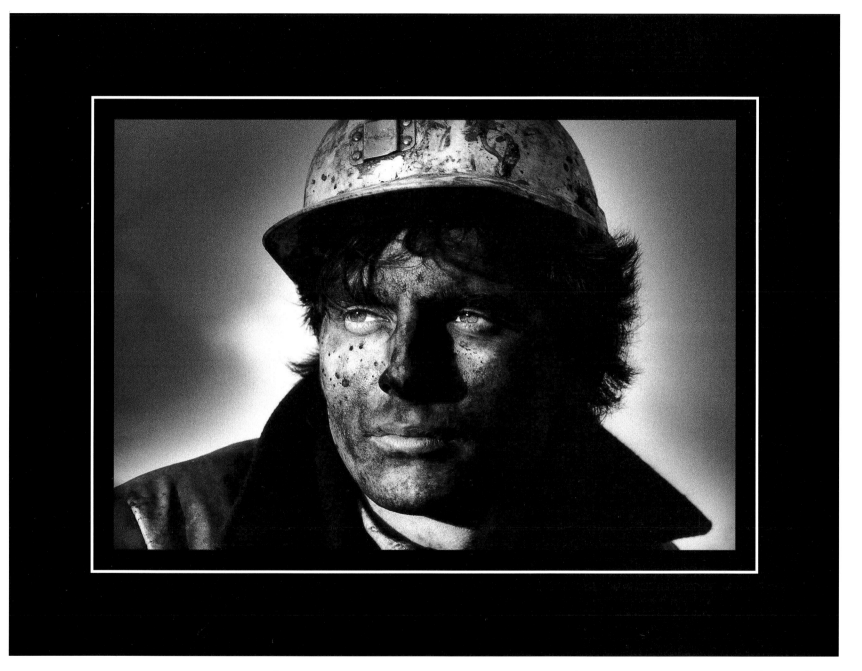

FINISHED PRINT

CHINESE GYMNAST

Photographer: Tom Stoddart

An available light action picture taken as part of a major photo-essay about a school in China that trains the country's young gymnasts. It was shot on uprated Ilford HP5 Plus with a Leica M6 rangefinder camera.

PRINTING TECHNIQUES

This picture's low contrast and abundance of dark tones makes a hard grade of paper the best choice for dramatic results. At first sight, using high contrast filtration might seem at odds with the brightness of the window in the picture, but to base the entire print on what is actually only a secondary element would be a mistake. Although it is very small, the glimpse of face seen under the girl's arm is the critical part of the image and it was for this area that the exposure was determined.

After the 10s initial exposure, during which the girl's face was held back very briefly, the entire picture to the left and right of the gymnast had to be darkened further. In both cases, this darkening was done following the lines of the girl, allowing a printing highlight to create a slight halo. The floor was cropped slightly, and the remaining area darkened to lend weight to the bottom of the picture while keeping a pool of light into which the gymnast appears to be jumping.

The window was burned-in in three stages. The same Grade 4 contrast was used throughout, making the bars stand out boldly and keeping the outdoor scene very light. While this lightness could possibly be seen as a distraction, it creates a strong sense of drama and also holds attention within the room as there is nothing recognisable to be seen outside.

ORIGINAL PRINT

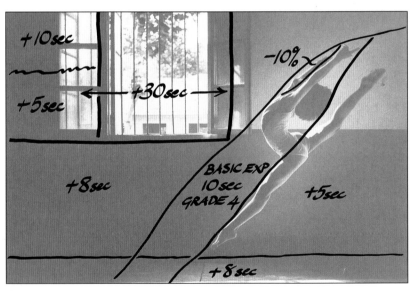

OVERLAY

118

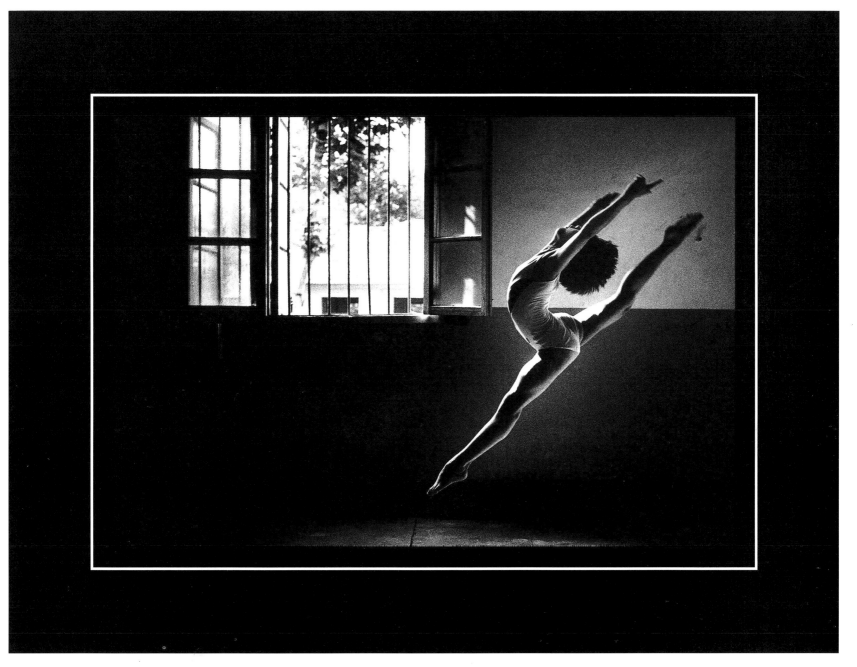

In two respects, this print breaks what are usually deemed to be unbreakable rules of photographic printing: there is a halo around the subject and there are clear whites in the window. But it is important to remember that the primary intention when making prints is to create the best possible final image, not simply to follow all the rules. Here, the rules have been broken deliberately, not by accident, nor by a lack of printing skill. Provided that the final image is pleasing and has impact, then the print is a success - regardless of how many rules it breaks.

CONCORD OVER LONDON

Photographer: Paul Massey

Sometimes it just isn't possible to shoot the picture you want in camera. In this case, Concord was to make a low fly-past over London, but even so would still be very small in the picture. It was therefore decided to photograph the aircraft and the cityscape separately.

As is usual when shooting composite pictures, the same film was used for both parts of the image, though there was a complication in this case because Concord was shot with the camera upright and the cityscape on landscape format. It is also very important to note that although the background behind Concord is totally black, that behind the skyline isn't: careful blending is needed if the two images are to be combined into a convincing final print.

PRINTING TECHNIQUES

Because the two negatives required printing at very different magnifications, it was not really practical to attempt this print with just one enlarger. Similarly, the difference in contrast between the two negatives meant that fixed grade prints would inevitably

have been inferior to those obtained using the variable contrast paper used here. It is also important to note that the black borders used on the picture were pre-printed onto the paper, and that all test images were made using these prepared sheets.

The two negatives were loaded in separate enlargers and masked off using the film carrier blades. The masking was arranged so that the Concord sky extended almost down to, but not overlapping, the top of the cityscape buildings. A carefully drawn baseboard sketch was used to check the positions of the two negatives.

The cityscape negative was tested to get the minimum acceptable exposure that gave a good darkness but still left the edges of the buildings visible against the night sky. The Concord negative was tested to give maximum black in the sky. Grade 5 was used to provide a graphic black, but meant burning-in the front of the aircraft. As the only area of overlap between the two prints is black sky, there was no contributory effect of one negative's exposure on the other's. This meant that the tested exposures should be correct for the final print.

CONCORD

LONDON

OVERLAY

120

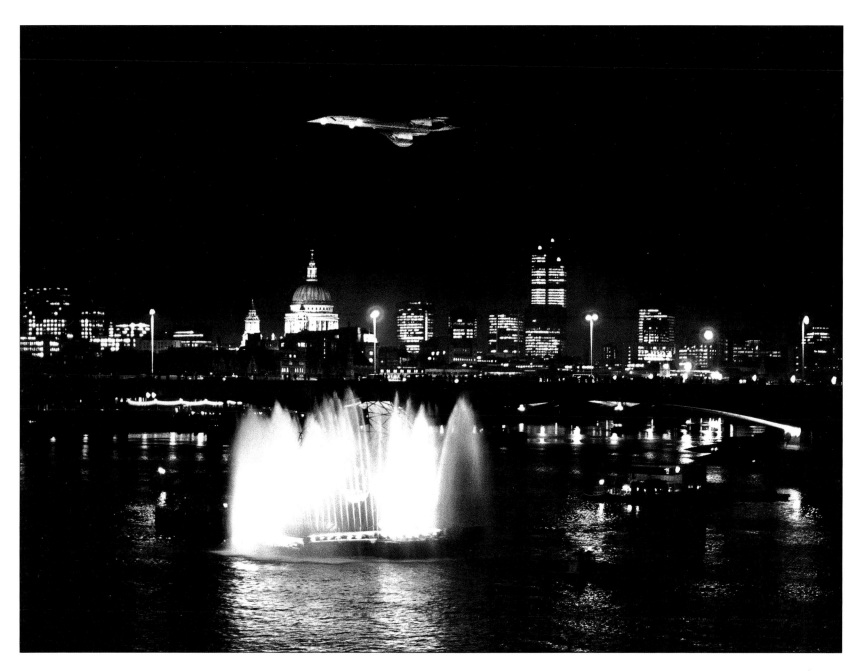

A FIRST ATTEMPT AT THE COMPOSITE WAS DONE BY SIMPLY PRINTING THE TWO NEGATIVES ONE AFTER THE OTHER WITH NO SPECIAL TREATMENT OTHER THAN TO BURN-IN THE FRONT OF THE AIRCRAFT. WHILST THIS PICTURE LOOKED GOOD, IT WASN'T PERFECT. THE PROBLEM WAS THAT THE BOUNDARY BETWEEN THE TWO PARTS OF THE PICTURE WAS A STRAIGHT LINE THAT COULD BE SPOTTED IF THE PRINT WAS EXAMINED CAREFULLY. RATHER THAN TRYING TO FADE THE STRAIGHT LINE BOUNDARY, WHICH WOULD STILL LOOK ARTIFICIAL, IT WAS DECIDED TO BURN-IN AREAS OF SKY BETWEEN THE BUILDINGS SO THAT THESE LOCAL PATCHES BLENDED TO BLACK. HAVING DISRUPTED THE BOUNDARY, THE FINISHED IMAGE BECOMES MUCH MORE CONVINCING. UNFORTUNATELY, THIS PARTICULAR PICTURE CAN NEVER BE TOTALLY PERFECT OWING TO THE DIFFERENCE IN GRAIN STRUCTURES, CAUSED BY THE DIFFERENT NEGATIVE ENLARGEMENTS BETWEEN THE CITYSCAPE AND THE AIRCRAFT.

FINISHED PRINT

ORPHAN

Photographer: John Downing

This picture was shot as part of a picture story on the lives of South American children. From the outset, the negative clearly had great potential, but equally clearly needed careful work to get a print that lived up to this potential.

PRINTING TECHNIQUES

The negative shows interesting detail present in large areas of both highlight and shadow, suggesting that a low to medium printing contrast should be used. Unfortunately, this conflicts with the fact that a higher contrast will give a more dramatic picture. Given the enormous potential of this picture, the harder grade was chosen and very careful attention paid to the balance between highlights and shadows.

To make the perfect print, the image was first tested across the centre of the picture taking in the boy's face, the window highlight at the end of the corridor and the shadow area on the adjacent wall - the most crucial area being the shadow side of the boy's face. A test print was then made of the entire image using variable contrast paper at Grade 2 filtration. Although this print was a

good compromise for the highlight and shadow areas, the overall result was definitely too flat.

A second test print was therefore made using Grade 4 filtration. This was just a little too hard, so the dial-in filtration was reduced to Grade $3\frac{3}{4}$. In the days before variable contrast paper, this process would have been far less simple, having required at least two separate boxes of paper and probably two different print developers. For the record, had continuous dial-in filtration not been available, the print would have been made using a Grade $3\frac{1}{2}$ slot-in filter.

The first burning-in operation was to darken the highlight side of the boy's face to balance the shadow side. This was done using an

TEST STRIP

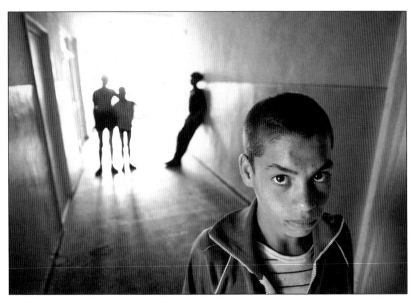

ORIGINAL PRINT

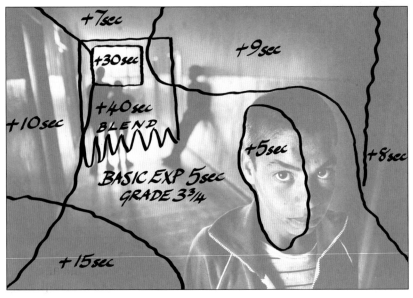

OVERLAY

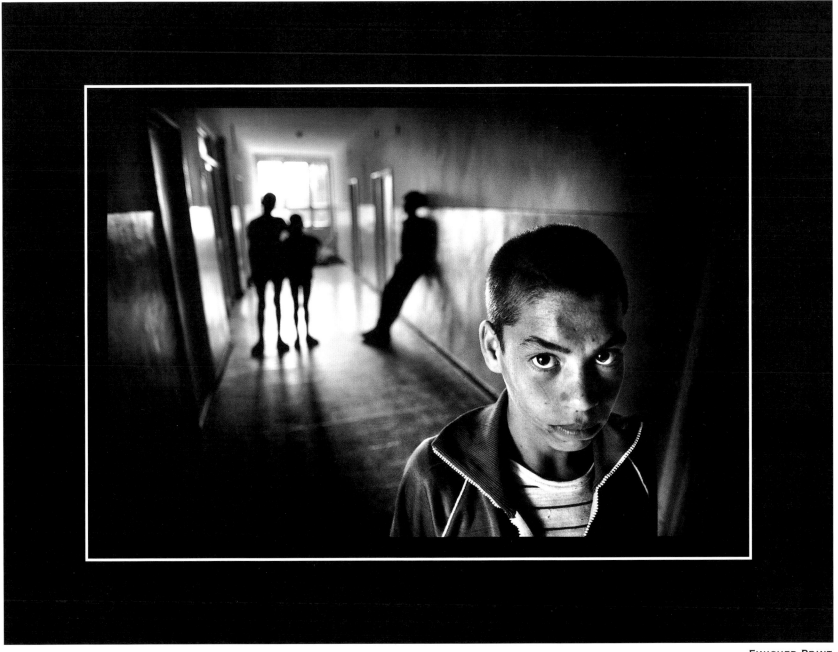

exposure equal to the base exposure. (There was no need to dodge the boy's eyes as they were bright enough already.) Next, attention was turned to the window at the end of the corridor, and its reflection in the floor. A 40s exposure was needed to start to show detail in this area. The floor including the distant boys' legs was shaded with rapid hand movements to provide a natural fade around the burned-in area. The window itself was then given a further 30s exposure to strengthen the lines of the frame and reduce, but not totally remove, the outdoor highlights. The distant ceiling was darkened to contrast with the window and floor. The left hand wall was similarly darkened, though it was important not to lose detail or make the print too heavy on that side, except in the very bottom corner, which was blended to total black. In the top right corner, an area shaped around the boy's face was darkened, with a second additional exposure given to the door frame. It is important that the door area isn't made totally black as this would ruin the balance of the finished print.

To see how even minor variations on this printing scheme can have a major effect, compare the finished print above with the "near misses" shown on the following two pages.

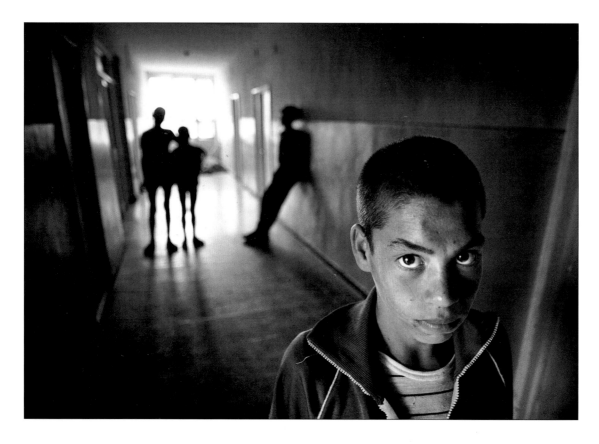

THIS PRINT IS SLIGHTLY LACKING IN CONTRAST AND IS POORLY BALANCED. THE WINDOW IS TOO BRIGHT, THE LEFT HAND SIDE IS TOO DARK AND THE RIGHT HAND SIDE TOO LIGHT.

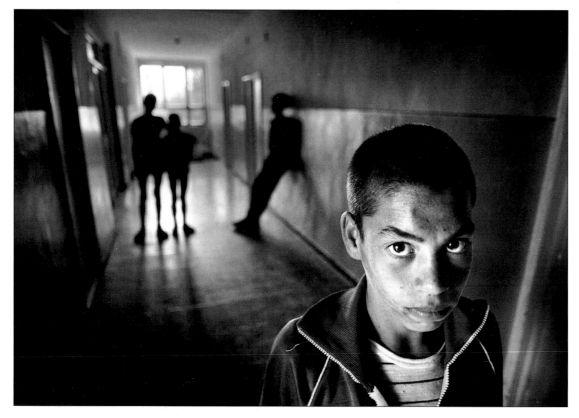

OVER-DARKENING THE WINDOW CREATES AN OBVIOUS AREA OF GREYNESS THAT IS ALWAYS A SIGN OF BAD PRINTING, AS SEEN HERE. THE CEILING ABOVE THE WINDOW IS TOO LIGHT, AS IS THE RIGHT HAND SIDE OF THE PRINT.

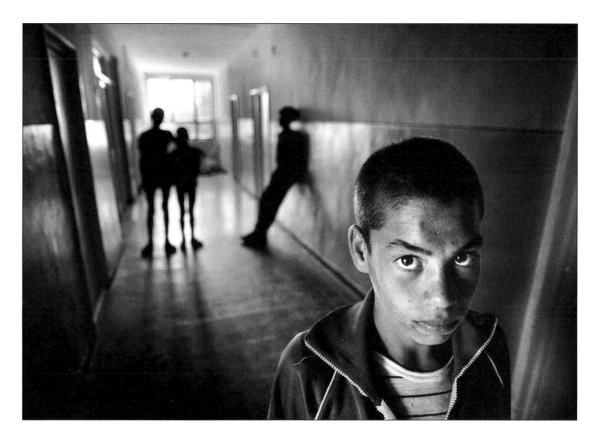

SOMETIMES, AS IN THIS CASE, A SLIGHTLY DIFFERENT BALANCE CAN CREATE A REASONABLE RESULT THAT COULD EASILY BE CONSIDERED ACCEPTABLE BY SOME VIEWERS. THE SHADOWS ON THE FLOOR ARE PARTICULARLY NICE HERE. WEAK POINTS ARE THE CEILING AND RIGHT HAND SIDE OF THE PRINT, BOTH OF WHICH ARE TOO LIGHT.

THE VERY FIRST BURNING-IN STAGE, THAT OF BALANCING THE SIDES OF THE BOY'S FACE, IS NOT RIGHT IN THIS PICTURE - THE HIGHLIGHT SIDE OF THE FACE HAVING BEEN LEFT TOO LIGHT. THE WINDOW IS ALSO TOO LIGHT. THE BOTTOM LEFT CORNER IS TOO DARK AND THE DARKNESS EXTENDS TOO FAR UP THE WALL. AS IN ALL THE OTHER "NEAR MISSES", THE DOOR FRAME IS TOO LIGHT.

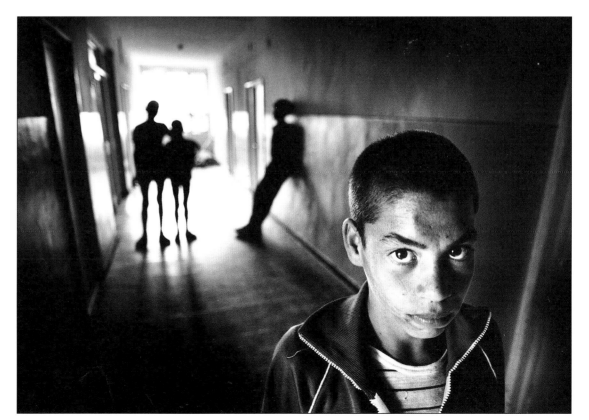

PUB WINDOW

Photographer: Bryn Colton

Although impressive in real life, this Belfast pub window would have made a rather boring picture on its own. The photographer therefore created a more interesting composition by posing a person across the foreground. As a print, this image presents challenges in retaining the semi-silhouette's shadow detail and also bringing out highlight detail in the back-lit window.

PRINTING TECHNIQUES

Tests were first made to find the best exposure (4.5s) and contrast filtration (Grade $2\frac{1}{2}$) for the semi-silhouette. The contrast was then reduced slightly, to Grade 2 for burning-in the window. This was done is several stages, using natural boundaries within the window area to avoid obvious printing marks. The area under the outstretched arm was burned-in for 6s; the area behind and above the semi-silhouette was given 10s, after which the area above was given a further 20s alone. The banister rail was then darkened slightly to avoid having a highlight leading out of the bottom of the picture.

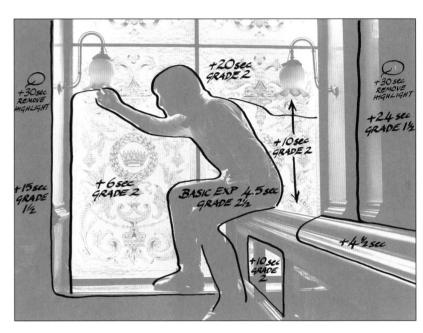

OVERLAY

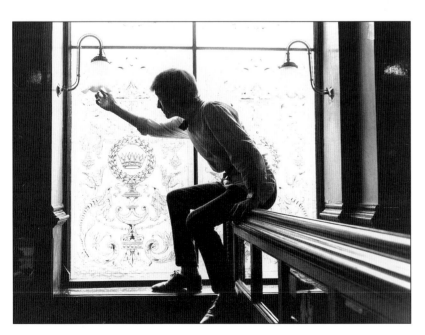

ORIGINAL PRINT

TO DARKEN THE SIDE PANELS, THE CONTRAST WAS DROPPED TO GRADE 1. AT FIRST IT MIGHT BE THOUGHT THAT A HARDER GRADE SHOULD HAVE BEEN USED TO DARKEN THE ALREADY DARK AREAS BECAUSE HIGHER CONTRASTS PRODUCE DEEPER BLACKS, BUT THIS IS NOT THE WHOLE STORY. HARDER GRADES ALSO SERVE TO EMPHASISE THE DIFFERENCES BETWEEN LIGHT AND DARK AREAS – AND IN THIS CASE THERE ARE HIGHLIGHTS WITHIN THE DARK PANELS THAT WOULD HAVE BEEN MADE MORE OBVIOUS WITH HIGHER CONTRAST FILTRATION. EVEN USING THE SOFTER GRADE CHOSEN, IT WAS STILL NECESSARY TO DARKEN THE HIGHLIGHTS THEMSELVES STILL FURTHER. BEING SMALL AREAS, IT MIGHT BE THOUGHT THAT CARD MASKS WOULD BE NEEDED, BUT BECAUSE THE AREAS ARE IRREGULARLY SHAPED IT IS ACTUALLY EASIER, AND QUICKER, TO USE HANDS HELD CLOSE TO THE ENLARGER LENS.

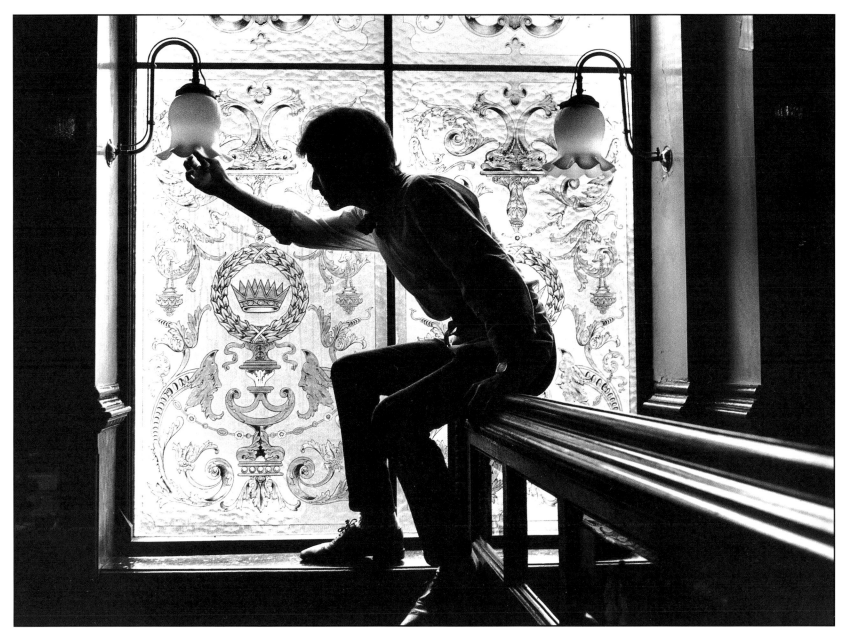

FINAL PRINT

ALBANIAN STEELWORKER

Photographer: Tom Stoddart

ollowing a commissioned trip to Albania shooting colour film, the photographer returned on a second occasion to take b/w pictures, partly for a book project entitled "Land of Darkness".

PRINTING TECHNIQUES

This was a very thin negative, but one that was correctly exposed nevertheless. Although the shadow side of the face is dark, it does still contain detail and it is this eye that holds the secret to printing the picture: if the eye disappears, the picture will fail.

The straight print was made full frame at Grade 2, after which the image was cropped and the contrast increased to Grade 2. Cropping served mainly to remove distracting areas that would have been difficult to handle any other way, but also increased the scale of the steel-worker, so making the picture more intense. The test exposure was made for the skin on the shadow side of the face, accepting that the eye itself would have to be dodged slightly to lighten it further. (Had the photographer not got the exposure exactly right, there would have been no detail to be seen on the shadow side of the face and the negative would simply not have been worth printing.)

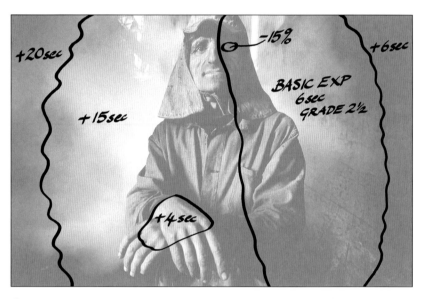

OVERLAY

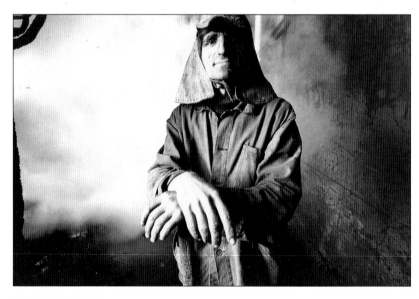

ORIGINAL PRINT

SINCE THE LIT SIDE OF THE FACE WAS MUCH BRIGHTER THAN THE SHADOW SIDE, THE LEFT HAND SIDE OF THE ENTIRE PRINT WAS DARKENED FROM A LINE RUNNING DOWN THE STEEL-WORKER'S NOSE AND TAKING IN BOTH OF HIS HANDS. THE HANDS THEMSELVES WERE THEN DARKENED EVEN MORE, AS WERE THE AREAS TO THE SIDES OF THE IMAGE. THE LEFT HAND SIDE REQUIRED HEAVY BURNING-IN, THOUGH THE SHAPES REVEALED IN THE STEAM WERE ALL PRESENT IN THE NEGATIVE AND WERE NOT INTRODUCED ARTIFICIALLY. SIMILARLY, THE WINDOW APPEARED AUTOMATICALLY AND DID NOT REQUIRE SPECIAL TREATMENT.

ONCE THE BASIC EXPOSURE HAD BEEN DETERMINED AND THE EYE CORRECTLY DODGED, THIS PICTURE WAS ACTUALLY REMARKABLY EASY TO PRINT. THE IMPORTANT THING WAS TO KEEP CHECKING THE SHADOW EYE AFTER EVERY CHANGE TO THE PRINTING PROCESS, OTHERWISE OVER-SPILL COULD CAUSE THE EYE TO DISAPPEAR AND THE IMAGE TO BE RUINED. WHEN NECESSARY, THE BASIC EXPOSURE TIME WAS ADJUSTED TO KEEP THE REQUIRED AMOUNT OF DETAIL. THE TIMES GIVEN ON THE OVERLAY SHOWN HERE ARE NOT THE STARTING VALUES, BUT ARE THOSE THAT WERE USED TO CREATE THE FINISHED RESULT.

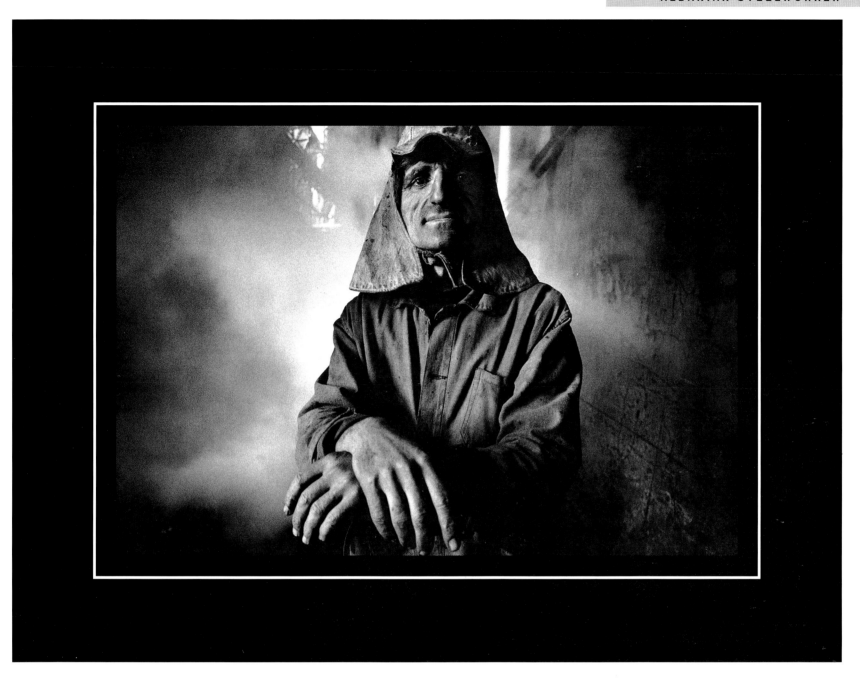

NOTE: IN GENERAL, AND ALMOST WITHOUT
EXCEPTION, THE TIMES USED FOR
EXPOSURES ON INTERMEDIATE PRINTS
ARE LONGER THAN THOSE USED ON FINAL
PRINTS. THE MORE EXPOSURES THAT ARE
APPLIED TO A PRINT, THE MORE OVER-SPILL
THERE WILL BE AND THE MORE INITIAL
TIMES HAVE TO BE REDUCED ACCORDINGLY.
IT IS VITAL TO REALISE THAT BASIC
EXPOSURES ARE NOT FIXED ON COMPLEX
MULTIPLE EXPOSURE PRINTS SUCH AS THIS.

HOLLYWOOD PORTRAIT

Photographer: Jon Tarrant

This was a joint project between the photographer, who was working on a series of b&w portraits in the style of classic Hollywood movie stars, and the actress Helen Levien who wanted such a picture for casting purposes.

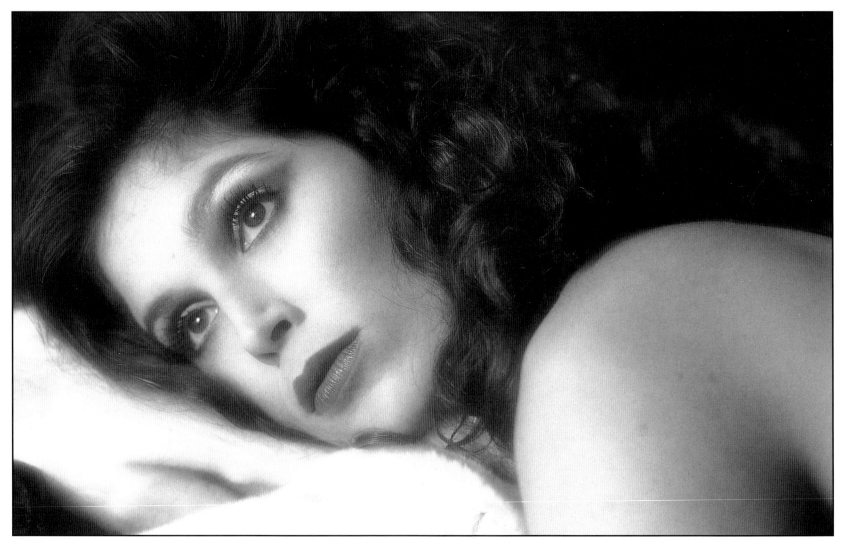

ORIGINAL PRINT

SQUARE CROP

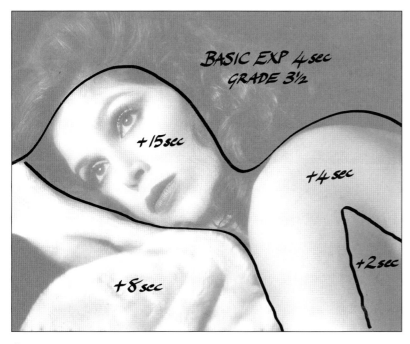

BASIC EXP 4 sec
GRADE 3½

+15 sec

+4 sec

+2 sec

+8 sec

OVERLAY FOR FINAL CROP SHOWN OVERLEAF

PRINTING TECHNIQUES

There is a real classic feel to this picture, making toning a likely option to use for the final print. But before that stage, the picture needs to be tidied up: in particular, the actress's shoulder, which tends to dominate the straight print, needs to be played down. One way of doing this would be to crop the shoulder out entirely, but this doesn't really work because it spoils the balance of the image. Therefore, the only answer is to use the entire negative and print carefully to direct attention towards the actress's face. Working from the whole negative also makes it possible to use an over-size negative carrier, giving rough edges to the picture area.

The basic exposure was determined for shadow detail in the hair. All but the top of the print was then darkened to give a good density to the skin tones. This is particularly important since the print was intended for toning, which can cause slight loses of highlight detail. The actress's eyes are so strong that there was no need to enhance them during printing. Indeed, when dodging was tried it just gave a muddy result.

The shoulder was darkened in two stages. First an overall exposure was given to drop the skin tone below that of the face. Then a local exposure was given to the shadow between the arm and body, so giving a stronger shape to the natural curve. One of the most useful skills in b/w printing is the ability to identify and emphasise shapes within pictures, whether they are intrinsic to the subject or arise as a result of the compositional arrangement of elements within the frame. In all cases, shapes give pictures interest and depth, and can also be used to convey emotions (jarring one element against another) or to suggest textures such as the soft sensual skin seen here.

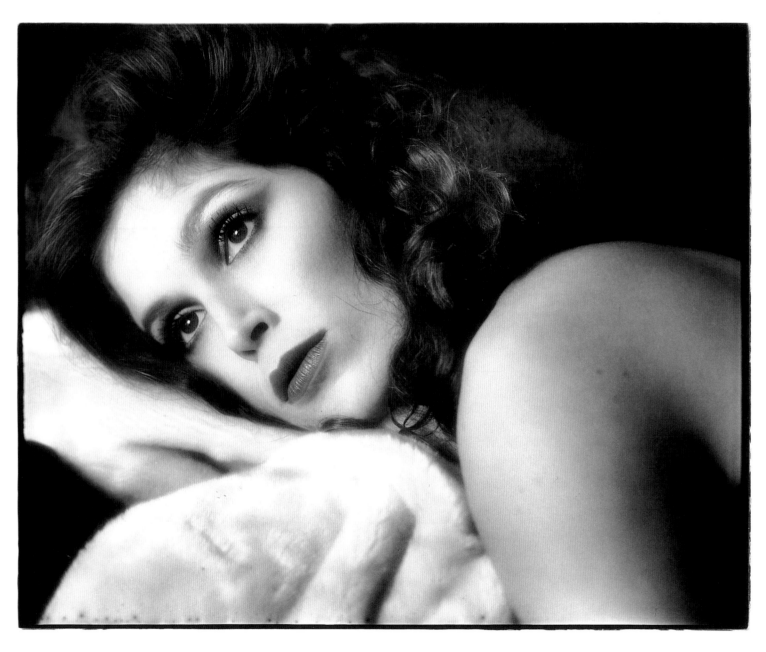

As always when working on pictures for toning, several prints were made. This allowed different times to be used in the bleach, leading to different colours in the final images. The two examples shown here were both toned in thiocarbamide, having been first pre-bathed in the toner before bleaching. (This technique helps to protect high density areas, making split toned effects easier.) The redder of the two prints (opposite) was bleached for longer than the bluer print (above), both being left in the final toning bath until fully affected. Since the redder print is more in keeping with the period feel of the picture, it was chosen as the final print.

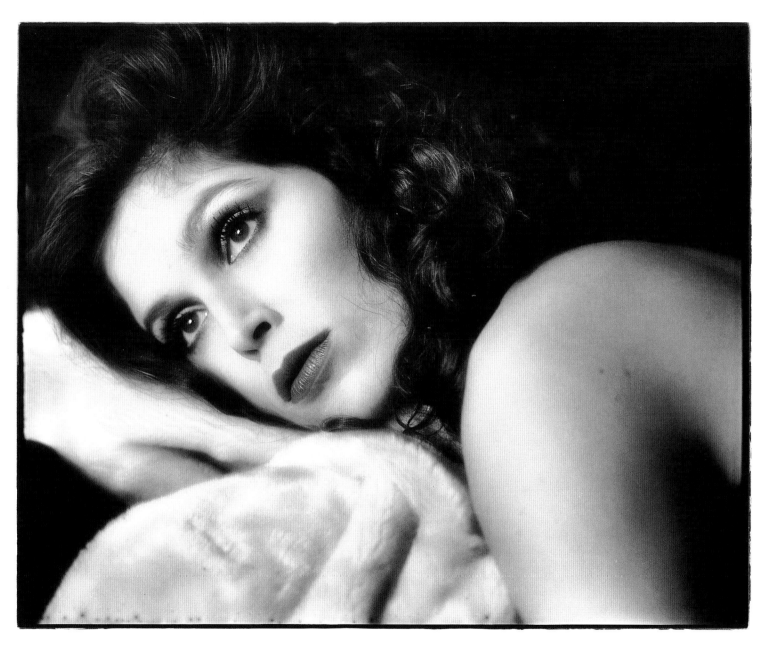

FINAL PRINT

BRIGHTON PAVILION

Photographer: Roger Bamber

Brighton Pavilion is one of southern England's best known landmarks, yet is shown here in a totally new light, reflected in the small ornamental pond that lies before it. With such a symmetrical image, it is essential that the finished print is completely balanced from left to right, with the reflection shown slightly darker than the building itself.

PRINTING TECHNIQUES

Two grades were used for the print: not one each for the building and its reflection, but one for all the architecture and the other for the sky. The basic exposure was on Grade $2\frac{1}{2}$, with 5s being determined as the maximum that kept the edges of the reflected minarets visible against the water. The upper part of the print,

from the top half of the reflection upwards, was given a substantial further exposure (15s). The two sides of the print were then balanced by giving 8s to all parts of the left-hand side of the picture other than the water area. The upper part was then darkened further following the natural line of the pond's brick wall.

To burn-in the already dark sky, while keeping the edges of the building as clear as possible, the contrast was increased to Grade 5. (Remember that high contrast printing grades affect blacks more than they do light tones, so helping to maintain separation of lighter foreground subjects against dark backgrounds.) Sufficient masking was provided by holding the hands loosely aligned over the minarets.

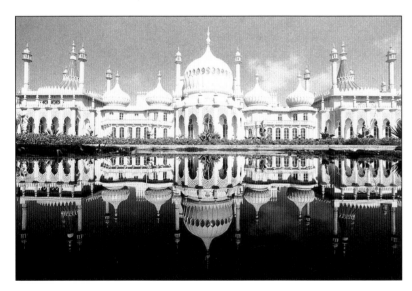

ORIGINAL PRINT

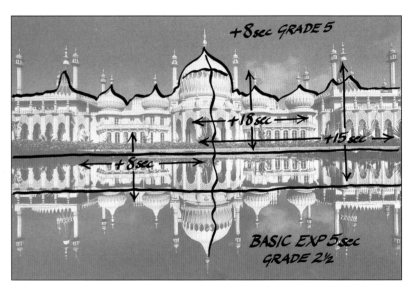

OVERLAY

FINISHED PRINT

SKIER ON THE ROOF

Photographer: John Downing

Given the general lack of snow in England, this country's speed skiers have to find other ways to train - one of which involves being strapped to the roof of a car and driven at high speed in order to perfect the most aerodynamic stance. The image was shot on a routine press assignment and obviously had particularly dramatic potential from the outset, but has been made even more so by using several different contrast exposures on the same sheet of variable contrast paper.

PRINTING TECHNIQUES

Just as it can sometimes be useful to regard burned and dodged prints as combinations of areas from differently exposed tests, so this image can be regarded as a combination of different grade areas blended on one sheet of printing paper. The small reproductions below and opposite show these contrasts as separate whole-image test prints: the gravel is right in one, the car in another and the background in the third.

CAR CONTRAST

BACKGROUND CONTRAST

FOREGROUND CONTRAST

Although each of these prints is right in part, trying to print the photograph at any one of these grades would give an imperfect overall result. The perfect print can be obtained only by combining aspects of all three.

In making the final print, overleaf, the whole sheet was first exposed as determined for the car (4s at Grade 3). During this exposure, the dust cloud was lighted using two fingers of the right hand - the tips of which traced the outline of the skier and car. Next, the driver's side head-light and wing were darkened slightly. This was an essential detail because the head-lights form a triangle with the skier's head, and the brighter light previously pulled attention away from the skier.

The background was then burned-in to total black. Grade 5 was used both to give the quickest maximum black and to avoid losing the skier's poles. Once again, harder grades are better at retaining

light details against dark backgrounds: softer grades make everything go grey and by the time the background is black the poles are such a dark grey that they can no longer be seen.) During this operation, the thumb of the right hand (held under the lens with its palm uppermost) was used to block the skier's head. The top of the thumb fell within the head area, rather than overlapping and blocking some of the background. This was to avoid creating a halo on the background which would have given the game away.

Switching to Grade 4, the foreground gravel was then darkened. The area to the left of print was blended downwards when burning-in the background, and upwards when doing the foreground. Had a higher contrast been used for the gravel, the highlights on it would have remained white. Had a softer grade been used, the ground would have looked too grey. Both are evident on the small test prints.

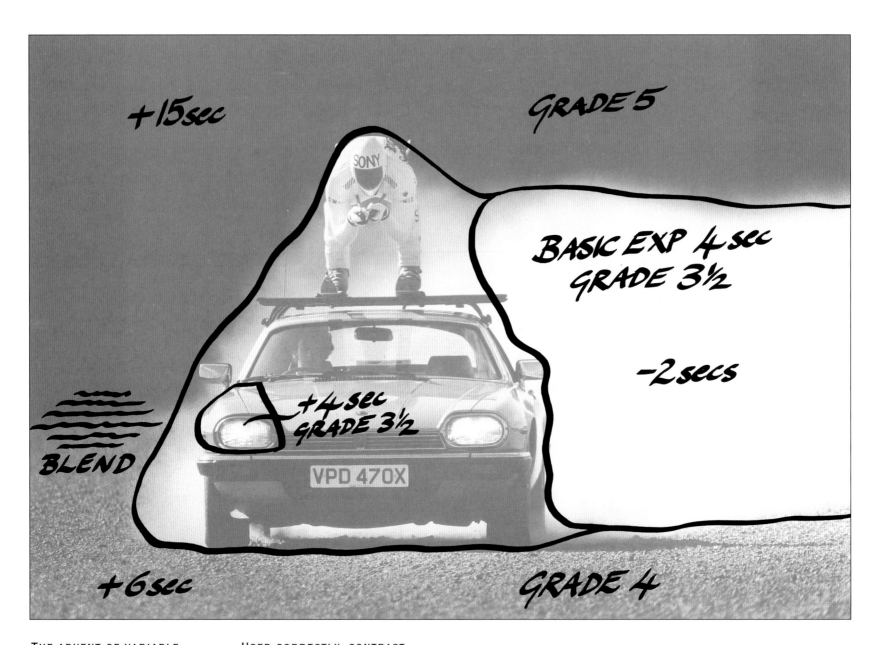

THE ADVENT OF VARIABLE CONTRAST PAPER HAS IN SOME WAYS MADE PRINTING MORE COMPLICATED THAN IT ONCE WAS SINCE IT IS NO LONGER ENOUGH TO QUESTION WHETHER AREAS OF AN IMAGE SHOULD BE MADE LIGHTER OR DARKER. NOW IT IS ALSO NECESSARY TO ASK WHETHER THE CONTRAST SHOULD BE HARDER OR SOFTER.

USED CORRECTLY, CONTRAST ADJUSTMENTS CAN MAKE FOR A REALLY DRAMATIC RESULT, BUT USED WRONGLY EVERYTHING CAN JUST END UP AS SHADES OF GREY. SO ALTHOUGH GRADE SHIFTS CAN BE VERY USEFUL, YOU MUST KNOW EXACTLY WHAT YOU WANT TO ACHIEVE BEFORE INTRODUCING THIS ELEMENT OF COMPLEXITY.

FINISHED PRINT

OLYMPIC SWIMMER

Photographer: Aidan Sullivan

This picture of Olympic swimmer Sharron Davis was shot using a Nikonos underwater camera and was originally envisaged with the diving platforms visible through the water in the distance. As it happened, the picture didn't come out that way. The photograph is still usable by cropping off the top half of the image, but can also be turned into something very much more eye-catching with a little careful darkroom work.

ORIGINAL PRINT

PRINTING TECHNIQUES

The first thing to say about this picture is that the double-image effect is not quite as simple to achieve as might be thought. In particular, it is no good printing the swimmer on one half of the paper, then just spinning the paper around to print the same image on the other half. If this had been done, the ladder in the background would have been on different sides in the top and bottom parts of the picture. What is actually needed is for the negative to be taken out of the carrier and turned upside down, then printed for the second time.

But before all this, the usual test procedure had to be followed to find the correct exposure and contrast for the right way around half of the picture. It was then necessary to devise a method of printing a soft edge to the bottom half of the picture, into which the new top half could later be blended. This was done using two pieces of 1" masking tape stuck one to each side of the easel. The exact centre of the intended blend between the two picture halves was drawn onto the tape. Using these lines as the limit of the picture, the bottom half was then printed with the hands held at the appropriate height and moved gently to and fro so as to create the required soft edge. Six sheets were exposed in this way, marked on their reverse sides to show which way is up, then stored in a light-tight box.

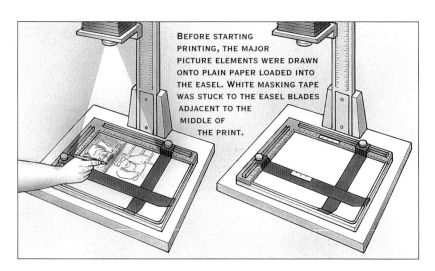

BEFORE STARTING PRINTING, THE MAJOR PICTURE ELEMENTS WERE DRAWN ONTO PLAIN PAPER LOADED INTO THE EASEL. WHITE MASKING TAPE WAS STUCK TO THE EASEL BLADES ADJACENT TO THE MIDDLE OF THE PRINT.

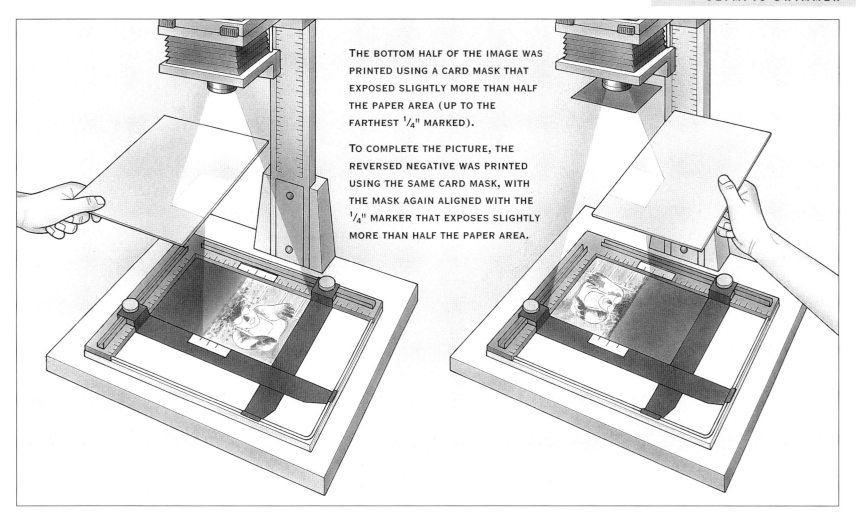

THE BOTTOM HALF OF THE IMAGE WAS PRINTED USING A CARD MASK THAT EXPOSED SLIGHTLY MORE THAN HALF THE PAPER AREA (UP TO THE FARTHEST $^1/_4$" MARKED).

TO COMPLETE THE PICTURE, THE REVERSED NEGATIVE WAS PRINTED USING THE SAME CARD MASK, WITH THE MASK AGAIN ALIGNED WITH THE $^1/_4$" MARKER THAT EXPOSES SLIGHTLY MORE THAN HALF THE PAPER AREA.

Before the negative was moved, the projected image was carefully drawn onto a plain piece of paper inserted into the easel. Any obvious lines (the ladder) were marked very accurately so that they can be aligned between the two halves of the picture. The negative was then removed from the carrier, turned upside down, replaced and re-aligned with the baseboard drawing.

A piece of anti-Newton glass was held under the enlarger lens when making the second exposure to subdue the reflected image slightly. Tests were made, using fresh sheets of paper (not the pre-prepared sheets), to find the best exposure for the reflection.

To combine the two halves, one of the previously prepared sheets was inserted into the easel, having checked the directional arrow on the reverse side of the sheet. The reflection image was printed, using the tested time, blending it up to the centre line marked on the 1" tape strips. After processing, this print was checked for density and alignment - looking to see whether there was either a light or dark band between the two halves of the picture.

A light band would have meant the images didn't join enough, and in the reprint the second image must therefore be blended deeper into the first. A dark band would have meant too much overlap, the blend should be moved further back in the next print. Whichever it was, the masking tape was marked with the proposed new blend line to make further adjustment possible in successive prints. By the time the sixth sheet had been used, a perfect print had been obtained!

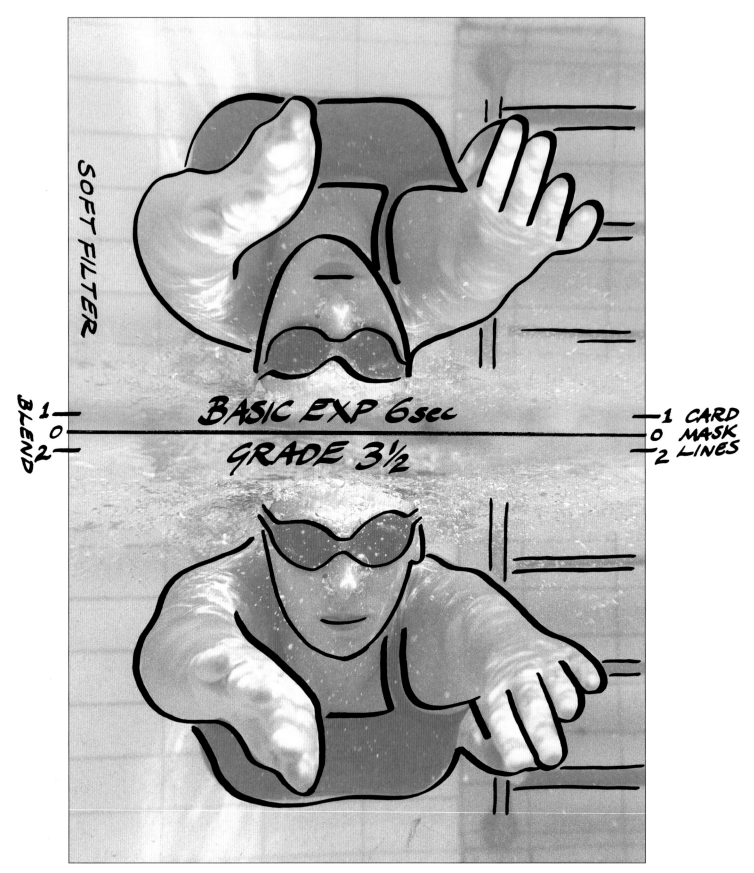

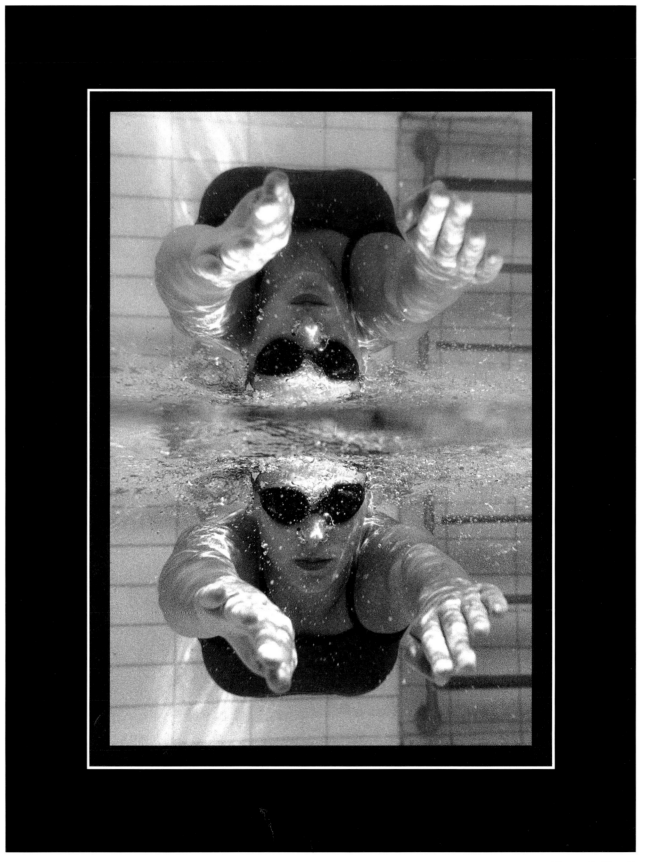

FINISHED PRINT

BALLET DANCERS

Photographer: Paul Massey

This is an inspiring negative, but also one that represents the ultimate in difficult printing: the whole feel of the picture must be kept very light, yet the windows mustn't be allowed to burn-out. The picture would obviously be a real cracker if printed well, but could so easily be totally ruined otherwise. It is all a matter of knowing the right technique to use. In this case, pre-flash is the only way to get a really good result.

PRINTING TECHNIQUES

A straight print from the negative provided the starting point, showing that the window areas would be very obviously burned-out if the image was printed using the interior's optimum contrast and exposure conditions. Darkening each window in turn would

have been very laborious and also unlikely to give a pleasing result. The answer, therefore, was to use pre-flash to boost highlight detail whilst leaving the mid-tones and shadows almost totally unaffected.

As has already been explained, pre-flash is not a technique that can be applied the same to all images. For this reason, and contrary to certain advice, batches of paper should not be pre-flashed and stored in advance.

To determine the correct amount of pre-flash for this particular negative, the pre-flash enlarger was set to the average pre-flash conditions determined previously. A test strip was then exposed using the average value, half that exposure, one-quarter that exposure, double the exposure and four-times the exposure.

ORIGINAL PRINT

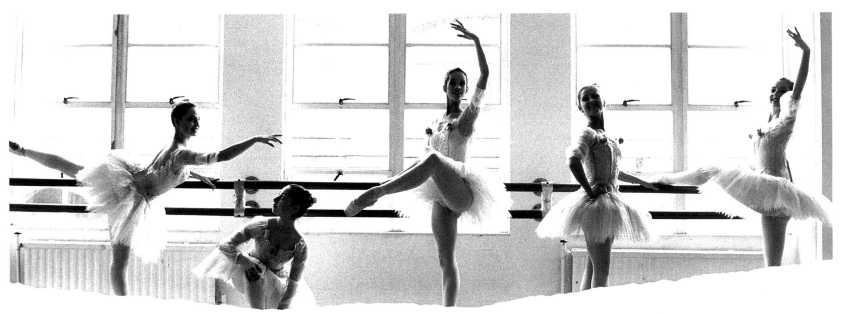

WITHOUT PRE-FLASH

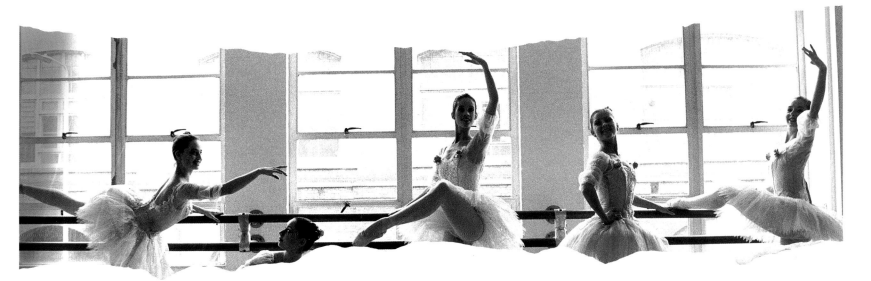

WITH PRE-FLASH

This test sheet was not processed, but was moved to the second enlarger, under which the image negative had already been composed and tested as a straight print.

Half of the pre-flashed sheet was covered with a card mask and, using the straight print exposure, the image exposed onto the visible half of the paper. After processing, the test was checked to see which pre-flash gave the best balance of highlight detail (in the image area) with the least fogging (on the masked-off half of the paper). Six sheets were then pre-flashed at this setting, giving opportunities for varying the image exposure to give the best final result.

Having found the optimum pre-flash, the negative was tested again to check the best exposure and contrast grade. Leaving out this last check is liable to result in poor print quality since, in general, prints that have been pre-flashed need higher contrast image exposures than straight prints from the same negatives.

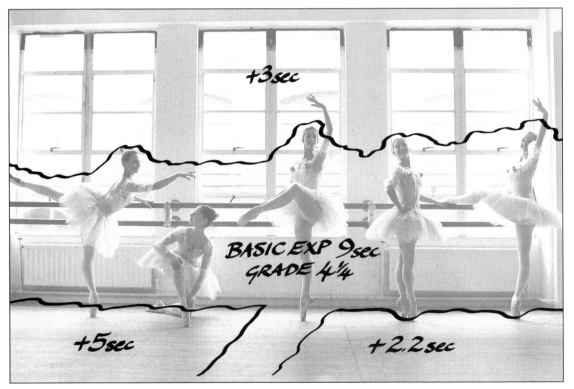

On the image: +3sec, BASIC EXP 9sec GRADE 4¼, +5sec, +2.2sec

OVERLAY

PRE-FLASH DOESN'T AVOID THE NEED FOR BURNING-IN, BUT IT DOES VERY MUCH REDUCE THE REQUIREMENT IN HIGHLIGHT AREAS. THE BALLET SCHOOL IMAGE SHOWN HERE HAS BEEN BOTH PRE-FLASHED AND BURNED-IN, THE LATTER TO DARKEN THE TOPS OF THE WINDOWS STILL FURTHER. TWO SECTIONS OF THE FLOOR HAVE ALSO BEEN DARKENED, LEAVING A LIGHTER AREA THAT LEADS THE EYE NATURALLY TOWARDS THE CENTRE OF THE PRINT.

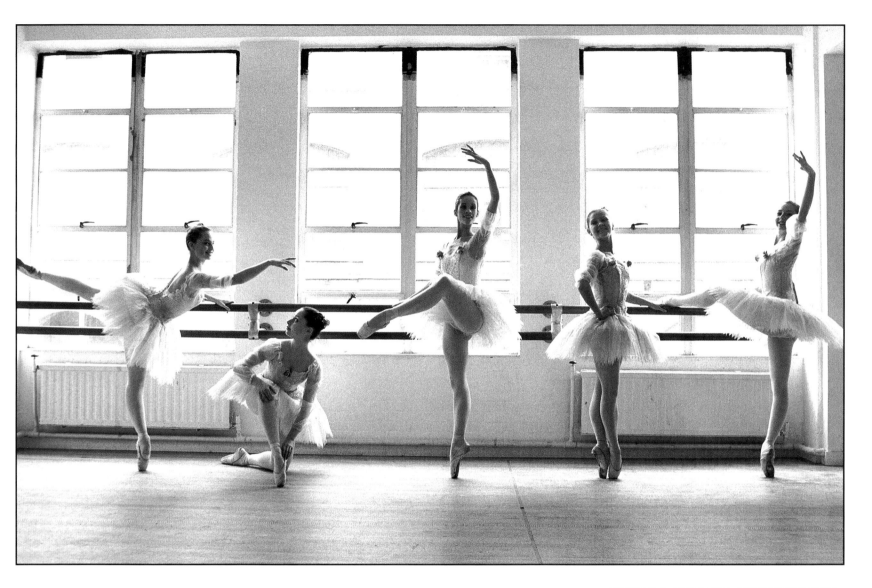

CLEARLY, A GREAT DEAL OF WORK HAS GONE
INTO THIS PRINT. THE RESULT JUSTIFIES
THE EFFORT, BUT THIS IS DUE AS MUCH TO
THE SKILL OF THE PHOTOGRAPHER AS IT IS
TO THAT OF THE PRINTER. IT IS A MISTAKE
TO TRY TO PERFECT IMAGES THAT SIMPLY
DON'T WARRANT THE TIME AND EFFORT THEY
REQUIRE: CAREFUL PRINTING CAN MAKE THE
DIFFERENCE BETWEEN A GOOD IMAGE AND
A GREAT ONE, BUT CAN'T MAKE A SILK
PURSE FROM A SOW'S EAR.

SHEEP WALKING

Photographer: Roger Bamber

Obviously this picture was shot on a very grey overcast day. There are even signs of local flare that suggest a drop or two of rain may have got onto the front of the lens. And yet, the image is highly effective and possesses a special quirky appeal. Unfortunately, the negatives were badly processed and have a series of tram lines that run through the sky. Given that the sky is both boring and damaged, it is tempting to think of doing a combined print using a new sky, but this would be unlikely to succeed owing to the difficulty of matching the grain and sharpness of the original image.

Anyway, it also happens that there are other ways of adding atmospheric elements to enhance this picture.

PRINTING TECHNIQUES

The very first thing that was done with this image was to crop the 35mm negative to a more dramatic panoramic shape.

A test strip was then exposed looking for separation between the far left sheep against the sand, and also the man's head against the background. Even though the negative was distinctly flat, Grade 5 contrast was still just very slightly too much. Grade $4^3/_4$ dial-in filtration was therefore used: if only slot-in filters been available, Grade $4^1/_2$ would have been used in preference to Grade 5. The main reason for this is that the sheep and sand create a multitude of highlights, which would have required an unreasonable amount of burning-in at Grade 5.

To enhance the atmosphere of the picture, a distant sea spray mist was added at the boundary between the sea and the head-land. This was created using deliberately poorly blended burn-ins. The entire sky area was burned-in for 11s, after which the top area was darkened by an additional 3s exposure to give the impression of a lower sun angle that could realistically have picked up on the sea spray and formed the mist effect already created.

Finally, the foreground was darkened, with the left side given slightly more exposure to provide a sense of direction within the narrow panoramic crop.

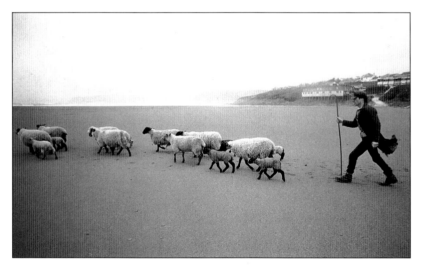

ORIGINAL PRINT

TEST STRIP

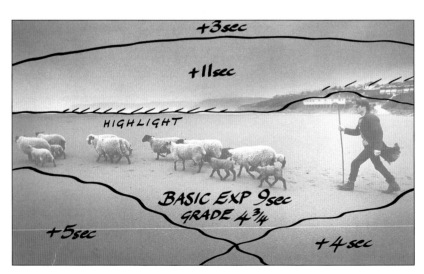

OVERLAY

148

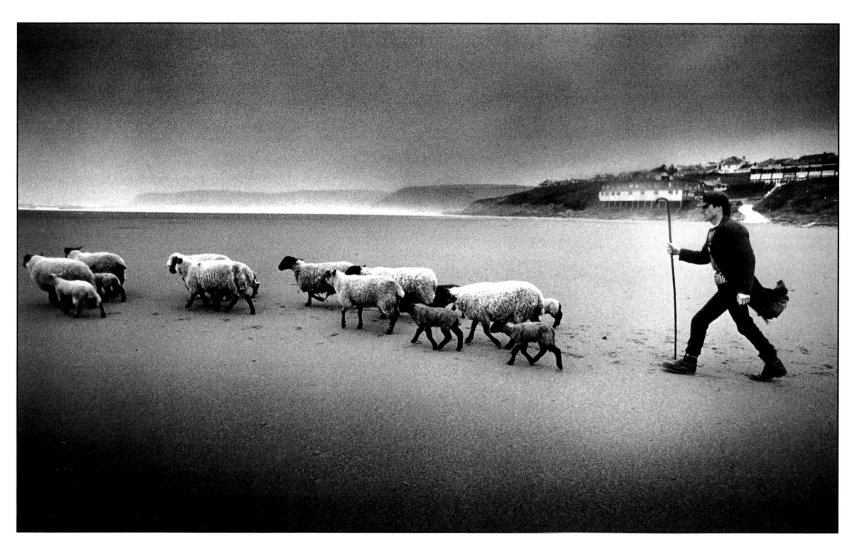

FINISHED PRINT

MALE PORTRAIT

Photographer: Caroline Hogan

As is the case here, simplicity is very often the key to success in a picture. Similarly, a simple darkroom trick can be used to create something a little more unusual from the negative. Although panoramic landscapes are quite common in photography, narrow upright crops are very much rarer. Here, such a crop was not possible from the negative because the subject was so full in the frame, but by fading the background to black the picture area could be extended under the enlarger.

PRINTING TECHNIQUES

In order to get really bold skin tones, the negative was tested at Grade 4. Even so, because the negative was quite soft, the eyes still benefited from being dodged. To do this, the basic exposure was split in half, with the dodging tool being used during the first period. Both eyes were dodged at once using the usual two blobs of plasticine on a single wire support. During the second period, the small highlight on the man's hair was held back. The contrast was then changed to Grade 5, so as to affect the hair highlight as little as possible, and the area above the head was darkened to maximum black.

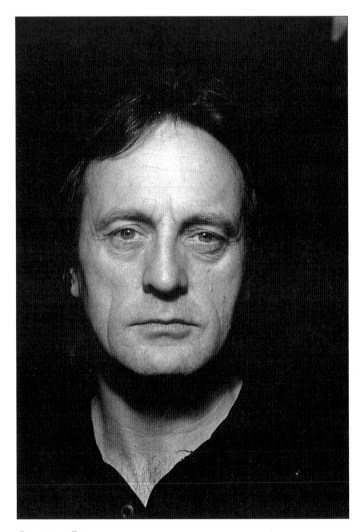

ORIGINAL PRINT

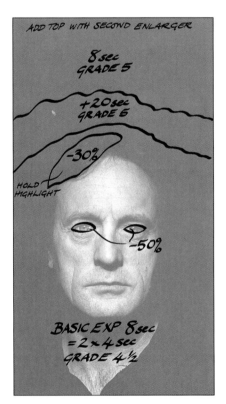

OVERLAY

TO EXTEND THE BACKGROUND, A SECOND ENLARGER, SET TO GRADE 5, WAS USED. THE ENLARGER HEAD WAS POSITIONED TO PROVIDE AN APPROPRIATE AREA OF COVERAGE FOR THE SIZE OF PRINT BEING MADE. THE PAPER, STILL IN ITS EASEL, WAS THEN MOVED TO THE SECOND ENLARGER AND THE BOTTOM PART OF THE PRINT PROTECTED BY SHADING WITH THE HANDS WHILE THE TOP PART WAS EXPOSED TO MAXIMUM BLACK. BECAUSE THE TOP OF THE IMAGE WAS ALREADY BLACK, NO TRICKY ALIGNMENT WAS REQUIRED PROVIDED THAT THE EXTENDED AREA WAS ALLOWED TO OVERLAP THE ORIGINAL IMAGE'S BACKGROUND. SIMILARLY, KEEPING THE PAPER IN THE SAME EASEL THROUGHOUT ENSURED THAT THERE WAS PERFECT ALIGNMENT BETWEEN THE EDGES OF THE IMAGE AND THE EXTENDED PICTURE AREA.

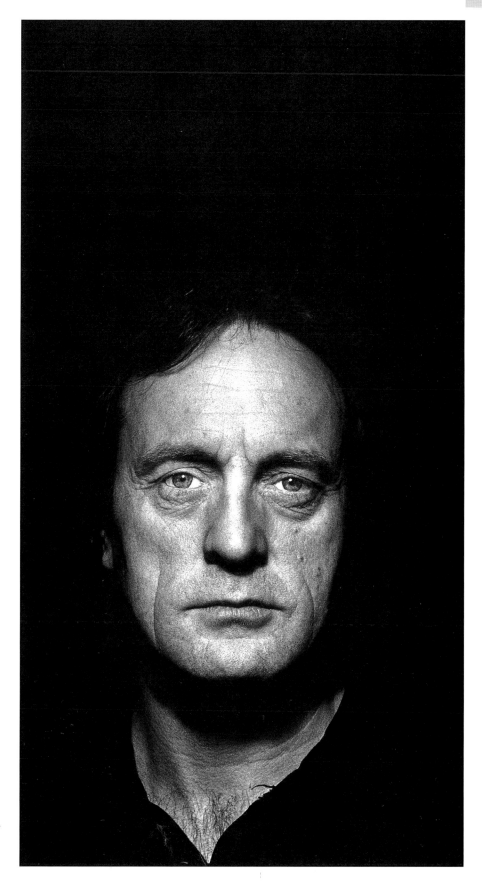

IT IS WORTH NOTING THAT
ALTHOUGH TWO ENLARGERS WERE
USED FOR CONVENIENCE, THE
EXTENSION COULD EASILY HAVE
BEEN PRINTED USING THE SAME
ENLARGER AS WAS USED TO PRINT
THE IMAGE SIMPLY BY REMOVING
THE NEGATIVE CARRIER.

NORMAN PARKINSON

Photographer: Denis Jones

ORIGINAL PRINT

Perhaps one of the most daunting assignments that any photographer can face is to photograph another photographer, even more so when the person concerned is the great Norman Parkinson. Add to that the fact that the portrait had to be shot in just five minutes and you have a photographer's nightmare. Yet despite these psychological and physical barriers, Denis Jones' portrait is one of the best ever taken of Norman Parkinson.

PRINTING TECHNIQUES

Even as a straight print, this is an inspired portrait, though it is a shame that the hands, wrists and watch are stronger than the photographer's eyes. Clearly, this balance needs to be rectified in the finished print. In addition, and in keeping with the style of the great photographer, it was decided to create a more controlled look, almost a studio shot, from the negative.

Grade 4 was chosen to give bold, gritty skin tones. This, and the off-balance tones in the straight print, meant that a great deal of burning-in would be necessary, though the finished print would be all the stronger for the effort.

The 9s basic exposure was split into components of 4.5s, 3s and 1.5s to allow different amounts of dodging in two separate areas. During the first stage, the eyes were held back. During the second, the area to the left of Parkinson's nose was lightened. The final component was given without adjustment. Following these initial subtractive (dodging) operations, all the following refinements were additive (burning-in) exposures.

The tip of the nose and chin, and the bottom corners of the image, were all darkened as shown on the printing guide. It took three or four attempts to get the print looking right up to this stage.

Attention was then turned towards the hands, which were treated as a series of separate areas. The left hand was first given 45s extra, then each of the two pairs of fingers was given another 15s, after which the area in the corner above the fingers was burned-in to maximum black. The right hand was given 45s up as far as the knuckles, then 30s to the lower pair of fingers and 45s to the upper pair. The corner was then taken to maximum black to match the opposite.

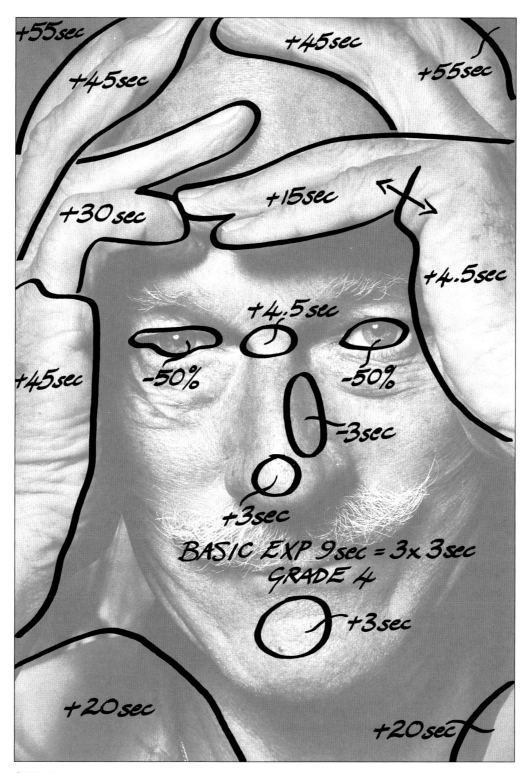

OVERLAY

1. GRADE 4 CHOSEN TO GIVE BOLD GRITTY TONES.

2. 9S BASIC EXPOSURE SPLIT INTO THREE COMPONENTS.

3. FIRSTLY EYES HELD BACK WITH DODGING TOOL FOR 4.5S.

4. SECOND AREA TO LEFT OF NOSE LIGHTENED FOR 3S.

5. THIRDLY 1.5S OVERALL WITHOUT ADJUSTMENT.

6. FOLLOWING DODGING STEPS BURNING-IN WAS USED +3S FOR TIP OF NOSE.

7. +3S FOR CHIN.

8. +4.5S FOR BRIDGE OF NOSE.

9. LEFT HAND +4.5S.

10. PAIRS OF FINGERS +15S.

11. COLLAR OF JACKET ON BOTTOM CORNERS +20S.

12. AREA ABOVE FINGERS BURNED-IN TO MAXIMUM BLACK.

13. RIGHT HAND +45S UP TO KNUCKLES.

14. RIGHT HAND +30S TO LOWER PAIR OF FINGERS.

15. RIGHT HAND +45S TO UPPER PAIR OF FINGERS.

16. TOP CORNER BURNED-IN TO MAXIMUM BLACK.

IN TOTAL, SIXTEEN DIFFERENT EXPOSURES WERE GIVEN TO THIS PRINT. A MARK-UP SHEET, SHOWING A SKETCH OF THE IMAGE AND THE VARIOUS EXPOSURES GIVEN, WAS ABSOLUTELY ESSENTIAL.

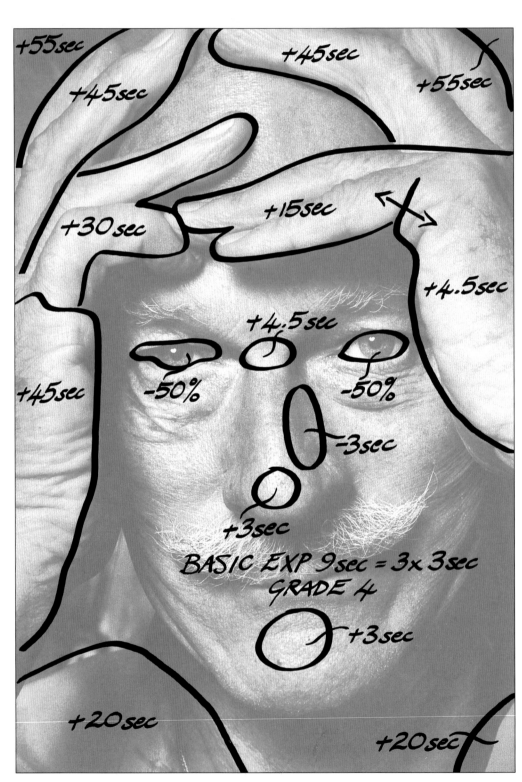

OVERLAY

154

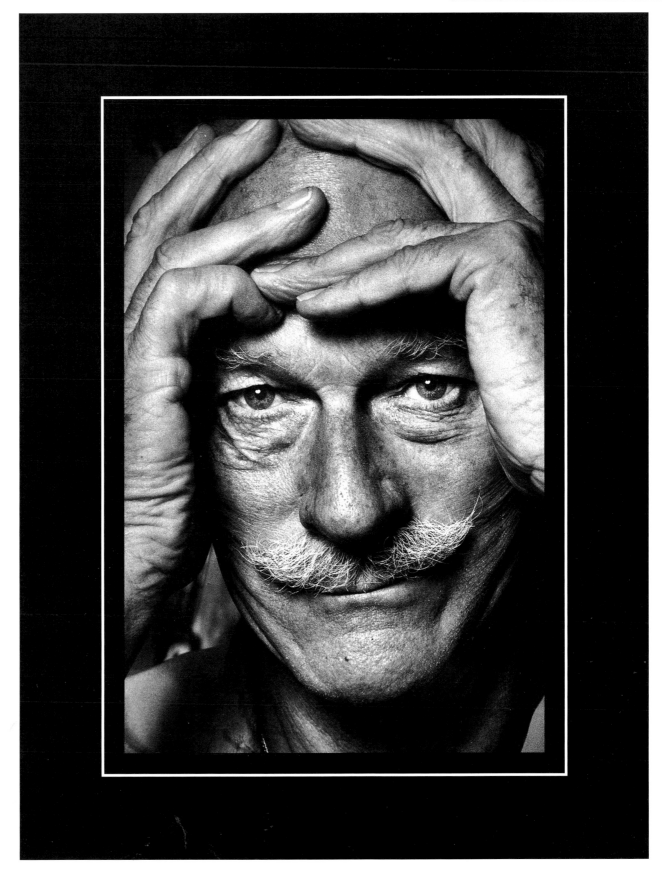

IT WILL BE NOTICED THAT THE PORTRAIT HAS BEEN CROPPED, BOTH TO MAKE PARKINSON'S FACE MORE UPRIGHT AND TO REMOVE THE WATCH FROM THE IMAGE AREA COMPLETELY, AND THAT ONLY A SMALL AREA OF THE PICTURE (IN THE GAP BETWEEN THE HAND AND CHEEK) GIVES AWAY THE FACT THAT THERE WAS DETAIL IN THE BACKGROUND WHEN THE PICTURE WAS TAKEN. TO HAVE TAKEN OUT THIS LAST BIT OF LOCATION INFORMATION WOULD HAVE BEEN A MISTAKE, AS YOU CAN JUDGE SIMPLY BY PUTTING A PIECE OF BLACK PAPER OVER THE AREA.

FINISHED PRINT

INDEX

ACKNOWLEDGMENTS

The authors would like to thank all those who helped to make this book possible. In particular, thanks are extended to the photographers who allowed their images to be used not only in their final forms but also as raw, original prints…

John Downing OBE (Chief Photographer of the Daily Express)

Tom Stoddart (courtesy of Katz Pictures)

Roger Bamber

Paul Massey

Bryn Colton (photo for The Sunday Times,
©Bryn Colton/Assignments)

Caroline Hogan

Aidan Sullivan

Denis Jones

Colin Davy

Chris Bennett

In addition, special thanks to Express Newspapers plc for permission to use images shot for the group's publications.

Larry Bartlett and Jon Tarrant would would also like to thank all the manufacturers, suppliers and photographic industry contacts who have supplied information and help, especially the staff of Ilford UK.

Finally, we would like to thank the family members who supported this long-running project; Pat, Daniel and Adam Bartlett, and Lin Tarrant.